Fantasy Art Templates

Fantasy Art Templates

Ready-made artwork to copy, adapt, trace, scan & paint

Illustrations by: Rafi Adrian Zulkarnain
Text by: Jean Marie Ward

A&CB

A & C BLACK • LONDON

A QUARTO BOOK

Copyright © 2010
Quarto Publishing plc

First published in the UK
in 2010 by
A & C Black Publishers
36 Soho Square
London W1D 3QY
www.acblack.com

ISBN: 978-1-4081-2218-1

Conceived, designed
and produced by
Quarto Publishing plc
The Old Brewery
6 Blundell Street
London N7 9BH

QUA: FATT

Editor & designer:
Michelle Pickering
Indexer: Dorothy Frame
Art director: Caroline Guest

Creative director: Moira Clinch
Publisher: Paul Carslake

Colour separation by PICA
Digital Pte Ltd, Singapore
Printed by Star Standard
Industries (PTE) Ltd, Singapore

10 9 8 7 6 5 4 3 2 1

CONTENTS

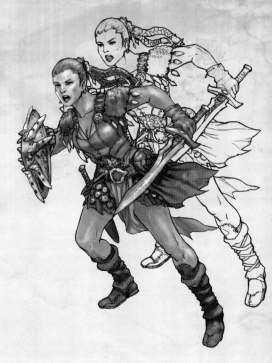

Introduction 6

Chapter 1
Heroes & Villains 8

Wizards 10

Techno-mages 12

Warriors 16

Thieves & assassins 20

Adventurers 24

Scholars & clerics 26

Bandits & pirates 28

Barbarians 30

Elves 34

Fairies 38

Dwarves 42

Sorcerers 44

Giants 48

Princes & princesses 50

Horsemen & -women 52

Beast masters 56

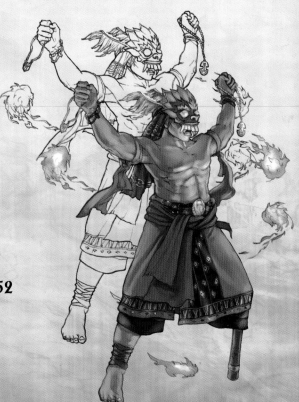

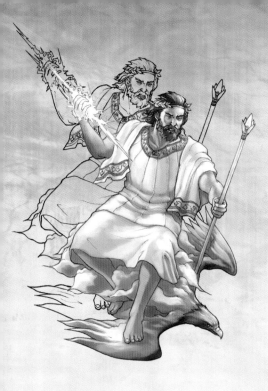

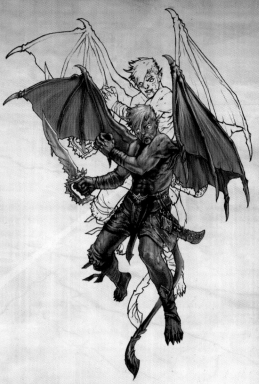

Chapter 2
Celestial &
Infernal 60

Gods & goddesses 62

Angels 70

Devils & demons 74

Chapter 3
Monstrous &
Mythical 78

Dragons 80

Mythical birds 84

Fantasy beasts 88

Nightmares 96

Ocrs & ogres 98

Ghouls 102

Yokai 104

Gremlins & goblins 108

Merfolk 110

Imps & familiars 114

Chapter 4
Techniques &
Backgrounds 116

Tools & media 118

Creating characters 122

Setting the scene 126

Applying colour 138

Index 142

Acknowledgements 144

INTRODUCTION

From Harry Potter to *The Lord of the Rings*, fantasy is not just for kids anymore. Illustrating fantastic characters in fabulous settings presents many challenges for novice and experienced artists alike. How do you render the intangible force of magic? How can you depict a vision from someone else's nightmare? How do you capture a dream? This book shows you how to overcome these challenges and make the impossible look real.

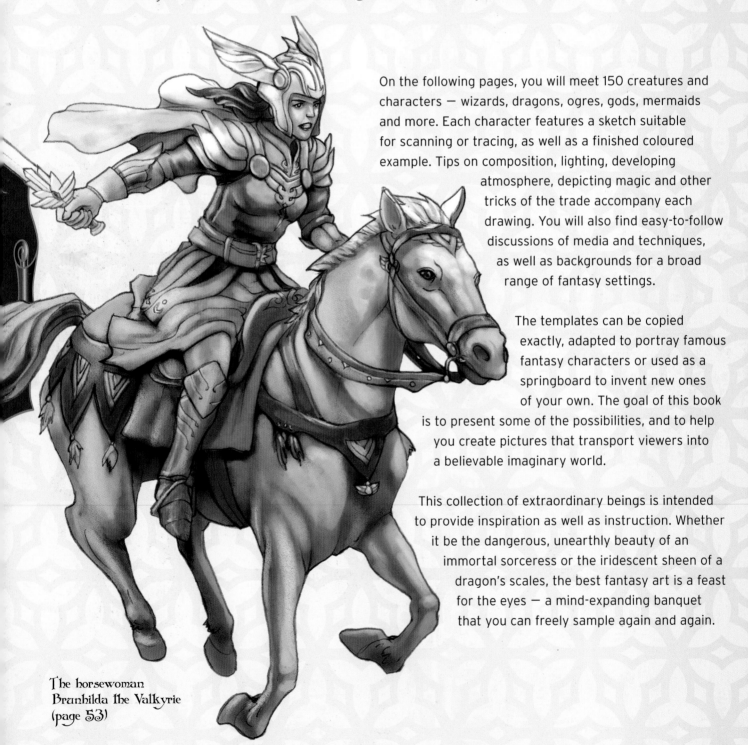

On the following pages, you will meet 150 creatures and characters — wizards, dragons, ogres, gods, mermaids and more. Each character features a sketch suitable for scanning or tracing, as well as a finished coloured example. Tips on composition, lighting, developing atmosphere, depicting magic and other tricks of the trade accompany each drawing. You will also find easy-to-follow discussions of media and techniques, as well as backgrounds for a broad range of fantasy settings.

The templates can be copied exactly, adapted to portray famous fantasy characters or used as a springboard to invent new ones of your own. The goal of this book is to present some of the possibilities, and to help you create pictures that transport viewers into a believable imaginary world.

This collection of extraordinary beings is intended to provide inspiration as well as instruction. Whether it be the dangerous, unearthly beauty of an immortal sorceress or the iridescent sheen of a dragon's scales, the best fantasy art is a feast for the eyes — a mind-expanding banquet that you can freely sample again and again.

The horsewoman
Brunhilda the Valkyrie
(page 53)

How to Use This Book

First, choose a fantasy character from Chapters 1, 2 or 3, which feature 150 heroes and villains, celestial and infernal beings, and monstrous and mythical creatures. In the beginning, you may wish to choose figures with simple shapes and large blocks of colour, such as Zenita (page 39), Princess Elena (page 50) or Jiaolong (page 81). Next, refer to Chapter 4 for advice on tools and media, how to trace or scan the template, plus tips on adapting and colouring it. Chapter 4 also features some sample backgrounds so that you can set your character into a fantasy scene.

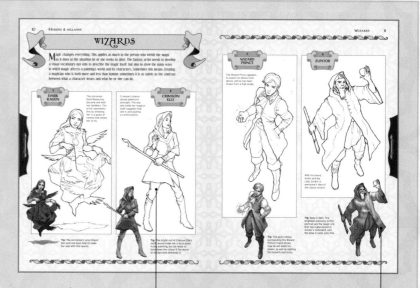

Each character features a sketch that can be used as a template, together with a name and some information about the character.

Look at the painted example of each character for ideas on how to colour the template. Handy tips are provided.

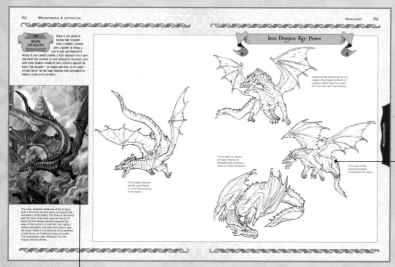

Selected characters have templates for four key poses. These can also be used as reference for adapting the poses of other characters in the book.

An example of one of the key poses in a background setting, with advice on how to fit the elements together.

Chapter 4 provides concise information about the techniques that can be used to copy, adapt and colour the templates.

Choose one of the ten sample backgrounds in Chapter 4 as a setting for your character, or use them as inspiration for creating your own background.

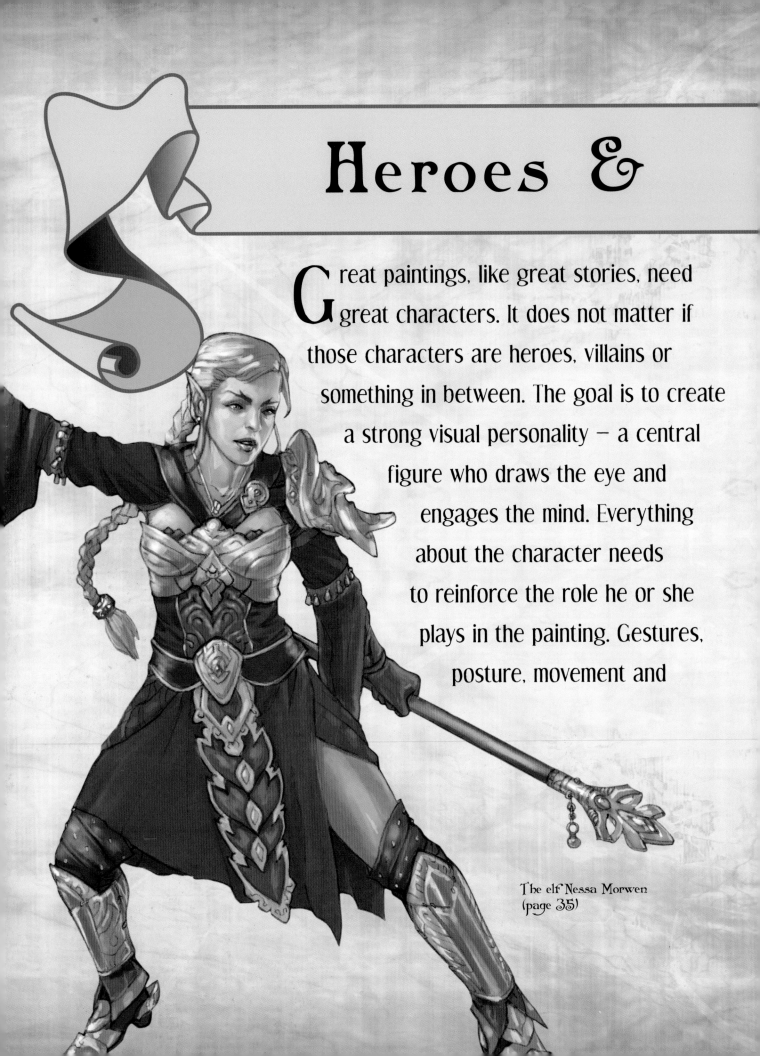

Heroes &

Great paintings, like great stories, need great characters. It does not matter if those characters are heroes, villains or something in between. The goal is to create a strong visual personality – a central figure who draws the eye and engages the mind. Everything about the character needs to reinforce the role he or she plays in the painting. Gestures, posture, movement and

The elf Nessa Morwen
(page 35)

Villains

accessories are just as important as the character's face and figure. A wizard prince expecting an attack from above will hold himself differently than a shaman scouting a haunted trail or a Viking warrior peering into the distance from the prow of a ship. This chapter shows you how to develop and depict the compelling characters needed to provide a strong focus for your fantasy paintings.

The assassin
Darsoz (page 21)

WIZARDS

Magic changes everything. This applies as much to the person who wields the magic as it does to the situation he or she seeks to alter. The fantasy artist needs to develop a visual vocabulary not only to describe the magic itself, but also to show the many ways in which magic affects a painting's world and its characters. Sometimes this means creating a magician who is both more and less than human; sometimes it is as subtle as the contrast between what a character wears and what he or she can do.

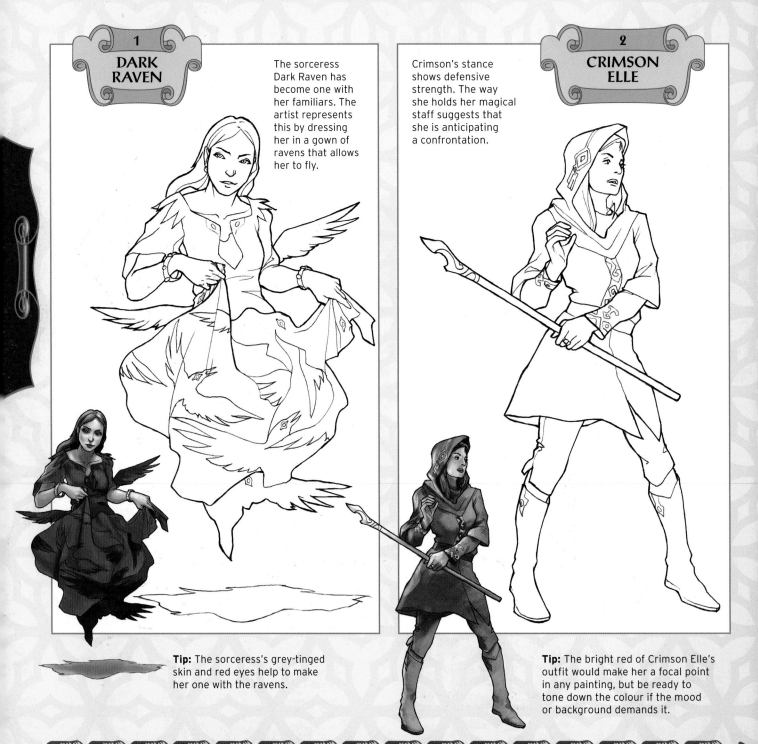

1 DARK RAVEN

The sorceress Dark Raven has become one with her familiars. The artist represents this by dressing her in a gown of ravens that allows her to fly.

Tip: The sorceress's grey-tinged skin and red eyes help to make her one with the ravens.

2 CRIMSON ELLE

Crimson's stance shows defensive strength. The way she holds her magical staff suggests that she is anticipating a confrontation.

Tip: The bright red of Crimson Elle's outfit would make her a focal point in any painting, but be ready to tone down the colour if the mood or background demands it.

3 WIZARD PRINCE

The Wizard Prince appears to expect an attack from above, and so has been drawn from a high angle.

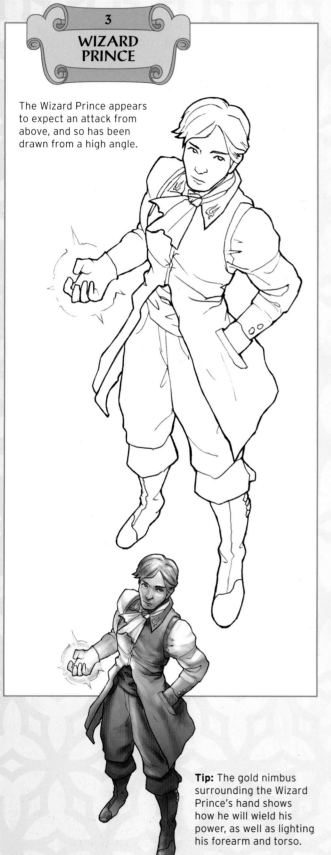

Tip: The gold nimbus surrounding the Wizard Prince's hand shows how he will wield his power, as well as lighting his forearm and torso.

4 ZUNTOR

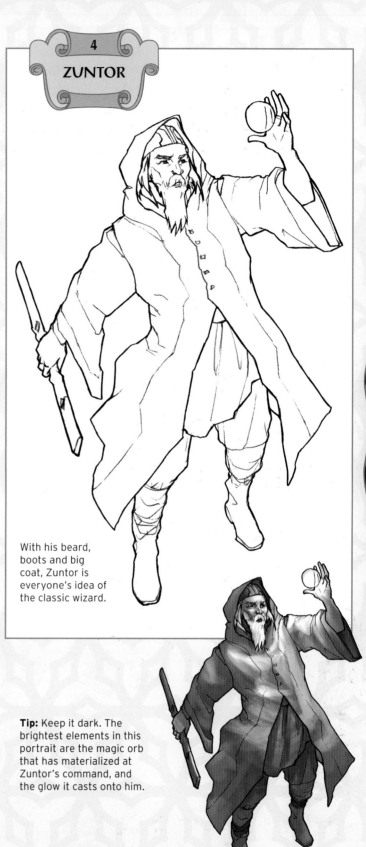

With his beard, boots and big coat, Zuntor is everyone's idea of the classic wizard.

Tip: Keep it dark. The brightest elements in this portrait are the magic orb that has materialized at Zuntor's command, and the glow it casts onto him.

TECHNO-MAGES

Magic demands many sacrifices from its practitioners – sacrifices that mages are not always willing to make. This leads them to develop technologies to augment their natural powers and avoid the negative impact that using magic can have on their life force. The enhancements can include energy packs, amplification devices and mental shields. Mages who use science to strengthen their magic blur the distinction between fantasy and science fiction, which allows them to fit in a wide variety of settings – they are equally at home in Victorian cities, on distant planets and in futuristic worlds.

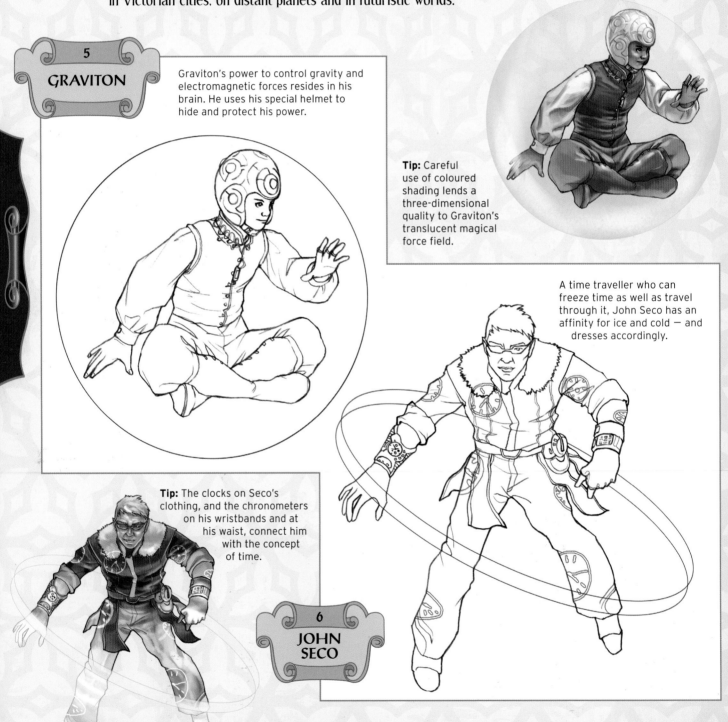

5 GRAVITON

Graviton's power to control gravity and electromagnetic forces resides in his brain. He uses his special helmet to hide and protect his power.

Tip: Careful use of coloured shading lends a three-dimensional quality to Graviton's translucent magical force field.

A time traveller who can freeze time as well as travel through it, John Seco has an affinity for ice and cold – and dresses accordingly.

Tip: The clocks on Seco's clothing, and the chronometers on his wristbands and at his waist, connect him with the concept of time.

6 JOHN SECO

7
ZAVORTAN

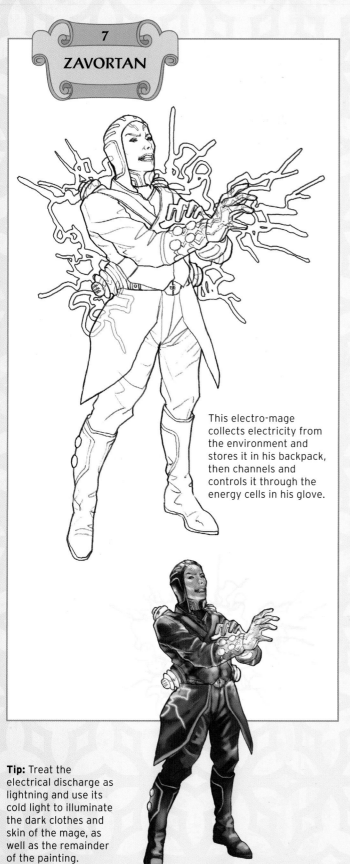

This electro-mage collects electricity from the environment and stores it in his backpack, then channels and controls it through the energy cells in his glove.

Tip: Treat the electrical discharge as lightning and use its cold light to illuminate the dark clothes and skin of the mage, as well as the remainder of the painting.

8
LEELA LAYN

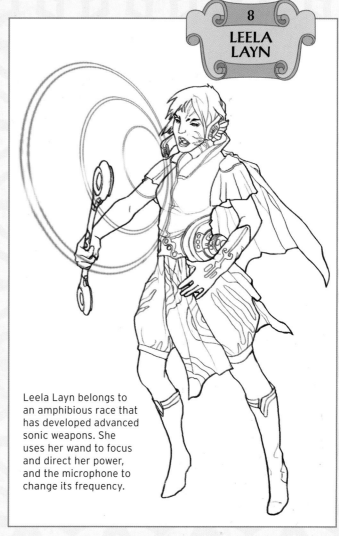

Leela Layn belongs to an amphibious race that has developed advanced sonic weapons. She uses her wand to focus and direct her power, and the microphone to change its frequency.

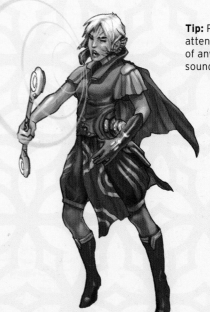

Tip: Pay particular attention to the ears of any being that uses sound as a weapon.

9

LUCIENNE SOL

Light-mage Lucienne Sol powers her magic with the solar panels on her capelet. She uses the controller on her left wrist to create a light-based shield, while the magic blasting from her short wand resembles flares from a miniature sun. Everything about her appearance reinforces her connection to light: white clothes, light blond hair, glittering instruments and solar panels, and (most importantly) protective goggles.

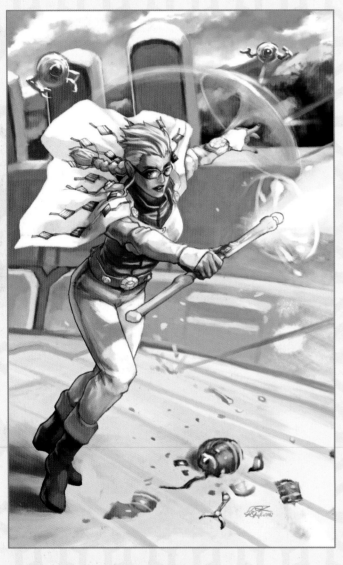

The light-mage races along a futuristic battlement pursued by grasping, airborne lasers. She uses her magic to defend herself as she runs. A shattered laser lies at her feet, its fuel glistening like blood. The bright daytime setting in no way lessens the sense of danger, and allows the artist to use colours as hot and intense as Lucienne's blasting wand.

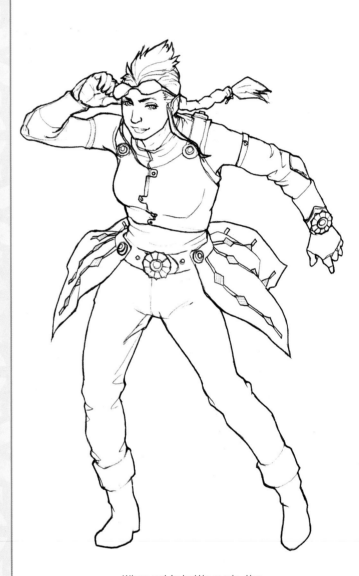

When not in battle mode, the mage's light-collecting capelet attaches to her belt to recharge.

Lucienne Sol: Key Poses

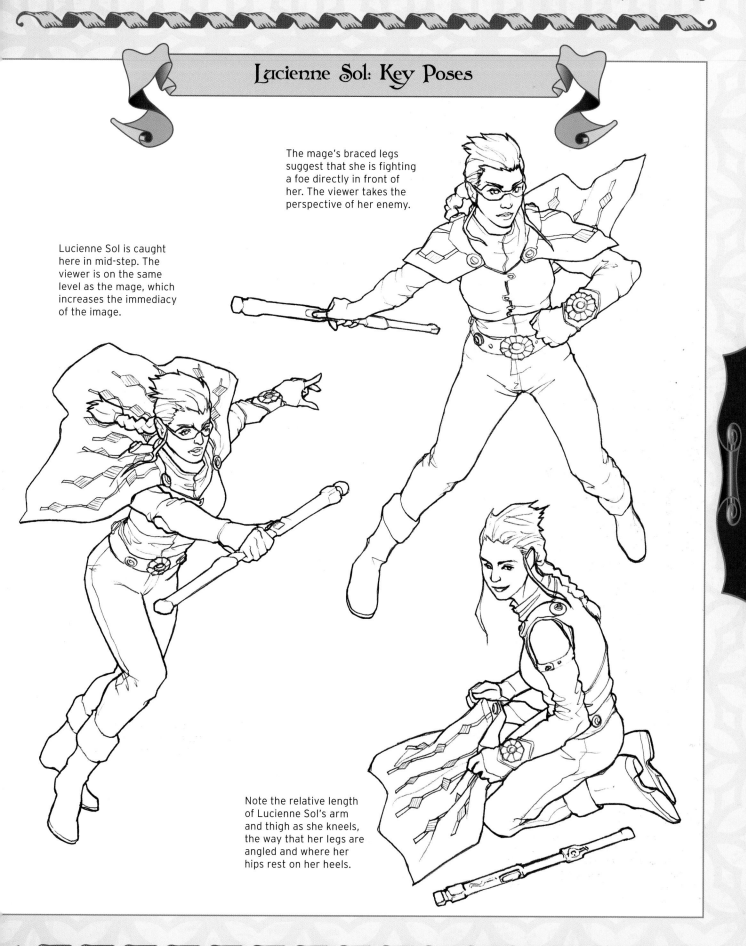

The mage's braced legs suggest that she is fighting a foe directly in front of her. The viewer takes the perspective of her enemy.

Lucienne Sol is caught here in mid-step. The viewer is on the same level as the mage, which increases the immediacy of the image.

Note the relative length of Lucienne Sol's arm and thigh as she kneels, the way that her legs are angled and where her hips rest on her heels.

WARRIORS

Every nation needs its defenders. The weapons and armour vary according to the country, their foes and the nature of the battle, but all warriors are tough, seasoned professionals, who will do whatever is needed to survive the fight and accomplish the mission. The best carry themselves with assurance and remain composed in the face of life-threatening danger. Their decisiveness in combat can be used to create exciting compositions. However, it is not the only way to portray the qualities that make them effective fighters and leaders.

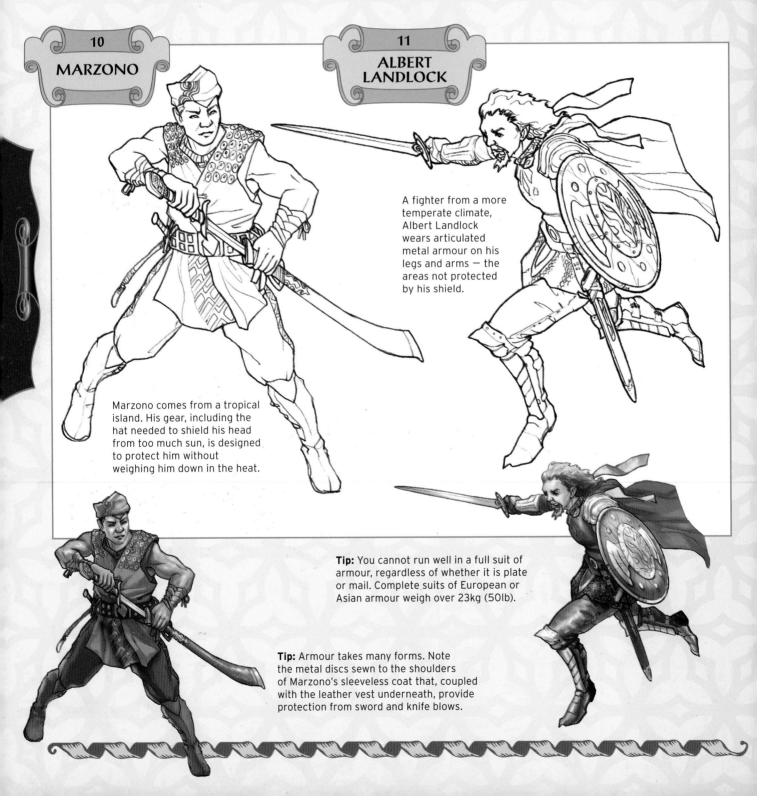

10 MARZONO

11 ALBERT LANDLOCK

A fighter from a more temperate climate, Albert Landlock wears articulated metal armour on his legs and arms — the areas not protected by his shield.

Marzono comes from a tropical island. His gear, including the hat needed to shield his head from too much sun, is designed to protect him without weighing him down in the heat.

Tip: You cannot run well in a full suit of armour, regardless of whether it is plate or mail. Complete suits of European or Asian armour weigh over 23kg (50lb).

Tip: Armour takes many forms. Note the metal discs sewn to the shoulders of Marzono's sleeveless coat that, coupled with the leather vest underneath, provide protection from sword and knife blows.

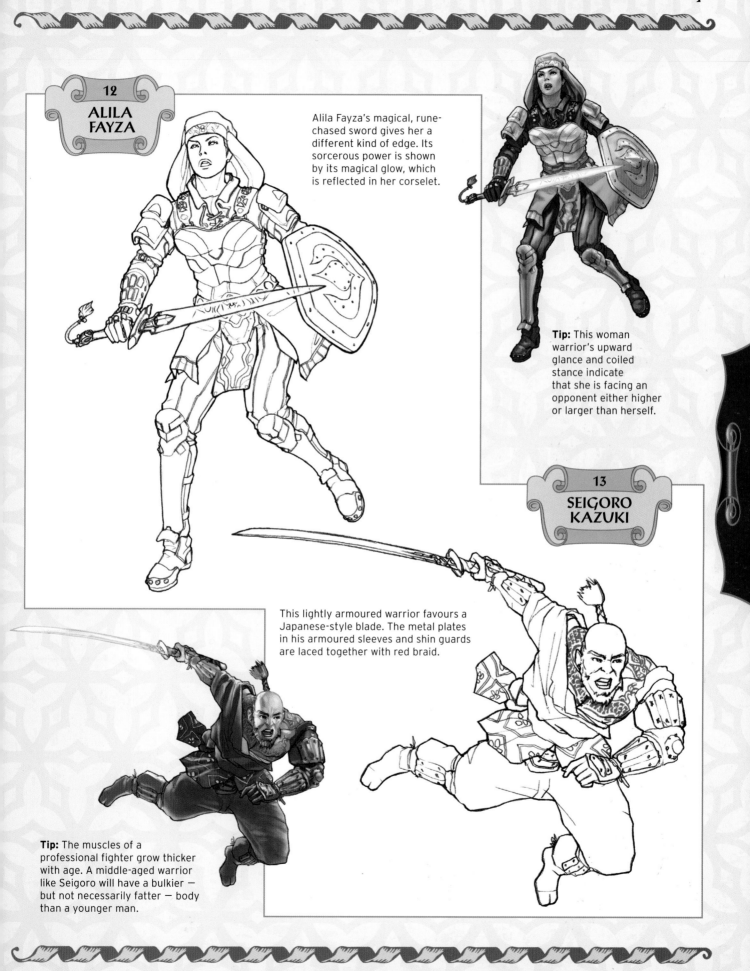

12
ALILA FAYZA

Alila Fayza's magical, rune-chased sword gives her a different kind of edge. Its sorcerous power is shown by its magical glow, which is reflected in her corselet.

Tip: This woman warrior's upward glance and coiled stance indicate that she is facing an opponent either higher or larger than herself.

13
SEIGORO KAZUKI

This lightly armoured warrior favours a Japanese-style blade. The metal plates in his armoured sleeves and shin guards are laced together with red braid.

Tip: The muscles of a professional fighter grow thicker with age. A middle-aged warrior like Seigoro will have a bulkier — but not necessarily fatter — body than a younger man.

14

SHARKAM

The commander of a large company composed of foot soldiers and their dragon allies, Sharkam surveys the battlefield from a slight rise, awaiting the right moment to engage the enemy. The harsh light on his face as well as the red-tinted sky suggest that both armies employ fire-breathing dragons, multiplying the danger and the potential for carnage many times over. However, Sharkam does not waver from his duty as a warrior leader.

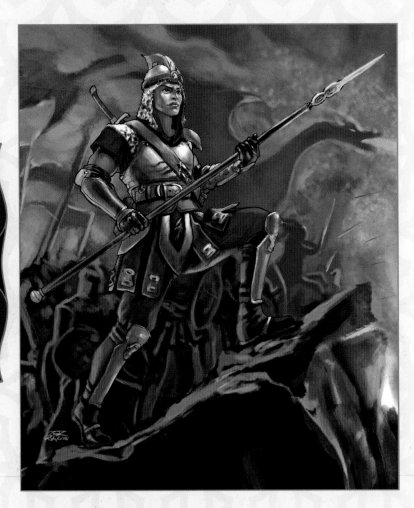

The predominantly red colour scheme suggests blood and fire. Sharkam's company is rendered impressionistically in evocative tones of steel grey and rust. The stippling of the clouds and the white-hot burn reflect the heat of the battle. The strong, parallel diagonal lines created by Sharkam's spear and the crag on which he stands give the composition a sense of forward momentum. Their upward sweep implies confidence in the outcome of the battle.

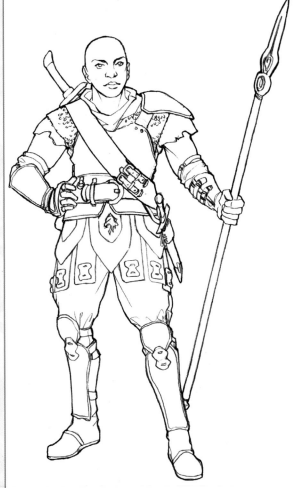

Sharkam is armed with a spear, sword and knife. Properly deployed, a line of spears can decimate a cavalry charge and keep a sword-wielding opponent outside of striking range.

Sharkam: Key Poses

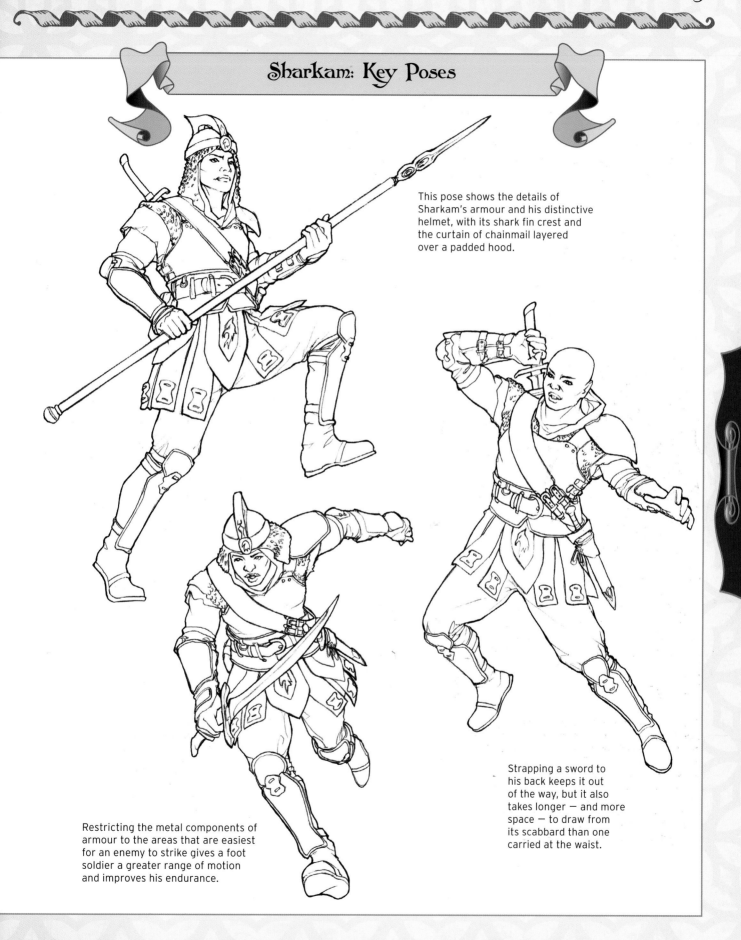

This pose shows the details of Sharkam's armour and his distinctive helmet, with its shark fin crest and the curtain of chainmail layered over a padded hood.

Strapping a sword to his back keeps it out of the way, but it also takes longer — and more space — to draw from its scabbard than one carried at the waist.

Restricting the metal components of armour to the areas that are easiest for an enemy to strike gives a foot soldier a greater range of motion and improves his endurance.

THIEVES & ASSASSINS

Thieves and assassins are professional lawbreakers, occupying a shadow world where none of the normal rules applies. They conform to no single model. Age, gender and body type are less important than cunning and skill. Their motives can be even harder to define. Many are simply criminals, robbing homes and murdering for hire, but some, like Robin Hood, break the law in pursuit of a higher good. It is hard not to have a sneaking admiration for characters who live by their wits — and get away with it.

15 REDDIN BAYRAM

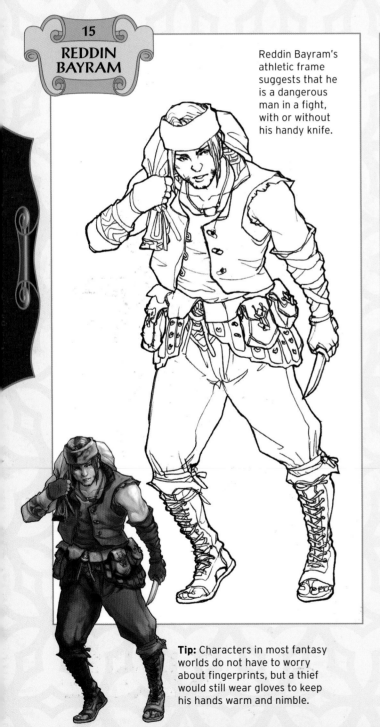

Reddin Bayram's athletic frame suggests that he is a dangerous man in a fight, with or without his handy knife.

Tip: Characters in most fantasy worlds do not have to worry about fingerprints, but a thief would still wear gloves to keep his hands warm and nimble.

16 CLAIRRE ASHEN

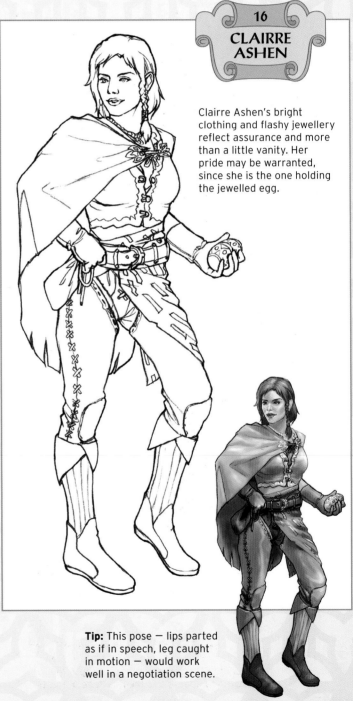

Clairre Ashen's bright clothing and flashy jewellery reflect assurance and more than a little vanity. Her pride may be warranted, since she is the one holding the jewelled egg.

Tip: This pose — lips parted as if in speech, leg caught in motion — would work well in a negotiation scene.

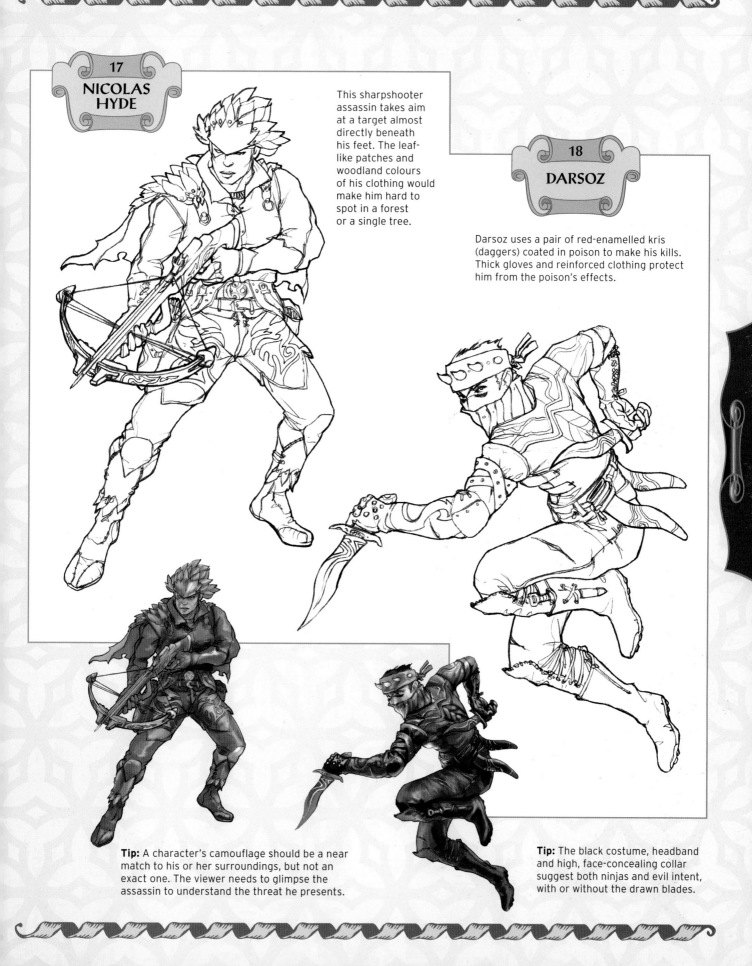

17 NICOLAS HYDE

This sharpshooter assassin takes aim at a target almost directly beneath his feet. The leaf-like patches and woodland colours of his clothing would make him hard to spot in a forest or a single tree.

18 DARSOZ

Darsoz uses a pair of red-enamelled kris (daggers) coated in poison to make his kills. Thick gloves and reinforced clothing protect him from the poison's effects.

Tip: A character's camouflage should be a near match to his or her surroundings, but not an exact one. The viewer needs to glimpse the assassin to understand the threat he presents.

Tip: The black costume, headband and high, face-concealing collar suggest both ninjas and evil intent, with or without the drawn blades.

19

KISMET GREY

Assassins are creatures of shadow. Physical darkness hides them; moral darkness shrouds their souls. They rely on stealth and speed, and equip themselves accordingly. As nimble as thieves, they are best portrayed in action. The fluid way in which the assassin moves her body, as well as the angle at which she is shown to the viewer, help to heighten the visual drama.

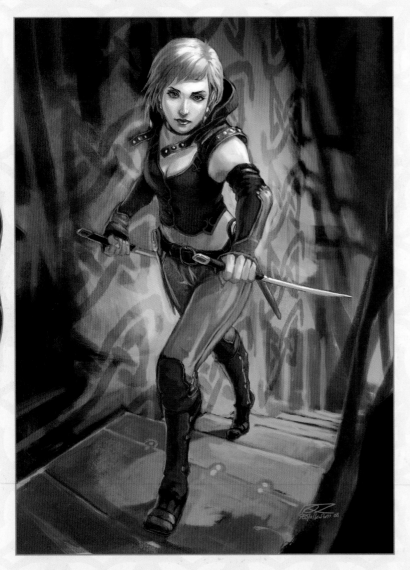

The assassin Kismet Grey reaches the top of a stairway. Although the viewer sees little beyond the stairs, the shadowy walls invite the viewer to imagine that the assassin is ascending a windowless tower. The palette is muted, with the colour concentrated within a triangle formed by Kismet Grey's red and silver swords, and her bright hand.

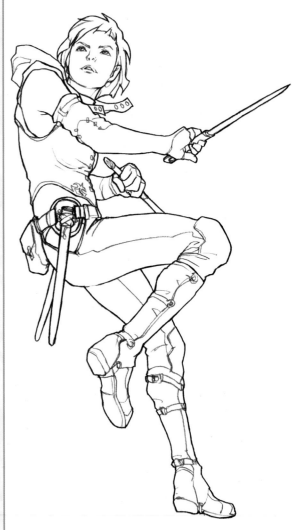

This low-angle view puts the viewer in the position of a fallen foe. The assassin's upturned face suggests an additional threat.

Kismet Grey: Key Poses

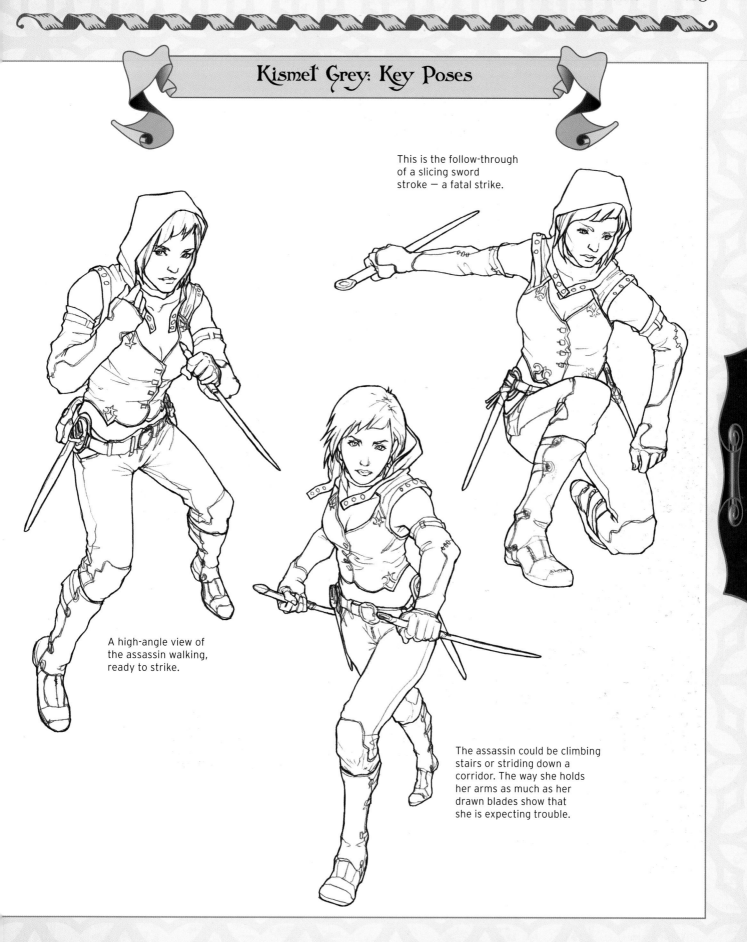

This is the follow-through of a slicing sword stroke — a fatal strike.

A high-angle view of the assassin walking, ready to strike.

The assassin could be climbing stairs or striding down a corridor. The way she holds her arms as much as her drawn blades show that she is expecting trouble.

ADVENTURERS

One of the great attractions of fantasy is its ability to transport you to other places and times. In a sense, it makes adventurers of us all, which may be why our favourite legends are those involving heroic quests. Giants and monsters go with the territory, as do fabulous treasures. Everything is bigger and bolder than life, from the characters to their opponents, and the colours used to paint them both. The irony is that many of our most fantastic legends may have a historic basis in fact.

20 SEQUINA

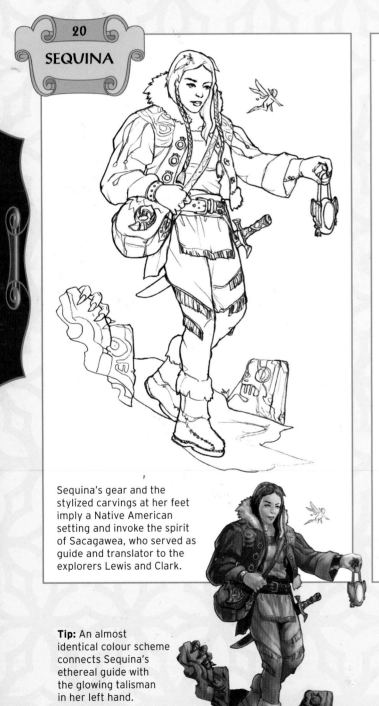

Sequina's gear and the stylized carvings at her feet imply a Native American setting and invoke the spirit of Sacagawea, who served as guide and translator to the explorers Lewis and Clark.

Tip: An almost identical colour scheme connects Sequina's ethereal guide with the glowing talisman in her left hand.

21 TYR THORSEN

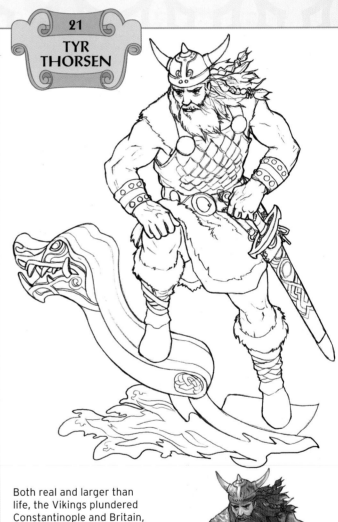

Both real and larger than life, the Vikings plundered Constantinople and Britain, founded kingdoms in Russia and France, and were the first Europeans to discover America.

Tip: Museum websites provide excellent visual references for historic clothing, armour and weapons.

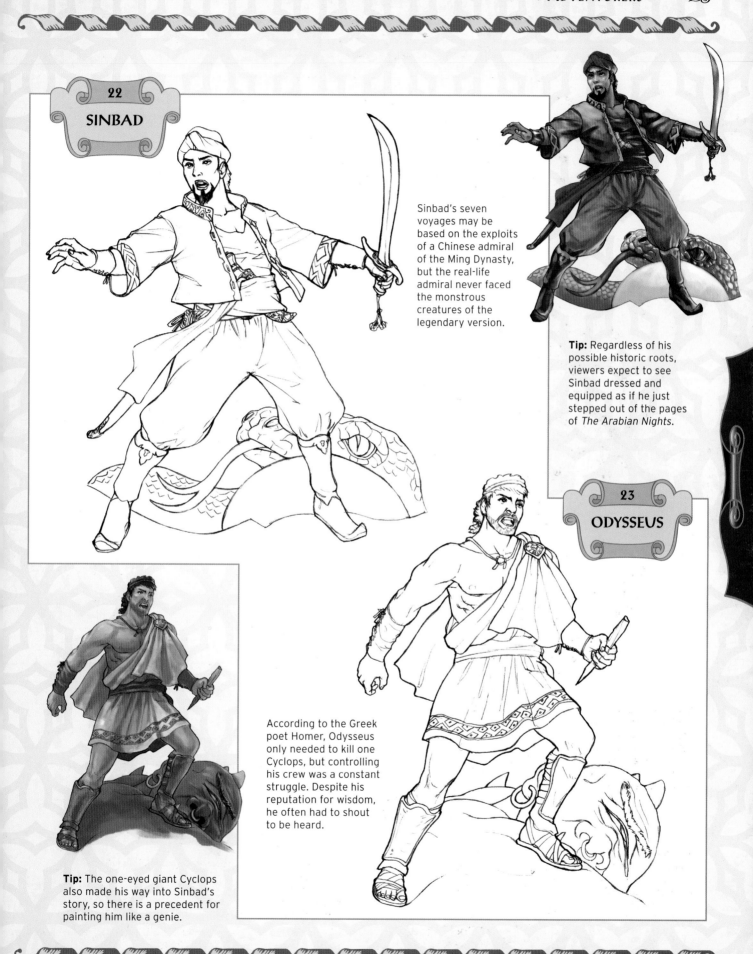

22
SINBAD

Sinbad's seven voyages may be based on the exploits of a Chinese admiral of the Ming Dynasty, but the real-life admiral never faced the monstrous creatures of the legendary version.

Tip: Regardless of his possible historic roots, viewers expect to see Sinbad dressed and equipped as if he just stepped out of the pages of *The Arabian Nights*.

23
ODYSSEUS

According to the Greek poet Homer, Odysseus only needed to kill one Cyclops, but controlling his crew was a constant struggle. Despite his reputation for wisdom, he often had to shout to be heard.

Tip: The one-eyed giant Cyclops also made his way into Sinbad's story, so there is a precedent for painting him like a genie.

SCHOLARS & CLERICS

It takes all kinds to make a fantasy world. Armies need doctors and pharmacists to heal the sick and injured. They need clerics to minister to soldiers' spiritual needs. Rulers, nobles and their generals look to alchemists and scholars to devise new weapons and strategies to defeat their foes. Alchemists also come in handy for changing base metal into gold to fund campaigns and quests. At the same time, these characters nurture ambitions of their own, and may wind up as the heroes – or villains – of the piece.

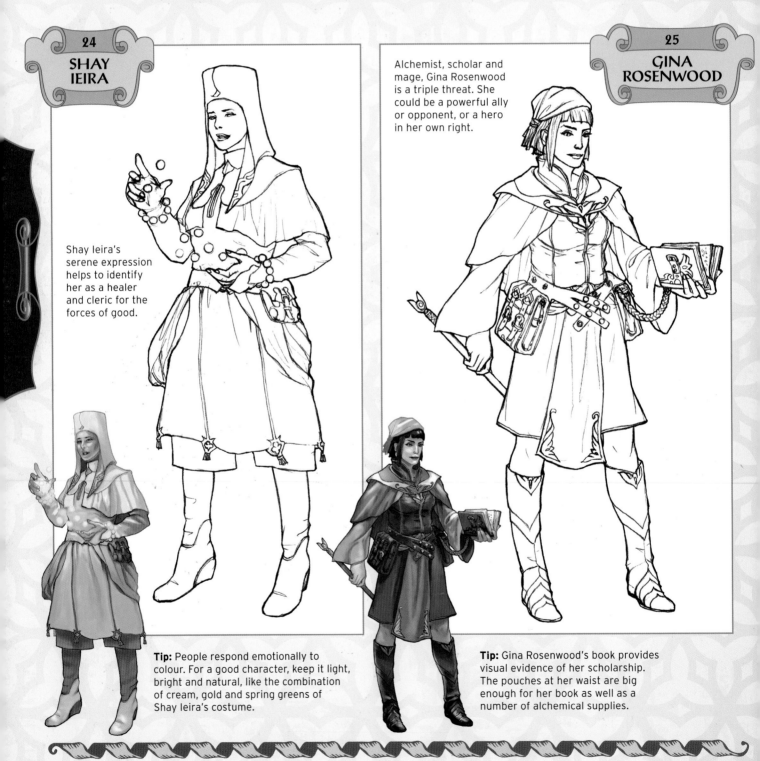

24 SHAY IEIRA

Shay Ieira's serene expression helps to identify her as a healer and cleric for the forces of good.

Tip: People respond emotionally to colour. For a good character, keep it light, bright and natural, like the combination of cream, gold and spring greens of Shay Ieira's costume.

25 GINA ROSENWOOD

Alchemist, scholar and mage, Gina Rosenwood is a triple threat. She could be a powerful ally or opponent, or a hero in her own right.

Tip: Gina Rosenwood's book provides visual evidence of her scholarship. The pouches at her waist are big enough for her book as well as a number of alchemical supplies.

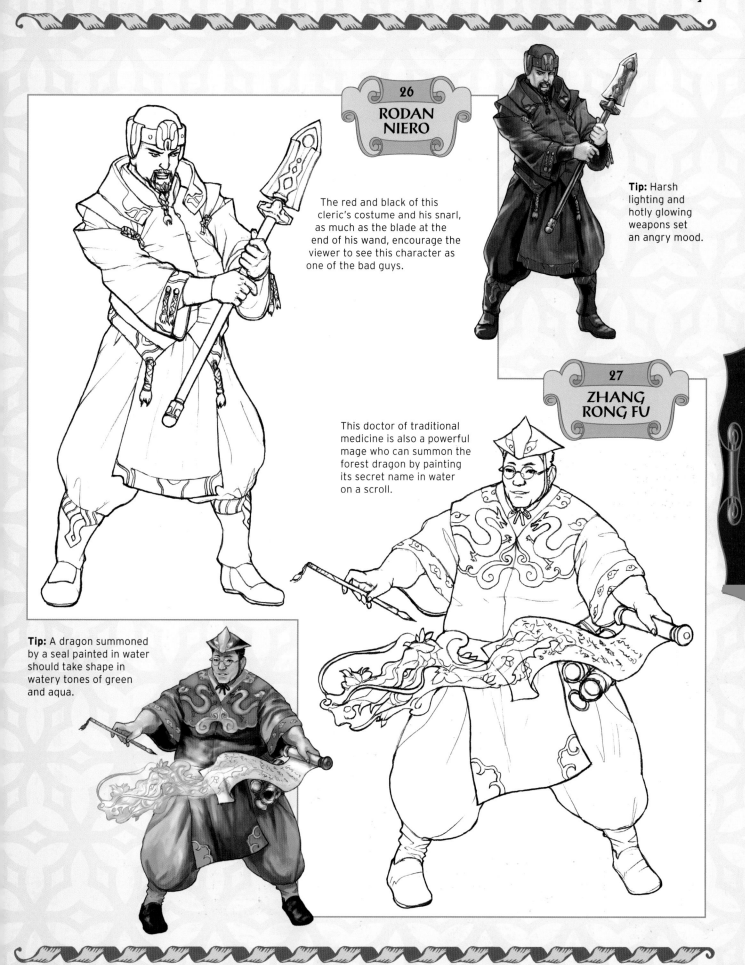

26
RODAN NIERO

The red and black of this cleric's costume and his snarl, as much as the blade at the end of his wand, encourage the viewer to see this character as one of the bad guys.

Tip: Harsh lighting and hotly glowing weapons set an angry mood.

27
ZHANG RONG FU

This doctor of traditional medicine is also a powerful mage who can summon the forest dragon by painting its secret name in water on a scroll.

Tip: A dragon summoned by a seal painted in water should take shape in watery tones of green and aqua.

BANDITS & PIRATES

Villainy seldom carries the day in fantasy stories, but visually the bad guys win hands down. They are the flashiest dressers and carry the coolest weapons, and they do not have to worry about matching their ensembles. If they see something they like, they take it and use it for as long as it amuses them. Answering to no authority, they appeal to the rebel in all of us. The life of an outlaw may be short, brutal and fraught with danger, but like a pirate ship under full sail, it also represents ultimate freedom.

28
OWANKANE

29
SIXZO

The gashes on Sixzo's arm and face, his torn shirt and the rents in his clothing as much as the weapon in his hands show that he is in the middle of a hard and bloody fight.

Owankane is a brutal bandit who favours a heavy sword to hack and slash.

Tip: A bandit steals his gear, so it seldom matches. Notice how incongruous Sixzo's fur-edged helmet appears in comparison to the rest of his outfit.

Tip: A big sword needs a large man (or woman) to wield it. Owankane would probably be the tallest and most muscular person in any group.

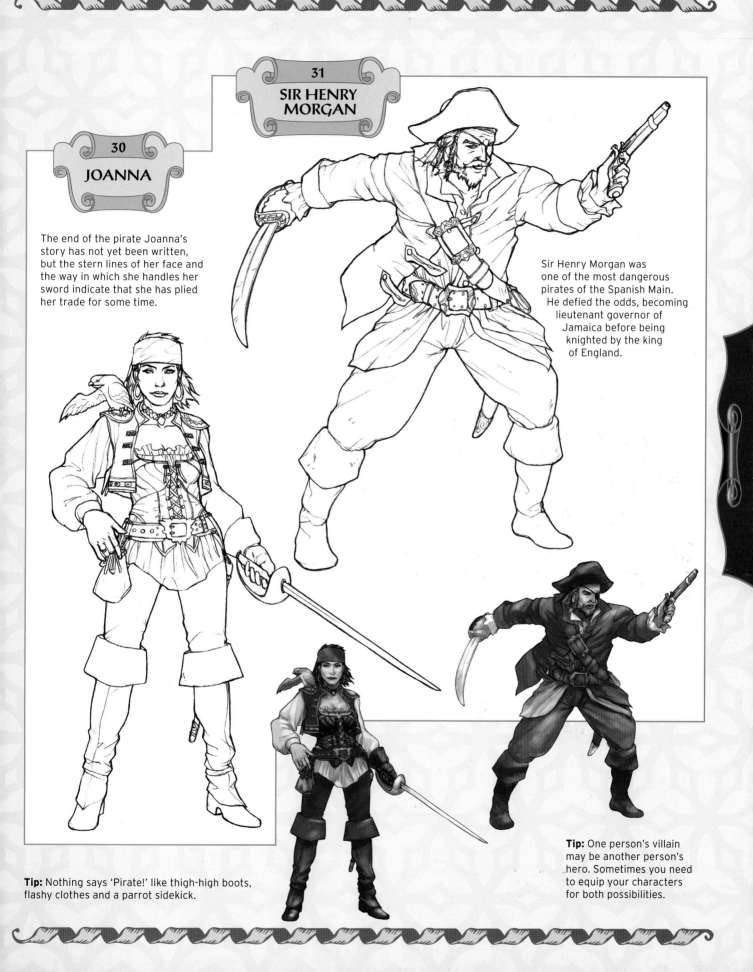

30 JOANNA

The end of the pirate Joanna's story has not yet been written, but the stern lines of her face and the way in which she handles her sword indicate that she has plied her trade for some time.

31 SIR HENRY MORGAN

Sir Henry Morgan was one of the most dangerous pirates of the Spanish Main. He defied the odds, becoming lieutenant governor of Jamaica before being knighted by the king of England.

Tip: Nothing says 'Pirate!' like thigh-high boots, flashy clothes and a parrot sidekick.

Tip: One person's villain may be another person's hero. Sometimes you need to equip your characters for both possibilities.

BARBARIANS

Barbarians are outsiders who live beyond the fringes of civilization. Their languages are strange and harsh to the ears of settled cultures. The ancient Greeks coined the word *barbaros* to refer to unlettered foreigners whose languages sounded like stammering or the 'baa-baa' noise made by sheep. However, the hardships of tribal life can nurture great strength. In their time, Philip of Macedon, Kublai Khan and Childeric the Frank were all dismissed as barbarians, and yet they founded some of the greatest dynasties in history.

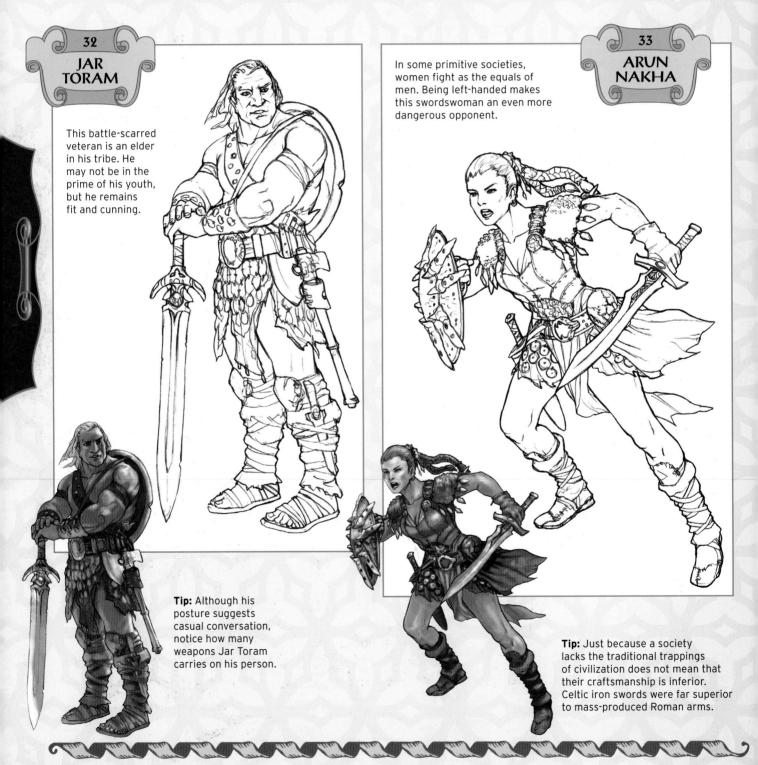

32

JAR TORAM

This battle-scarred veteran is an elder in his tribe. He may not be in the prime of his youth, but he remains fit and cunning.

Tip: Although his posture suggests casual conversation, notice how many weapons Jar Toram carries on his person.

In some primitive societies, women fight as the equals of men. Being left-handed makes this swordswoman an even more dangerous opponent.

33

ARUN NAKHA

Tip: Just because a society lacks the traditional trappings of civilization does not mean that their craftsmanship is inferior. Celtic iron swords were far superior to mass-produced Roman arms.

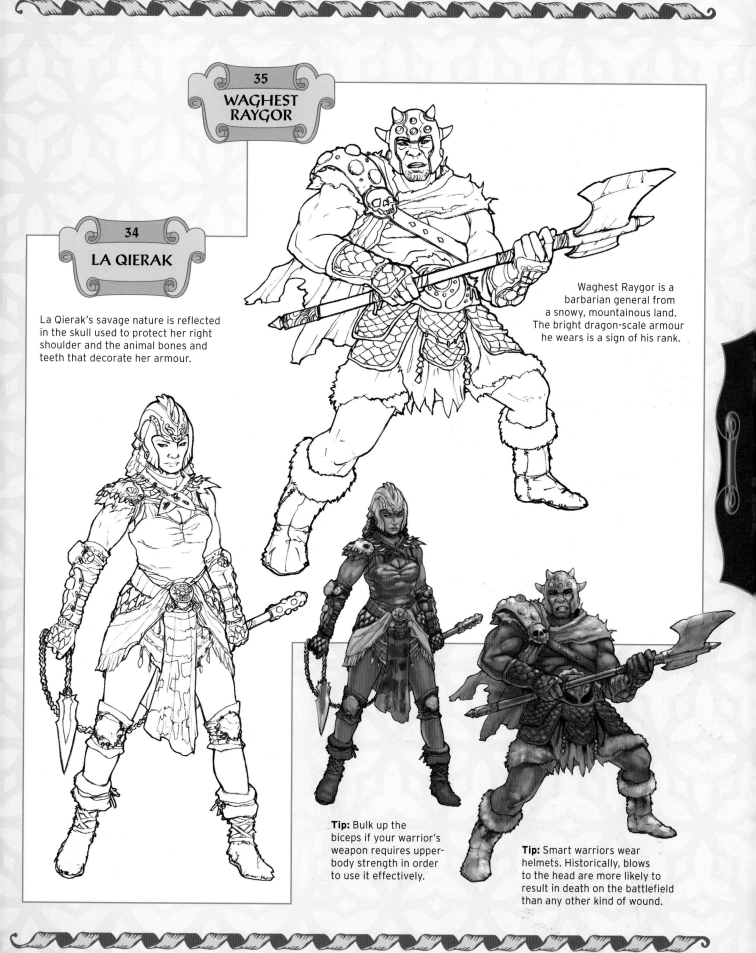

35

WAGHEST RAYGOR

34

LA QIERAK

La Qierak's savage nature is reflected in the skull used to protect her right shoulder and the animal bones and teeth that decorate her armour.

Waghest Raygor is a barbarian general from a snowy, mountainous land. The bright dragon-scale armour he wears is a sign of his rank.

Tip: Bulk up the biceps if your warrior's weapon requires upper-body strength in order to use it effectively.

Tip: Smart warriors wear helmets. Historically, blows to the head are more likely to result in death on the battlefield than any other kind of wound.

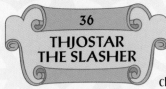

36

**THJOSTAR
THE SLASHER**

Viewers want barbarians to look the part – rugged, wild and in some ways nobler than those who live in more developed societies. A character's lack of civilization is easy to express visually. Witness Thjostar's minimal armour, fashioned from the scales of a giant lizard, and the monster's jawbone that he uses as a shield. However, the symmetry of this composition underscores the heroic nature of the fight.

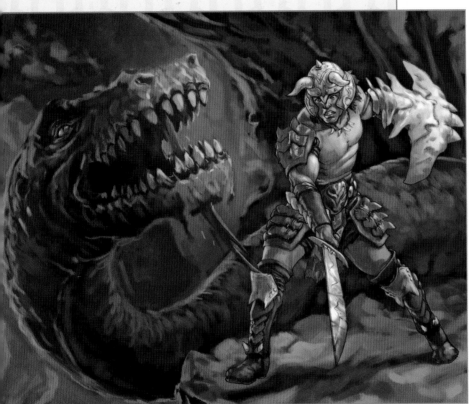

Thjostar is roughly the same size as the parts of the theropod that we see most clearly. This implies that Thjostar is its equal, although the monster is much larger. The theropod's dark, unhealthy colour serves as visual shorthand for evil. At the same time, the line formed by its neck and head, and the answering curve of the bone shield, coupled with the lighting, draw all eyes to Thjostar.

Note the way Thjostar's body coils around the upright sword, and how much foreshortening the pose requires.

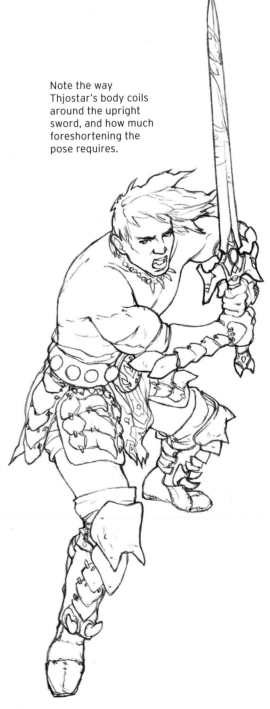

Thjostar the Slasher: Key Poses

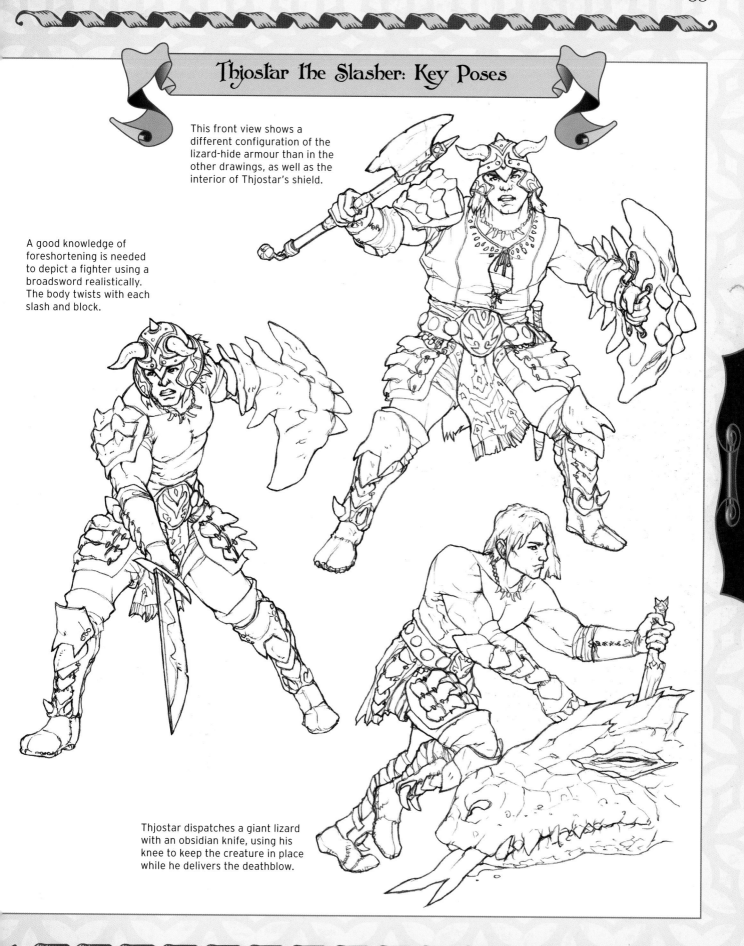

This front view shows a different configuration of the lizard-hide armour than in the other drawings, as well as the interior of Thjostar's shield.

A good knowledge of foreshortening is needed to depict a fighter using a broadsword realistically. The body twists with each slash and block.

Thjostar dispatches a giant lizard with an obsidian knife, using his knee to keep the creature in place while he delivers the deathblow.

ELVES

Elves bridge the divide between mortals and magical creatures. Although they closely resemble humans, they are set apart by their beauty and, of course, their pointed ears. They live exceptionally long lives, wield magic as their birthright and cherish a passion for obscure points of honour that gives them an unusual perspective on people and events. This nonhuman outlook can be taken to extremes by the dark elves.

37
DURION ALAGOS

The dark elf Durion Alagos displays a characteristic elfin concern for fine craftsmanship. The leather on his right thigh is designed to protect his armour from being damaged by his own sword.

38
CALANON

A princely high elf warrior, Calanon enhances his swordsmanship with white magic.

Tip: The emotional effect of a colour depends on how it is used. White snow is normal; snow-white skin shadowed in grey is unnatural and evokes fear.

Tip: The many sharp points of the armour, the forward-leaning posture and the triangle formed by the cape and helmet allow Calanon to project energy while standing still.

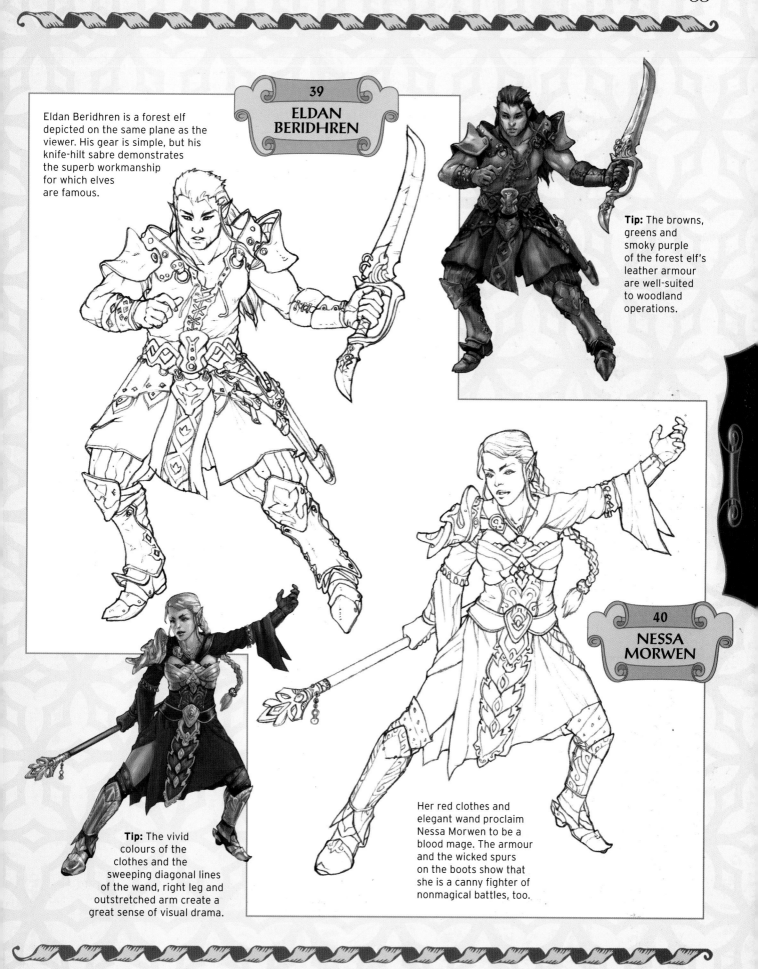

39
ELDAN BERIDHREN

Eldan Beridhren is a forest elf depicted on the same plane as the viewer. His gear is simple, but his knife-hilt sabre demonstrates the superb workmanship for which elves are famous.

Tip: The browns, greens and smoky purple of the forest elf's leather armour are well-suited to woodland operations.

40
NESSA MORWEN

Tip: The vivid colours of the clothes and the sweeping diagonal lines of the wand, right leg and outstretched arm create a great sense of visual drama.

Her red clothes and elegant wand proclaim Nessa Morwen to be a blood mage. The armour and the wicked spurs on the boots show that she is a canny fighter of nonmagical battles, too.

41

**ARTANIS
VANYA**

Artanis Vanya is a moon elf skilled in the use of magic and several mundane weapons. Her magical silver bow calls to mind Artemis and Diana, the huntress moon goddesses of classical Greek and Roman mythology. The bow's curve also serves to direct attention to her moonlit face. The fur trimming her boots and armour suggests that she originated in a northern climate.

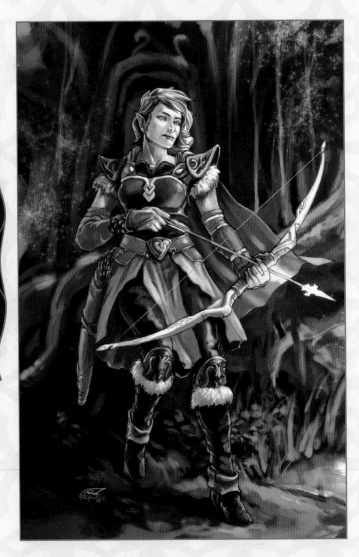

Night scenes can be challenging. You want to illuminate the figure so that important details are not lost, but you do not want to lose the distinction between night and day. Here, the artist has solved the problem by changing the light's effects to evoke both moonlight and magic. Instead of bright daytime white, the highlights take on a blue cast that extends to the depths of the forest behind Artanis. Purple tints the shadows and provides definition to her black hair and the black components of her armour.

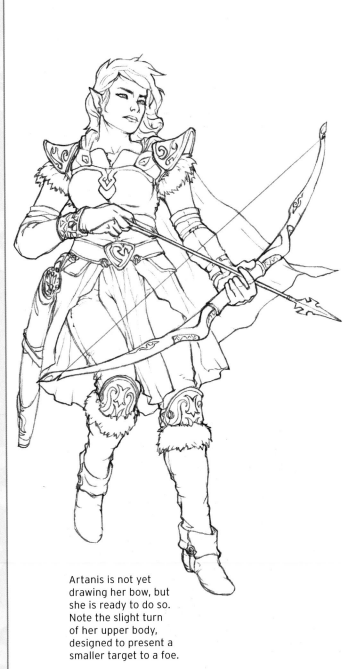

Artanis is not yet drawing her bow, but she is ready to do so. Note the slight turn of her upper body, designed to present a smaller target to a foe.

Artanis Vanya: Key Poses

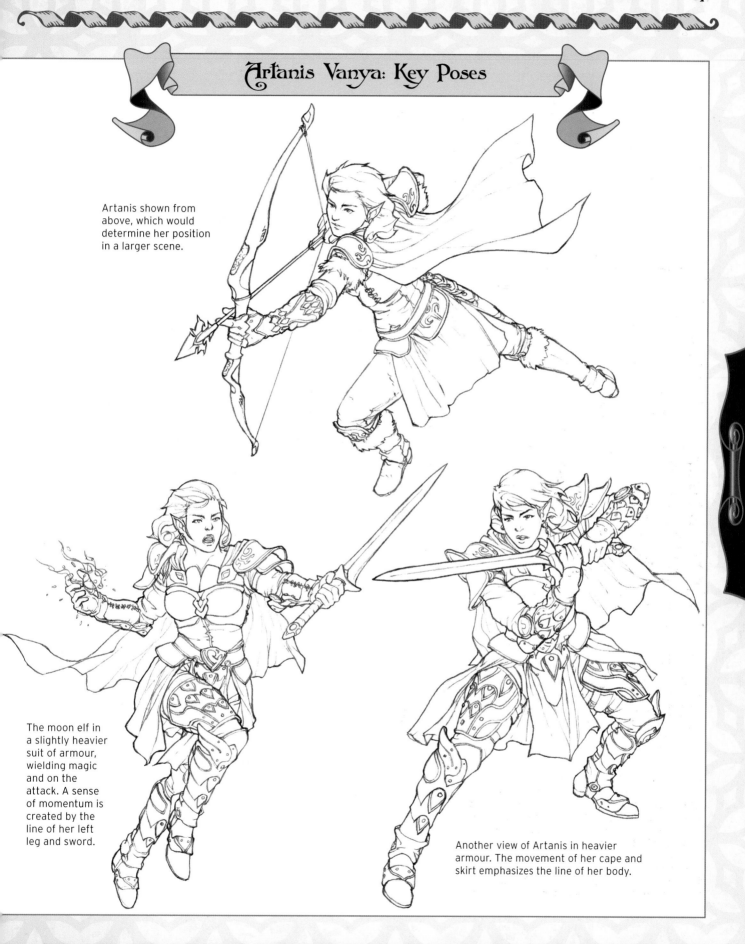

Artanis shown from above, which would determine her position in a larger scene.

The moon elf in a slightly heavier suit of armour, wielding magic and on the attack. A sense of momentum is created by the line of her left leg and sword.

Another view of Artanis in heavier armour. The movement of her cape and skirt emphasizes the line of her body.

FAIRIES

Fairies come in all shapes and sizes. They share an affinity for the natural world, but can become attached to material creations as well. They live in the moment, which gives them a reputation for fickleness and, sometimes, spite. They are more imbued with magic than elves, and more subject to magic's rules. Most hide a secret that would allow others to control them: it could be their name or a simple binding spell. They are also sensitive to expressions of gratitude. Foolish as it is to insult a fairy, thanking them may lead to worse.

42
CLARICE CURLFALL

Clarice Curlfall is an autumn fairy, dressed in the fruits and multicoloured tatters of the season.

The cut and fashionable colours of key master and lock keeper Rosie Mylan's costume, as much as her mechanical wings, reveal that she is an indoor sprite.

43
ROSIE MYLAN

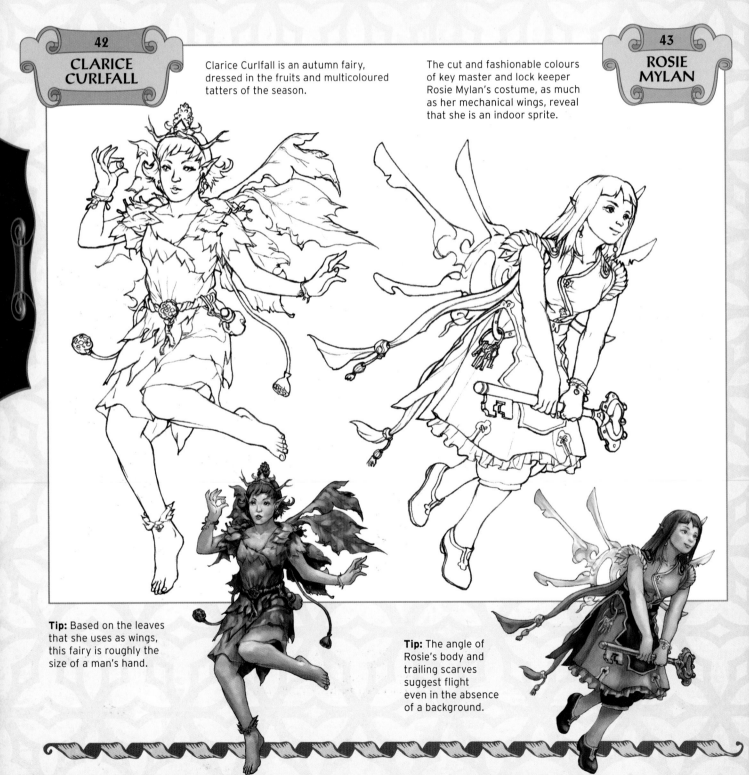

Tip: Based on the leaves that she uses as wings, this fairy is roughly the size of a man's hand.

Tip: The angle of Rosie's body and trailing scarves suggest flight even in the absence of a background.



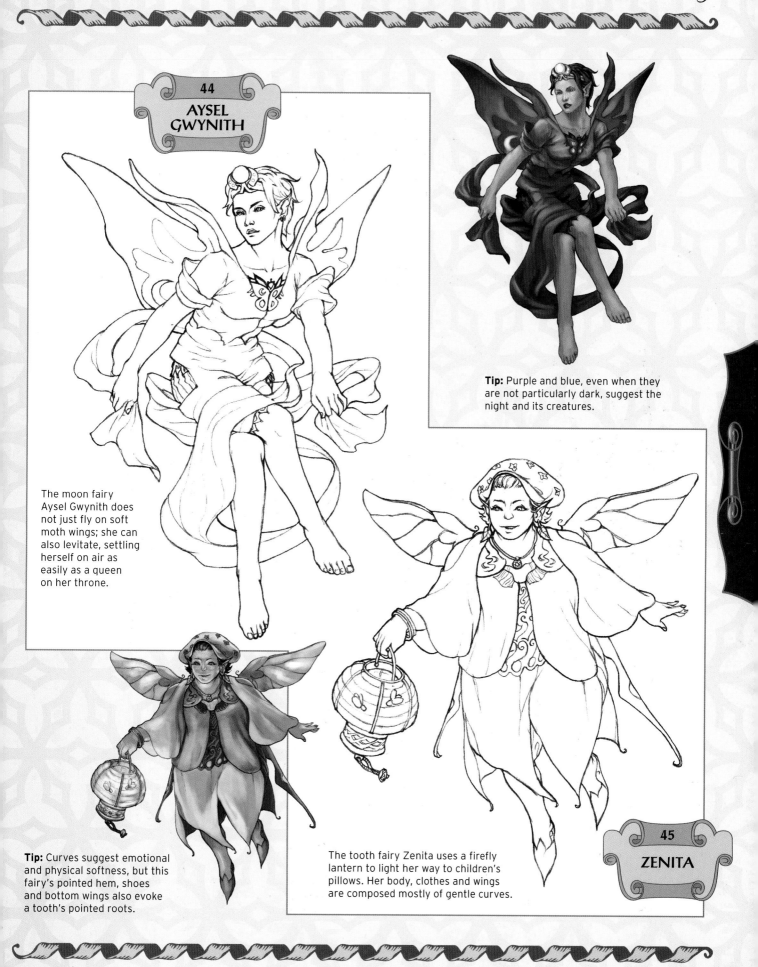

44

AYSEL GWYNITH

The moon fairy Aysel Gwynith does not just fly on soft moth wings; she can also levitate, settling herself on air as easily as a queen on her throne.

Tip: Purple and blue, even when they are not particularly dark, suggest the night and its creatures.

Tip: Curves suggest emotional and physical softness, but this fairy's pointed hem, shoes and bottom wings also evoke a tooth's pointed roots.

The tooth fairy Zenita uses a firefly lantern to light her way to children's pillows. Her body, clothes and wings are composed mostly of gentle curves.

45

ZENITA

46

ELFINA BRUCIE

Forest fairy Elfina Brucie draws her power from the sun and forest spirits, channelling it through both a wand and a staff. Although her proportions are human, she is not much larger than the flower petals used to make her costume. She also displays many nonhuman characteristics in addition to her wings – antennae, nasal ridges and photosensitive patches of skin.

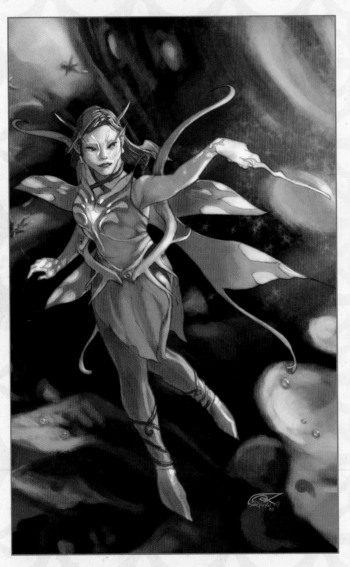

The sharp highlights along Elfina's legs and the wash of light across her face show the intensity of the sunlight and its position relative to the scene. The vivid green patches on her wings, hands and arms, as well as the jewel on her chest, suggest how she absorbs and stores power. Although green can denote sickness, it becomes a beacon of life energy when used as a bright counterpoint to the loosely rendered background.

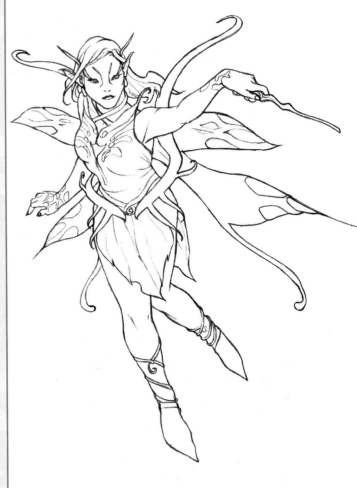

Hovering above a large flower, Elfina's feet hang loosely, toes pointed downwards.

Elfina Brucie: Key Poses

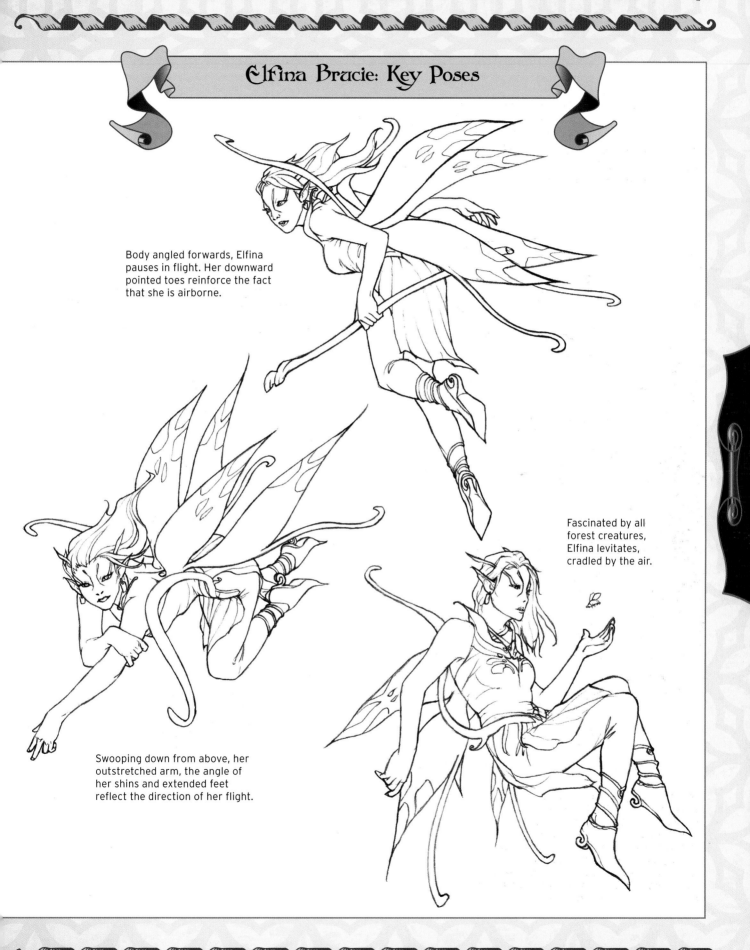

Body angled forwards, Elfina pauses in flight. Her downward pointed toes reinforce the fact that she is airborne.

Fascinated by all forest creatures, Elfina levitates, cradled by the air.

Swooping down from above, her outstretched arm, the angle of her shins and extended feet reflect the direction of her flight.

DWARVES

Dwarves, like elves, display both human and superhuman characteristics, but overall they seem more grounded than other supernatural races. With a magical connection to the riches of the earth, dwarves make prodigious miners and extraordinary smiths. They are renowned for their unlikely strength, large appetites and quick tempers. They feel only disdain for the exaggerated courtliness and Byzantine power plays that elves cherish – a disdain that often leads to war.

47 SOGETH HOETZEL

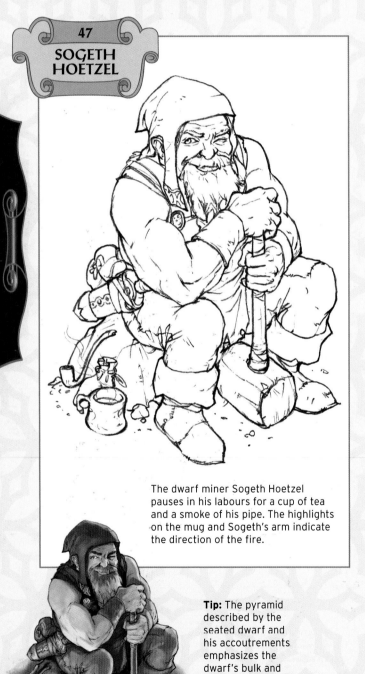

Tip: Dwarves' heads, hands and feet are larger in proportion to their bodies than other mortal and magical people.

The dwarf miner Sogeth Hoetzel pauses in his labours for a cup of tea and a smoke of his pipe. The highlights on the mug and Sogeth's arm indicate the direction of the fire.

Tip: The pyramid described by the seated dwarf and his accoutrements emphasizes the dwarf's bulk and low centre of gravity.

48 KARREN KRUSE

Karren Kruse shows the domestic side of dwarfish society.

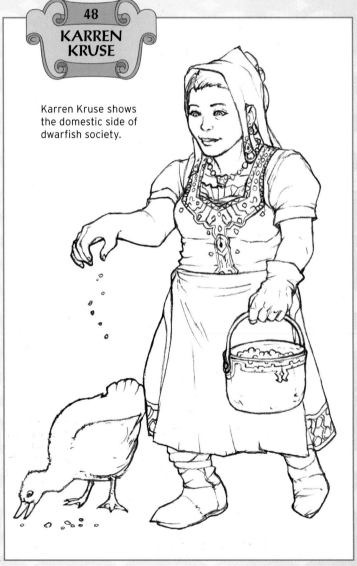

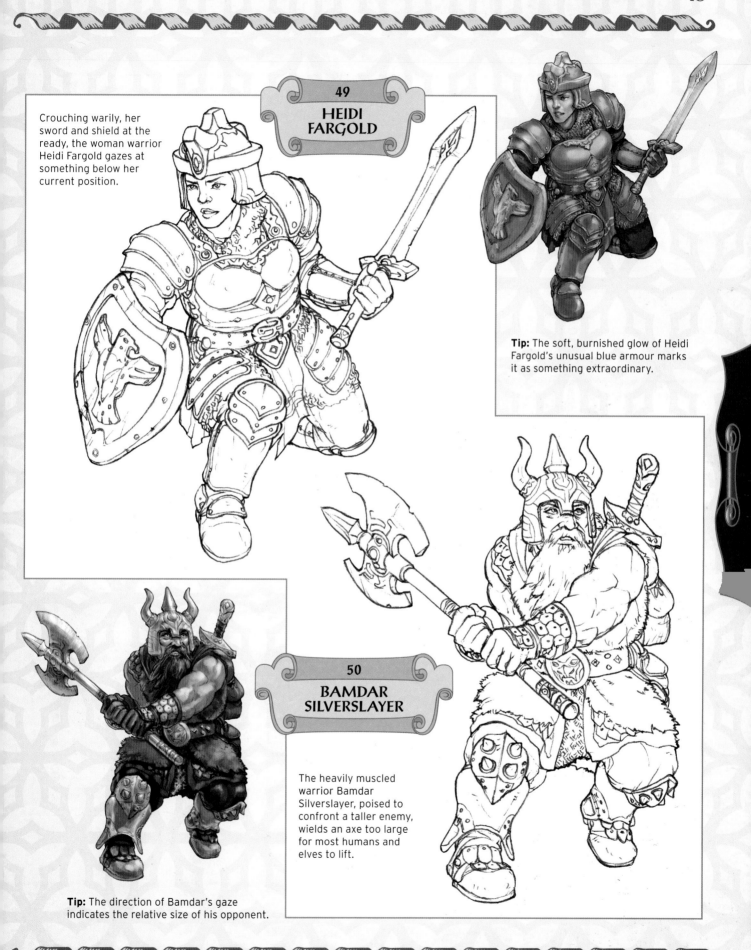

49

HEIDI FARGOLD

Crouching warily, her sword and shield at the ready, the woman warrior Heidi Fargold gazes at something below her current position.

Tip: The soft, burnished glow of Heidi Fargold's unusual blue armour marks it as something extraordinary.

50

BAMDAR SILVERSLAYER

The heavily muscled warrior Bamdar Silverslayer, poised to confront a taller enemy, wields an axe too large for most humans and elves to lift.

Tip: The direction of Bamdar's gaze indicates the relative size of his opponent.

SORCERERS

The word 'sorcery' comes from *sors*, the Latin word for fate. Sorcerers are those who try to manipulate fate to their own ends. However, fate is nothing more nor less than the natural path of the universe. Altering its course is hard, prompting some sorcerers to employ extreme and horrific measures to achieve their ends – blood sacrifices, ritual murder, the invocation of demons and the binding of dead souls. On the other hand, sometimes the natural order of things is out of balance or just plain wrong. To correct it, you need a specialist, but choose carefully. The price for choosing wrongly could be more than your life.

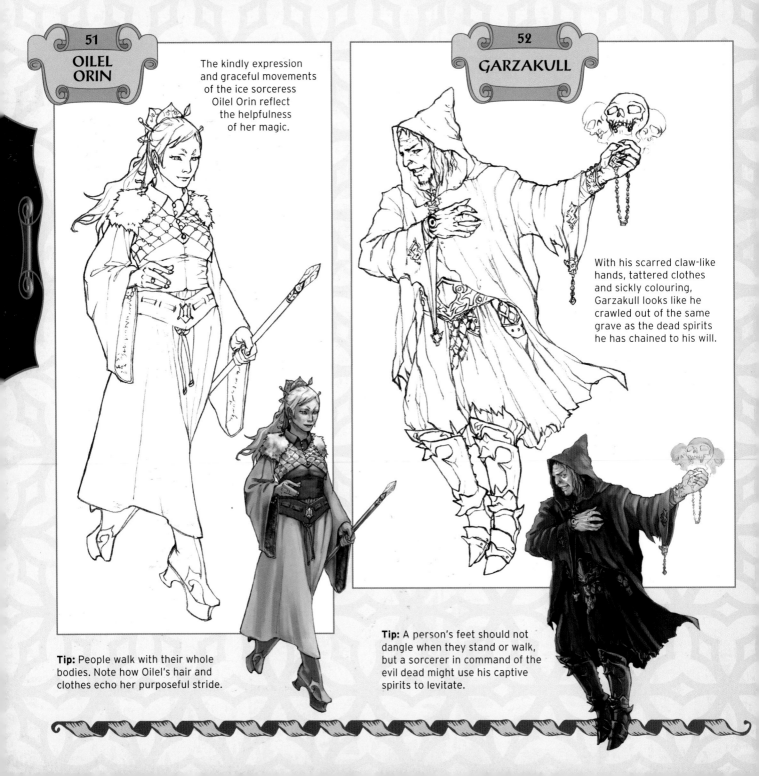

51 OILEL ORIN

The kindly expression and graceful movements of the ice sorceress Oilel Orin reflect the helpfulness of her magic.

Tip: People walk with their whole bodies. Note how Oilel's hair and clothes echo her purposeful stride.

52 GARZAKULL

With his scarred claw-like hands, tattered clothes and sickly colouring, Garzakull looks like he crawled out of the same grave as the dead spirits he has chained to his will.

Tip: A person's feet should not dangle when they stand or walk, but a sorcerer in command of the evil dead might use his captive spirits to levitate.

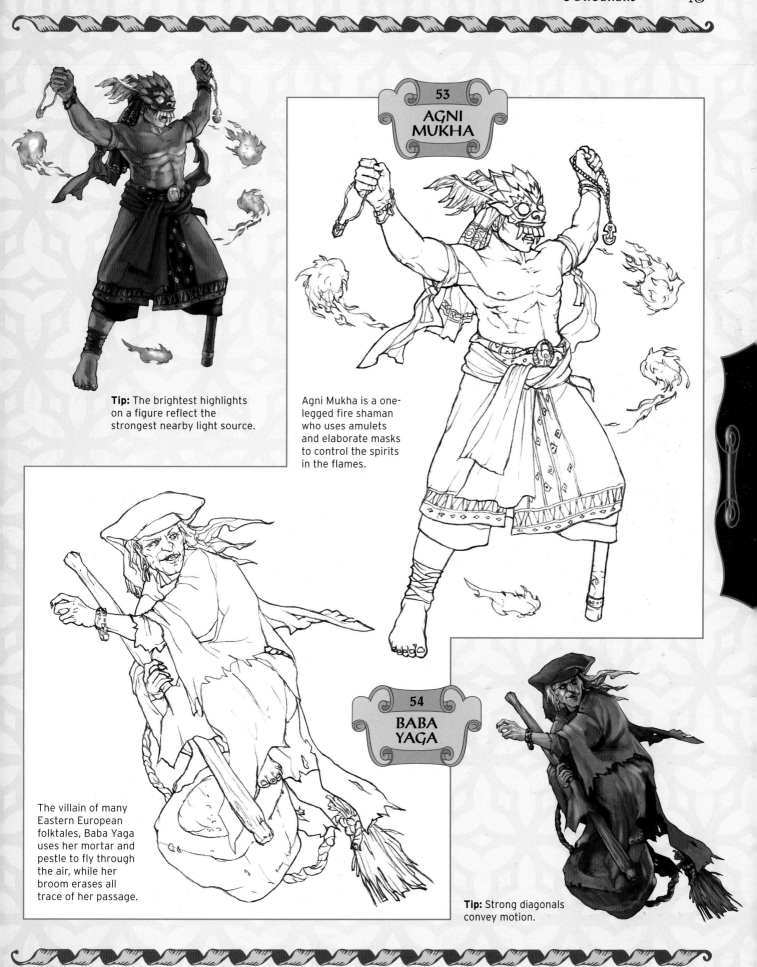

53

AGNI MUKHA

Tip: The brightest highlights on a figure reflect the strongest nearby light source.

Agni Mukha is a one-legged fire shaman who uses amulets and elaborate masks to control the spirits in the flames.

The villain of many Eastern European folktales, Baba Yaga uses her mortar and pestle to fly through the air, while her broom erases all trace of her passage.

54

BABA YAGA

Tip: Strong diagonals convey motion.

55

NORA VAUNDU

This painting provides a number of clues to the nature of Nora Vaundu's magic. Her dark leather outfit with its deep red accents – the better to camouflage bloodstains, ichor and even less savoury fluids – suggest that she frequents dark, dangerous places. The purple smoke wafting from her glowing red wand connects her magic to the skull-shaped shadows that fill the background of the painting.

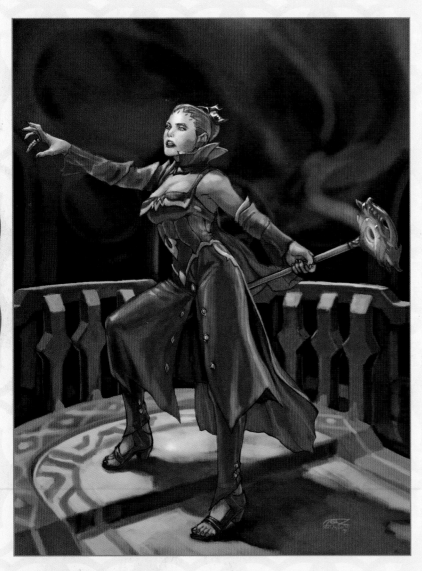

The curving balcony, carpet and floor decorations, as much as the light on her face and chest, focus attention on Nora Vaundu. The curves provide a strong contrast to the angles and vertical lines of her pose. The zigzag formed by the angle of her head to her shoulder, breast to waist, and hip to knee and upraised foot creates a sense of great tension, reinforced by her straining right hand.

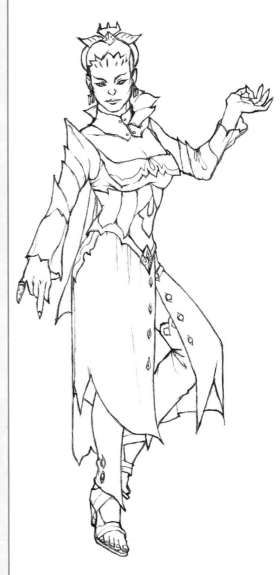

Poised on one leg, Nora could be dancing or gathering power in her left hand. Note the finger armour on Nora's right hand.

Nora Vaundu: Key Poses

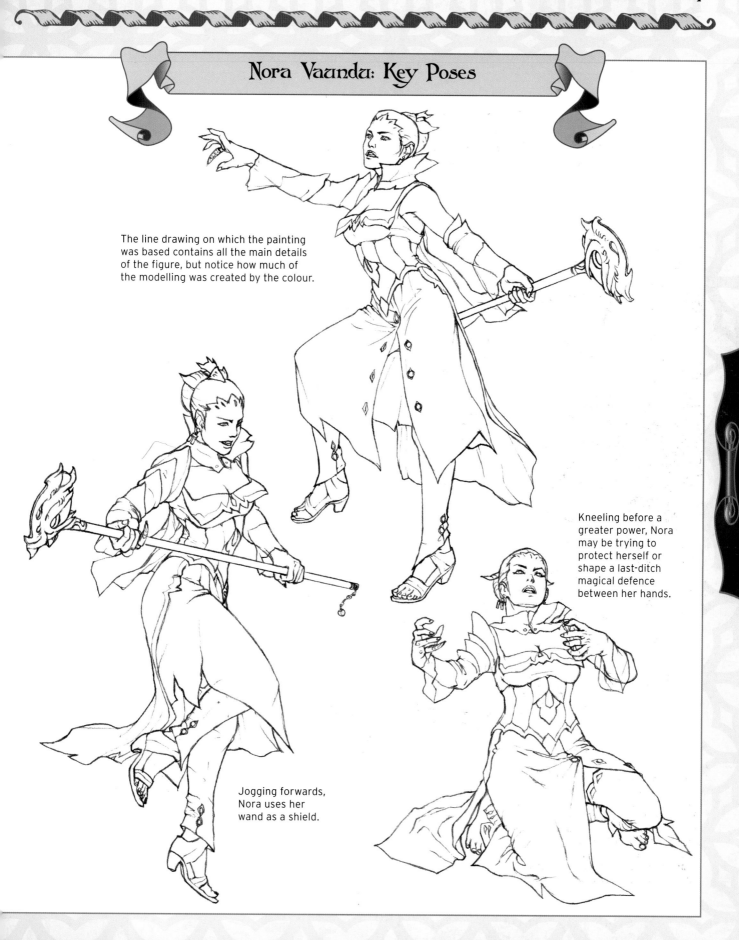

The line drawing on which the painting was based contains all the main details of the figure, but notice how much of the modelling was created by the colour.

Kneeling before a greater power, Nora may be trying to protect herself or shape a last-ditch magical defence between her hands.

Jogging forwards, Nora uses her wand as a shield.

GIANTS

Magical giants are not just the opposite of dwarves in terms of size. Unlike dwarves, they seldom display any goodwill to human beings or human-friendly magical races. They tend to see humans as food or beneath their contempt, which makes it inevitable that some hero will need to cut them down to size. Achieving this end with standard, human-sized weapons demands great resourcefulness. However, when a hero succeeds, it proves the old saying: 'The bigger they are, the harder they fall.'

56 YETI

Opinion varies on whether the Yeti (or Abominable Snowman, as he is sometimes called) exists, but travellers and adventurers in the Himalayas continue to report sightings.

57 KUMBHAKARNA

Kumbhakarna belongs to the Rakshasas, a race of supernatural giants common in Hindu mythology.

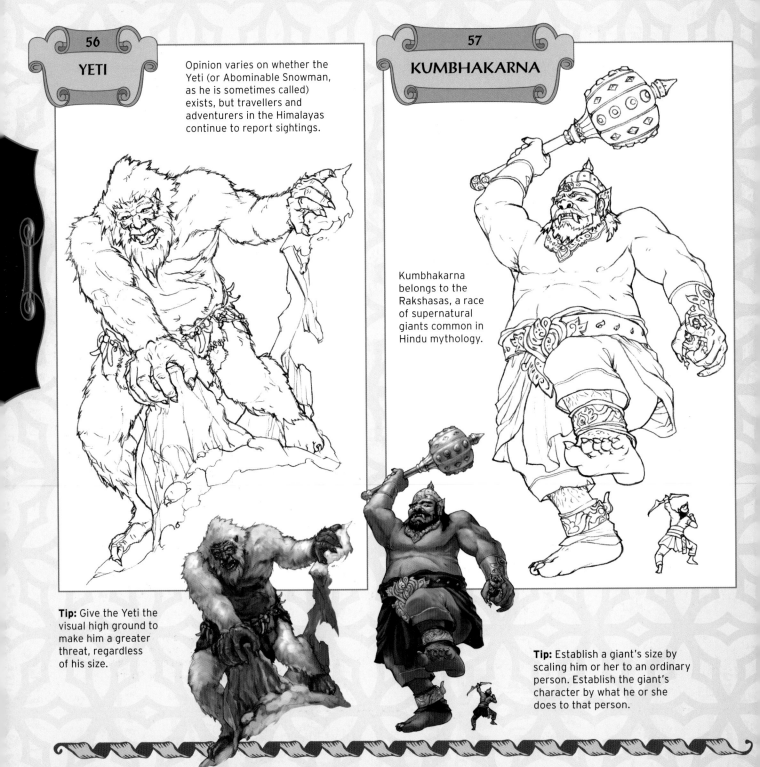

Tip: Give the Yeti the visual high ground to make him a greater threat, regardless of his size.

Tip: Establish a giant's size by scaling him or her to an ordinary person. Establish the giant's character by what he or she does to that person.

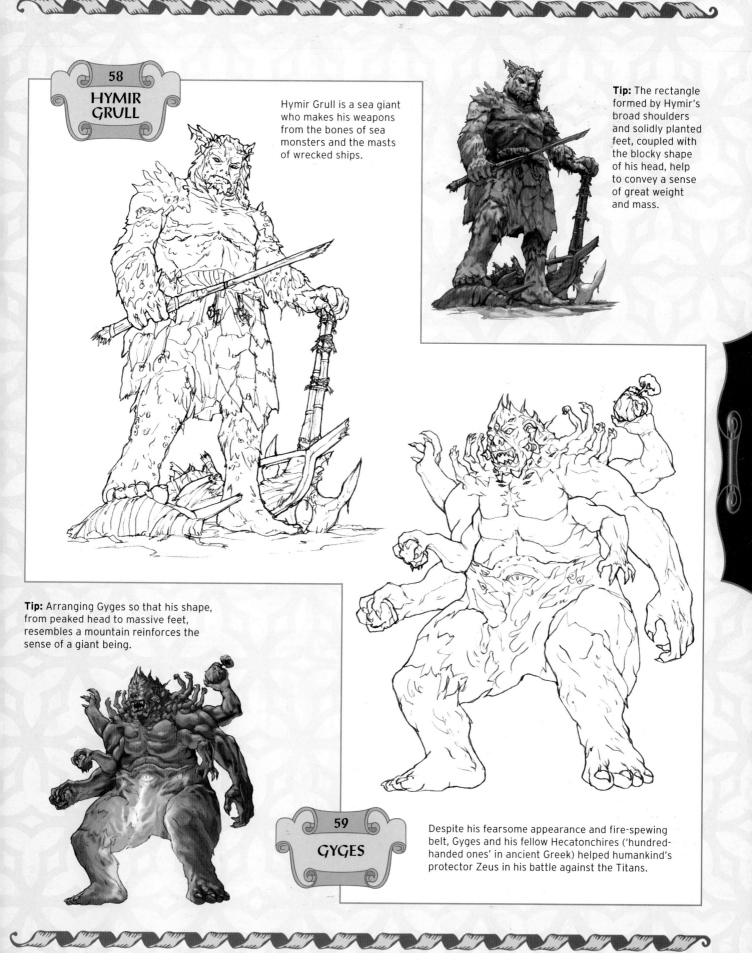

58 HYMIR GRULL

Hymir Grull is a sea giant who makes his weapons from the bones of sea monsters and the masts of wrecked ships.

Tip: The rectangle formed by Hymir's broad shoulders and solidly planted feet, coupled with the blocky shape of his head, help to convey a sense of great weight and mass.

Tip: Arranging Gyges so that his shape, from peaked head to massive feet, resembles a mountain reinforces the sense of a giant being.

59 GYGES

Despite his fearsome appearance and fire-spewing belt, Gyges and his fellow Hecatonchires ('hundred-handed ones' in ancient Greek) helped humankind's protector Zeus in his battle against the Titans.

PRINCES & PRINCESSES

We have all been raised on fairy tales featuring beautiful princesses and brave princes who must overcome a myriad extraordinary obstacles to achieve their happily-ever-afters. The trials faced by these fairy-tale royals allow us to identify with them. We use their power and status to measure our own achievements. Finally – and most importantly for the artist – royal characters can and should be dressed in the finest fabrics, furs and jewels. In the visual arts, a touch of the gorgeous is never amiss, and more is always more.

60 PRINCESS ELENA

Princess Elena strides towards the viewer carrying a jewelled sceptre. The silvery sheen of her gown and its subtle but intricate ornamentation convey wealth and taste.

Prince Rayner Silverstar's pose is one of forward momentum at the start of battle, but the direction of the prince's gaze and the fluttering fabrics lead the viewer's eye to the scene behind him instead of in front.

61 PRINCE RAYNER SILVERSTAR

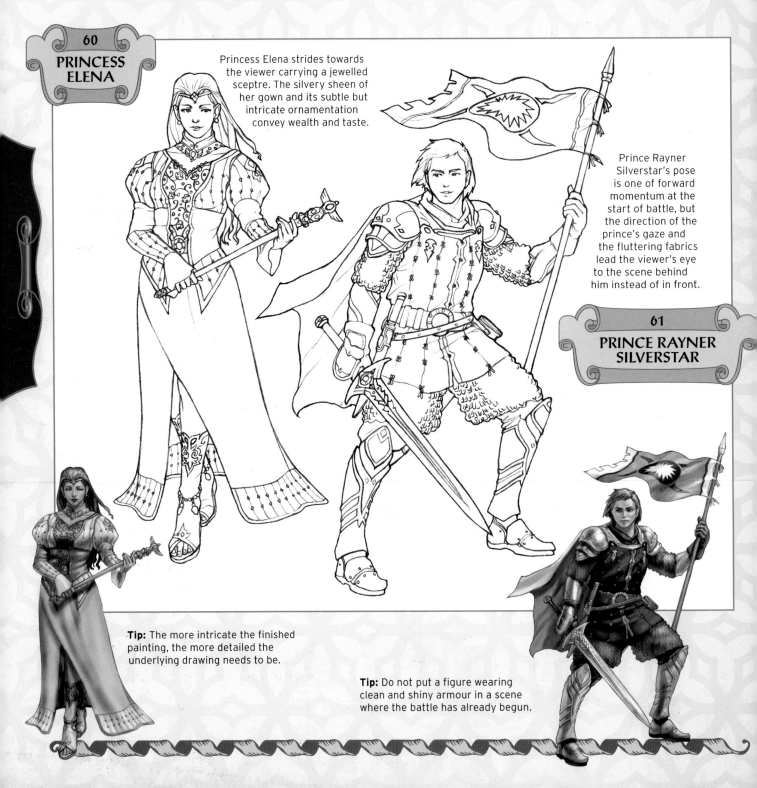

Tip: The more intricate the finished painting, the more detailed the underlying drawing needs to be.

Tip: Do not put a figure wearing clean and shiny armour in a scene where the battle has already begun.

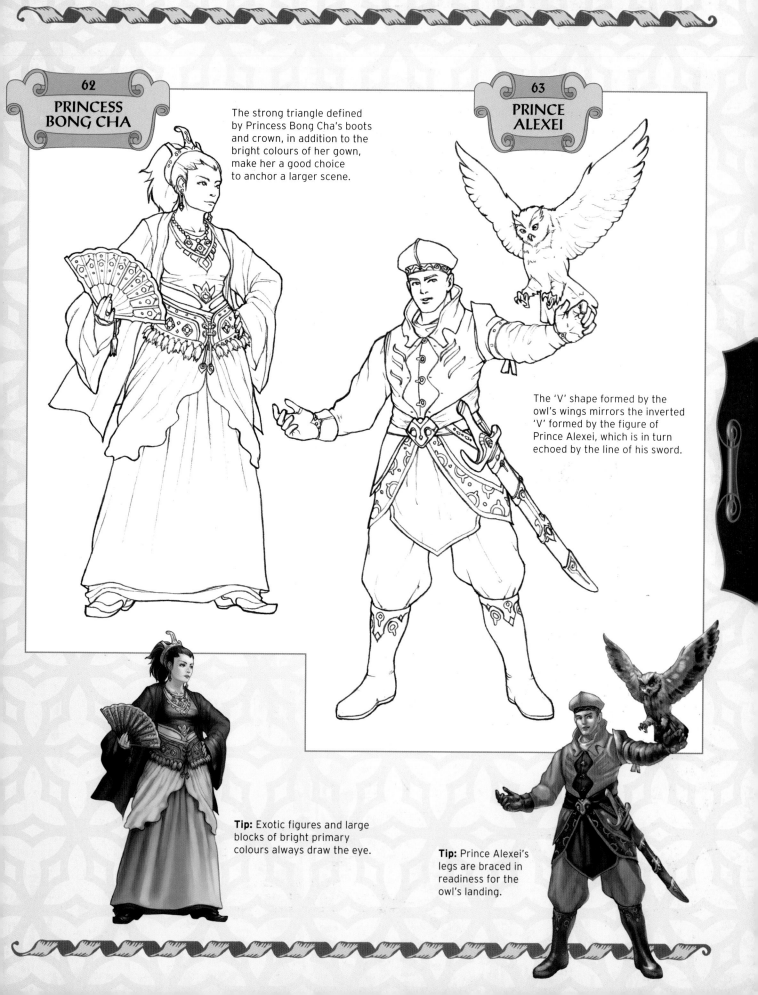

62
PRINCESS BONG CHA

The strong triangle defined by Princess Bong Cha's boots and crown, in addition to the bright colours of her gown, make her a good choice to anchor a larger scene.

63
PRINCE ALEXEI

The 'V' shape formed by the owl's wings mirrors the inverted 'V' formed by the figure of Prince Alexei, which is in turn echoed by the line of his sword.

Tip: Exotic figures and large blocks of bright primary colours always draw the eye.

Tip: Prince Alexei's legs are braced in readiness for the owl's landing.

HORSEMEN & ~WOMEN

According to the Bedouins, Allah made the horse the lord of all other animals, proclaiming: 'Men shall follow you wherever you go; you shall be as good for flight as for pursuit; you shall fly without wings.' This is certainly true in painting, where a well-rendered horse and rider can make a picture's two-dimensional surface seem to explode into motion. Unlike many other staples of fantasy, however, horses are real; the artist must pay careful attention to their anatomy and movement – as well as to their riders – to depict them to best advantage.

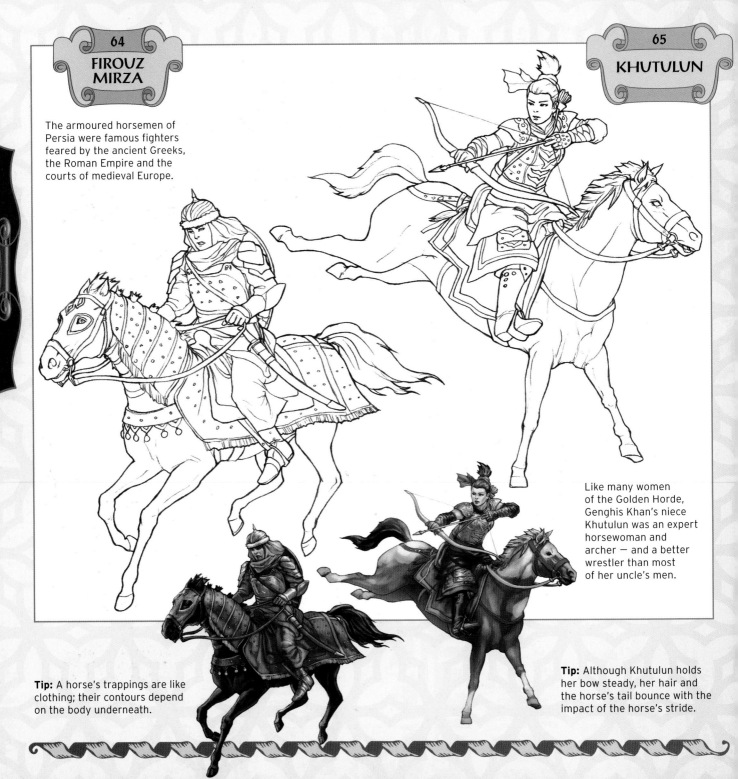

64
FIROUZ MIRZA

65
KHUTULUN

The armoured horsemen of Persia were famous fighters feared by the ancient Greeks, the Roman Empire and the courts of medieval Europe.

Like many women of the Golden Horde, Genghis Khan's niece Khutulun was an expert horsewoman and archer — and a better wrestler than most of her uncle's men.

Tip: A horse's trappings are like clothing; their contours depend on the body underneath.

Tip: Although Khutulun holds her bow steady, her hair and the horse's tail bounce with the impact of the horse's stride.

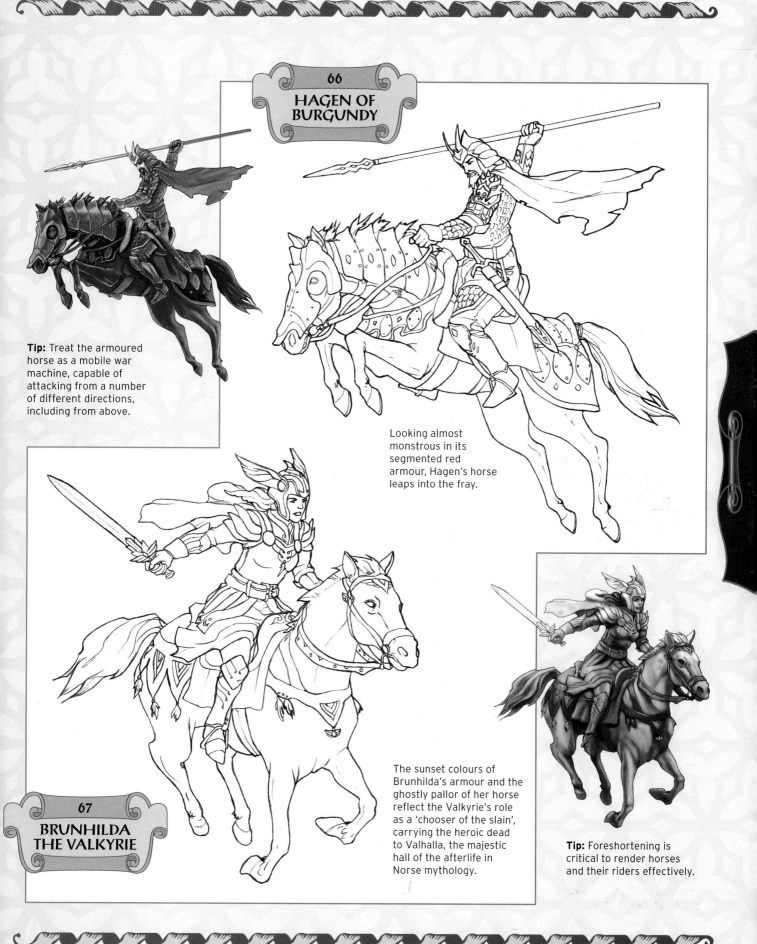

66
HAGEN OF BURGUNDY

Tip: Treat the armoured horse as a mobile war machine, capable of attacking from a number of different directions, including from above.

Looking almost monstrous in its segmented red armour, Hagen's horse leaps into the fray.

67
BRUNHILDA THE VALKYRIE

The sunset colours of Brunhilda's armour and the ghostly pallor of her horse reflect the Valkyrie's role as a 'chooser of the slain', carrying the heroic dead to Valhalla, the majestic hall of the afterlife in Norse mythology.

Tip: Foreshortening is critical to render horses and their riders effectively.

**68
FAUCON
DE VALOIS**

Few fantasy images are more evocative than the knight in shining armour charging to the rescue on his mighty steed. The knight and horse in this vision almost invariably wear a full suit of plate armour. The play of light over these gleaming surfaces can be challenging. The artist needs to keep in mind the direction of the light and how it reflects off polished surfaces. Used correctly, these effects can have the same visual punch as a spotlight.

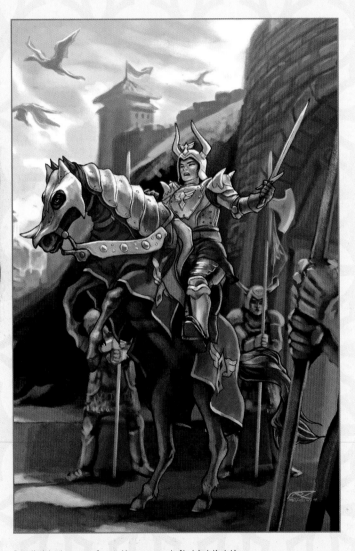

Sunlight streams from the upper left, highlighting the acute angle formed by the horse's body and the stalwart figure of the chevalier. Another sunbeam crosses the lower left of the painting, effectively casting the other soldiers into shadow, reducing their pictorial weight in comparison to the horse and rider. At the same time, the strong verticals of the halberd and spear to the right of the painting form a visual barrier, pushing the eye back to the chevalier and his horse.

A clear picture of Faucon's rearing horse in full trappings. Note the horse's slight sideways twist.

Faucon de Valois: Key Poses

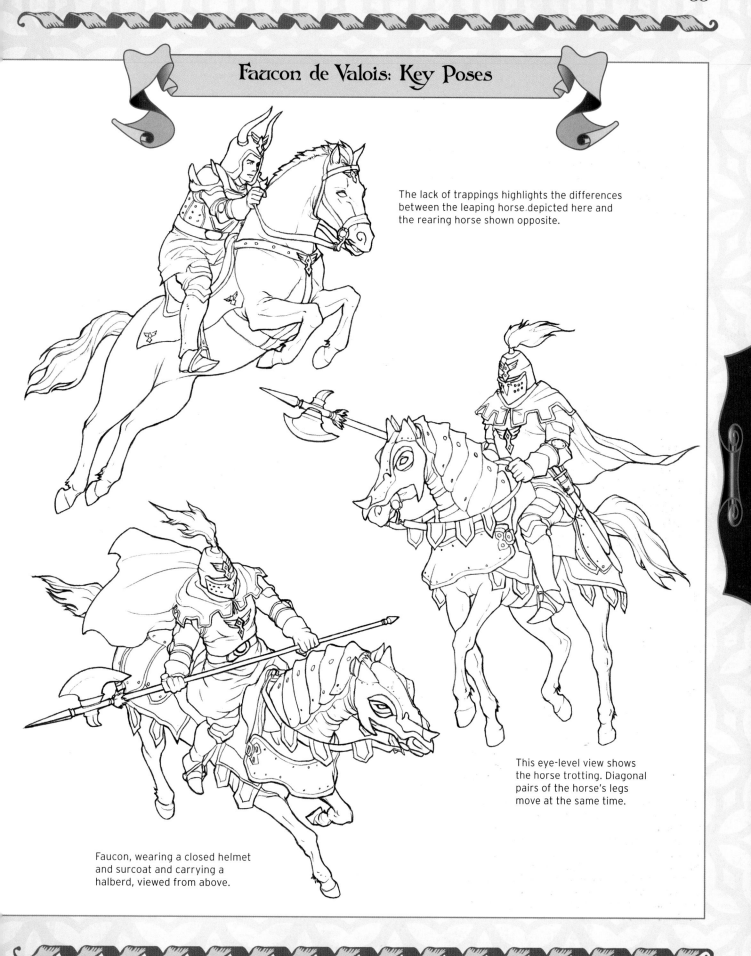

The lack of trappings highlights the differences between the leaping horse depicted here and the rearing horse shown opposite.

This eye-level view shows the horse trotting. Diagonal pairs of the horse's legs move at the same time.

Faucon, wearing a closed helmet and surcoat and carrying a halberd, viewed from above.

BEAST MASTERS

Who does not yearn to pet the tiger? Who would not be just a little bit afraid of the person who did? We equate power over animals with dominion over nature. This makes those who successfully master the creatures that we fear – big cats, the monsters of the ocean deep and creatures only imagined in our nightmares – somewhat intimidating, if not downright frightening. We wonder about the source of the unusual, perhaps unnatural, connection between man, woman and beast, and worry that they may turn against us.

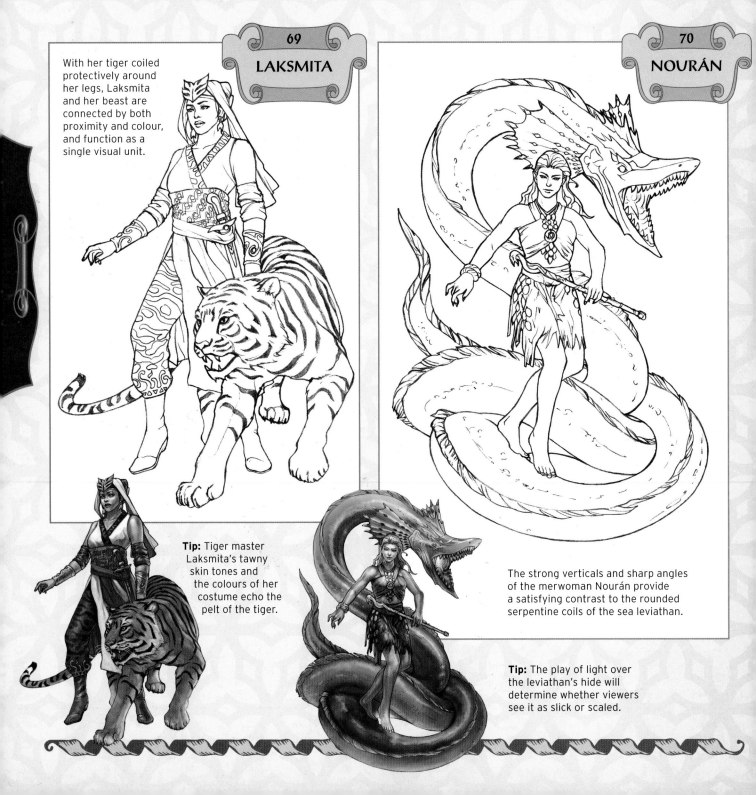

69 LAKSMITA

With her tiger coiled protectively around her legs, Laksmita and her beast are connected by both proximity and colour, and function as a single visual unit.

Tip: Tiger master Laksmita's tawny skin tones and the colours of her costume echo the pelt of the tiger.

70 NOURÁN

The strong verticals and sharp angles of the merwoman Nourán provide a satisfying contrast to the rounded serpentine coils of the sea leviathan.

Tip: The play of light over the leviathan's hide will determine whether viewers see it as slick or scaled.

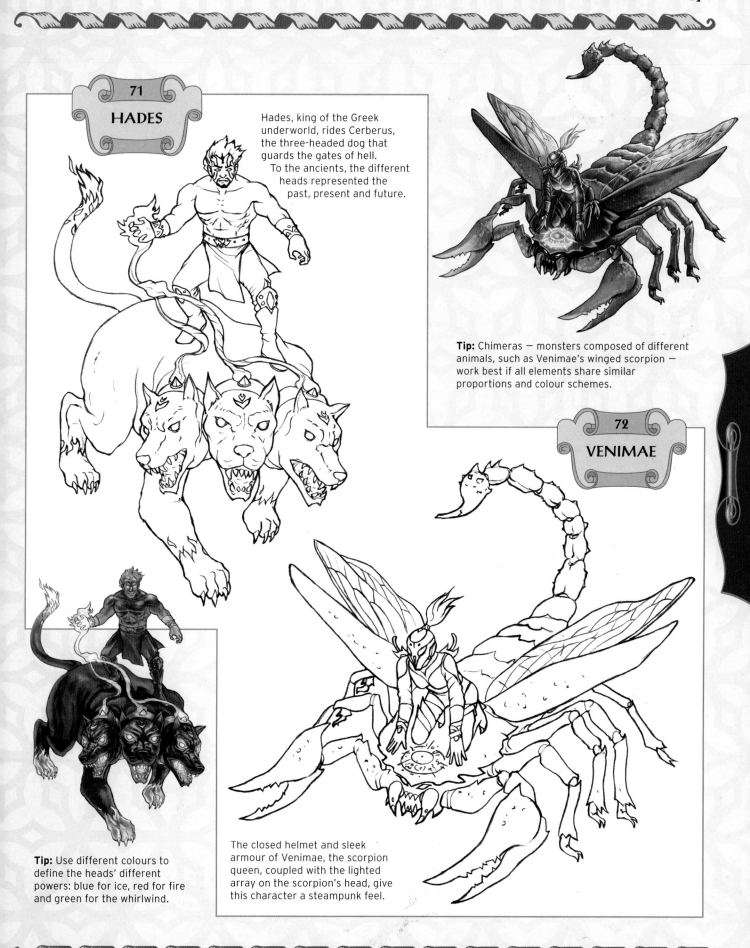

71 HADES

Hades, king of the Greek underworld, rides Cerberus, the three-headed dog that guards the gates of hell.
To the ancients, the different heads represented the past, present and future.

Tip: Chimeras — monsters composed of different animals, such as Venimae's winged scorpion — work best if all elements share similar proportions and colour schemes.

72 VENIMAE

Tip: Use different colours to define the heads' different powers: blue for ice, red for fire and green for the whirlwind.

The closed helmet and sleek armour of Venimae, the scorpion queen, coupled with the lighted array on the scorpion's head, give this character a steampunk feel.

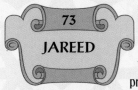

73

JAREED

Fortunately for human survival, our ancestors never had to compete with or run from dinosaurs, which is probably why we find them so irresistible. We would like to think that human cunning could prevail against reptilian savagery, and perhaps even harness it to create a living weapon more formidable than the horse. In addition, dino-beasts such as Jareed's mount give the artist an opportunity to play with unusual textures, anatomy and a range of motion seldom seen in other contexts.

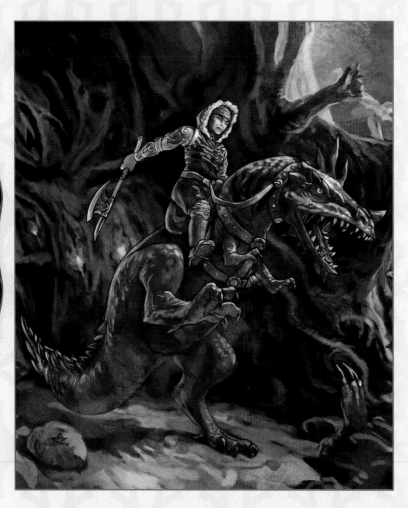

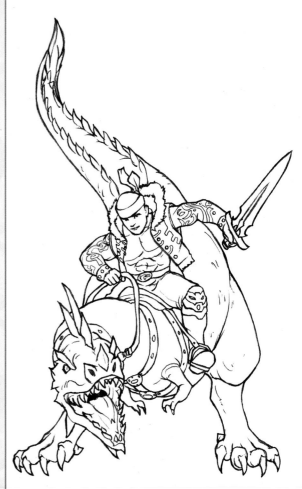

Although the main light source in this painting illuminates both Jareed and the dino-beast, the focus here is the beast, not the man. The strong red diagonal of the reptile's body dominates the picture plane. The eye is drawn to the beast's glittering head, which is rendered in greater detail than the painting's other elements. The sharp angle of the head parallels that of the tail, which amplifies the energy of the scene, as does the unexpected but realistic hind-leg attack.

The dino-beast's thick tail acts as a counterbalance to the weight of its body. Jareed wears the same hooded vest that he wears in the painting, but this time it is open, with the hood thrown back.

Jareed: Key Poses

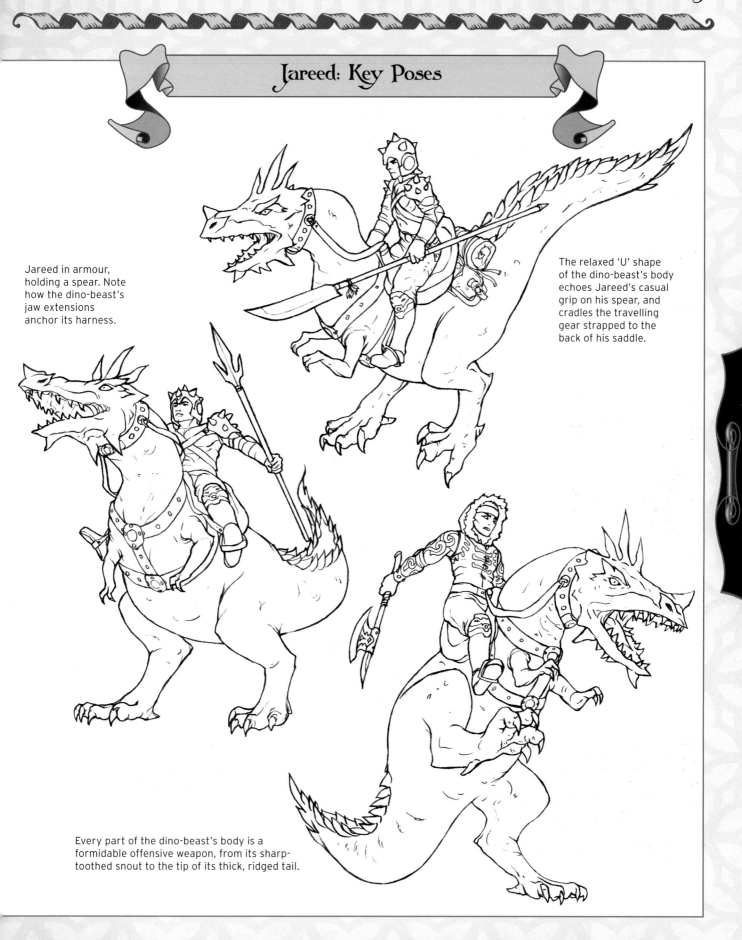

Jareed in armour, holding a spear. Note how the dino-beast's jaw extensions anchor its harness.

The relaxed 'U' shape of the dino-beast's body echoes Jareed's casual grip on his spear, and cradles the travelling gear strapped to the back of his saddle.

Every part of the dino-beast's body is a formidable offensive weapon, from its sharp-toothed snout to the tip of its thick, ridged tail.

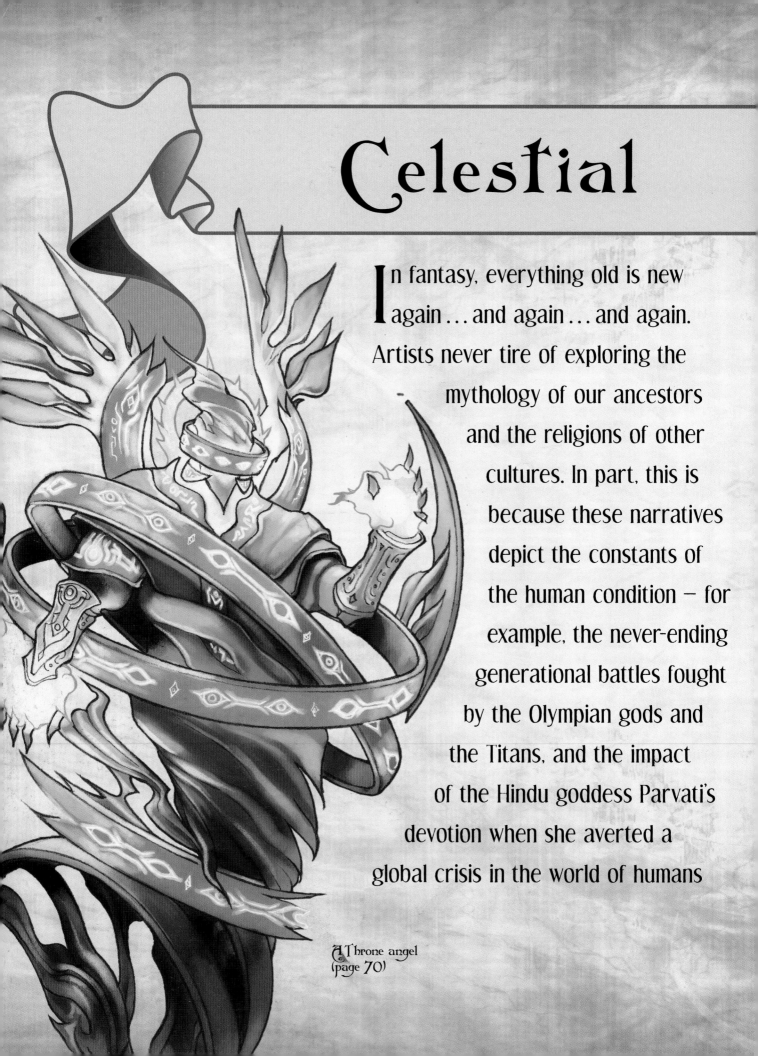

Celestial

In fantasy, everything old is new again…and again…and again. Artists never tire of exploring the mythology of our ancestors and the religions of other cultures. In part, this is because these narratives depict the constants of the human condition – for example, the never-ending generational battles fought by the Olympian gods and the Titans, and the impact of the Hindu goddess Parvati's devotion when she averted a global crisis in the world of humans

A Throne angel
(page 70)

& Infernal

by reawakening love in the heart of the grieving god Shiva. They also happen to be first-rate stories. This chapter introduces some of the gods and demons whose tales form the basis of world culture, familiarizes you with the symbols that define them and demonstrates how to combine these elements into strong compositions that look fantastic and tell great stories.

The demon Empusa
(page 77)

GODS & GODDESSES

Whatever their individual characteristics, gods and goddesses can be seen as metaphors for humanity's highest aspirations – and the dangers inherent in pursuing those goals. Even helpful deities, like Athena, had their dark side. After all, it was Athena's cruelty that created the monster Medusa, whose head adorns Athena's armour. This duality is most clearly expressed in the trickster gods, such as the Norse fire god Loki and the Native American shapeshifter Coyote, who keep the affairs of mortals and immortals from ever growing dull.

74
LOKI

75
ANUBIS

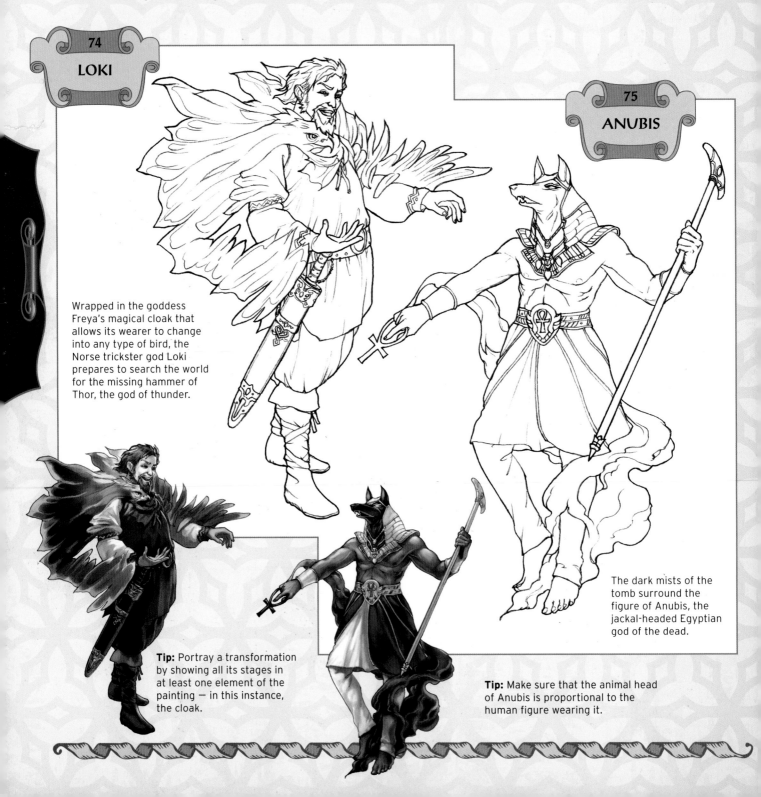

Wrapped in the goddess Freya's magical cloak that allows its wearer to change into any type of bird, the Norse trickster god Loki prepares to search the world for the missing hammer of Thor, the god of thunder.

The dark mists of the tomb surround the figure of Anubis, the jackal-headed Egyptian god of the dead.

Tip: Portray a transformation by showing all its stages in at least one element of the painting — in this instance, the cloak.

Tip: Make sure that the animal head of Anubis is proportional to the human figure wearing it.

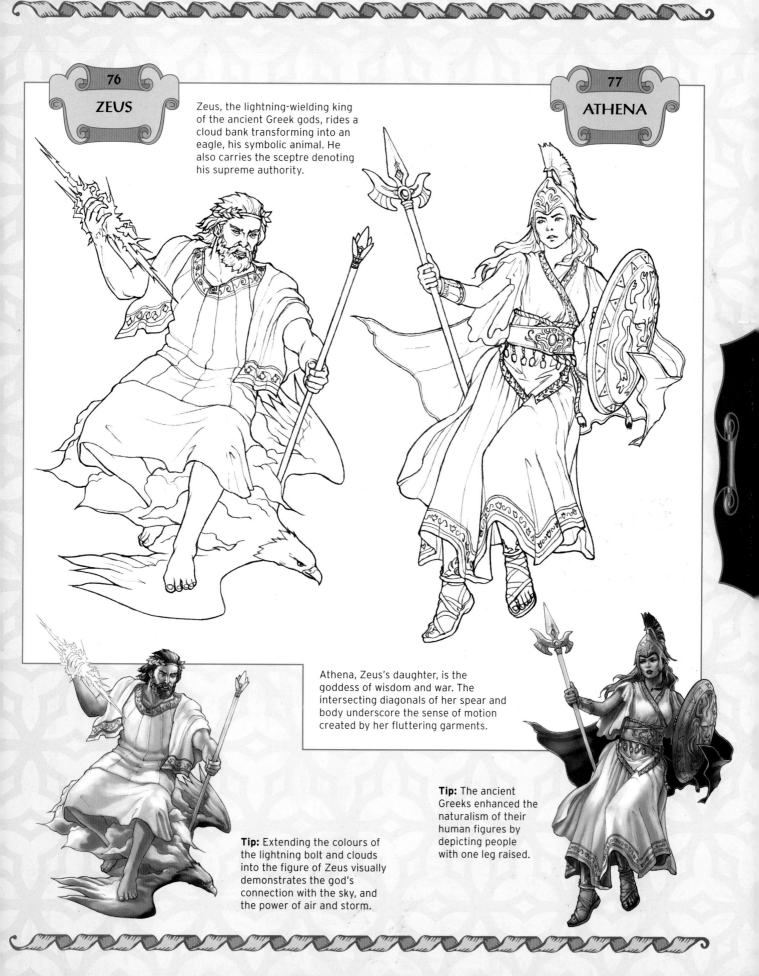

76 ZEUS

Zeus, the lightning-wielding king of the ancient Greek gods, rides a cloud bank transforming into an eagle, his symbolic animal. He also carries the sceptre denoting his supreme authority.

77 ATHENA

Athena, Zeus's daughter, is the goddess of wisdom and war. The intersecting diagonals of her spear and body underscore the sense of motion created by her fluttering garments.

Tip: Extending the colours of the lightning bolt and clouds into the figure of Zeus visually demonstrates the god's connection with the sky, and the power of air and storm.

Tip: The ancient Greeks enhanced the naturalism of their human figures by depicting people with one leg raised.

Like the two large cats that draw her chariot, the nature of the Norse goddess Freya combines beauty and savagery. She is the goddess of war and magic, as well as love, vegetation and fertility. The danger of her allure is epitomized by her fabulous gold and amber necklace, Brisingamen, the cause of a feud between the gods Loki and Heimdall, which will last until the end of time.

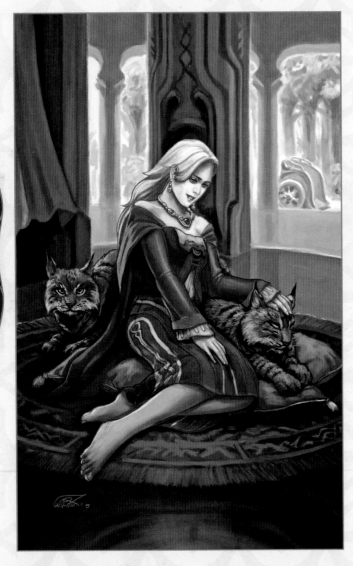

The hem of Freya's magical cloak, the tassel of the orange cushion and the top of Freya's head form a strong triangle in the middle of this composition. Visual interest is added by contrasting this brightly coloured shape with the curves of the rug and chariot wheel, and with the dark, tree-like interior columns and the column-like trees glimpsed outside the window. The triangular ears of the brown cats, the folds of the curtain and the corners of the cushions echo the interplay of shape and colour.

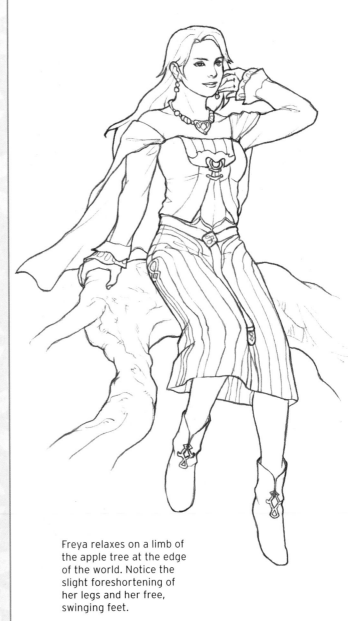

Freya relaxes on a limb of the apple tree at the edge of the world. Notice the slight foreshortening of her legs and her free, swinging feet.

Freya: Key Poses

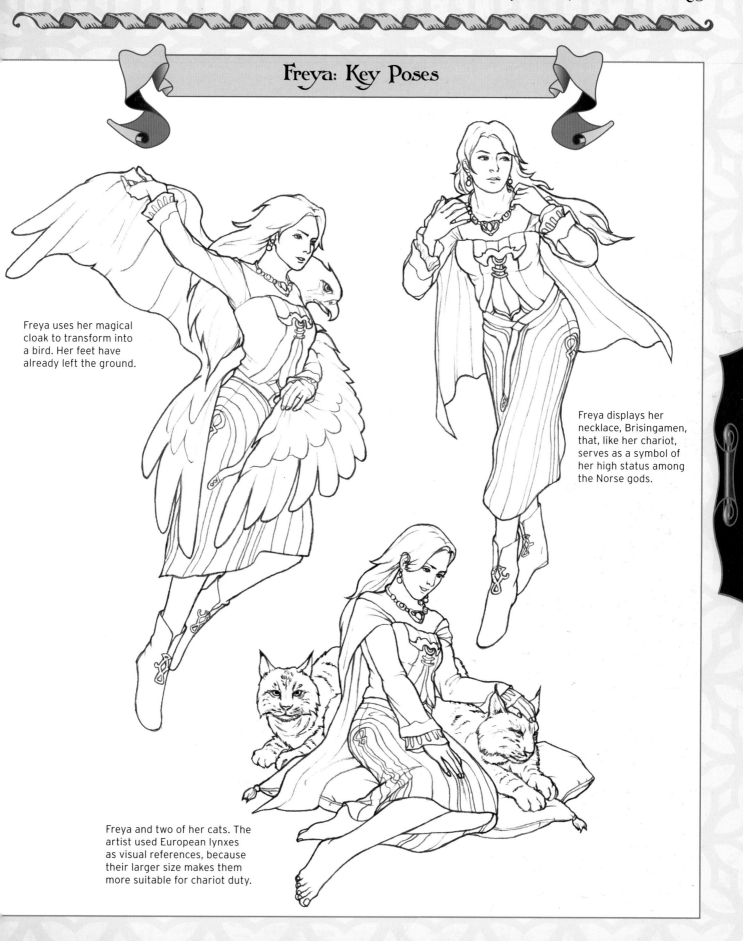

Freya uses her magical cloak to transform into a bird. Her feet have already left the ground.

Freya displays her necklace, Brisingamen, that, like her chariot, serves as a symbol of her high status among the Norse gods.

Freya and two of her cats. The artist used European lynxes as visual references, because their larger size makes them more suitable for chariot duty.

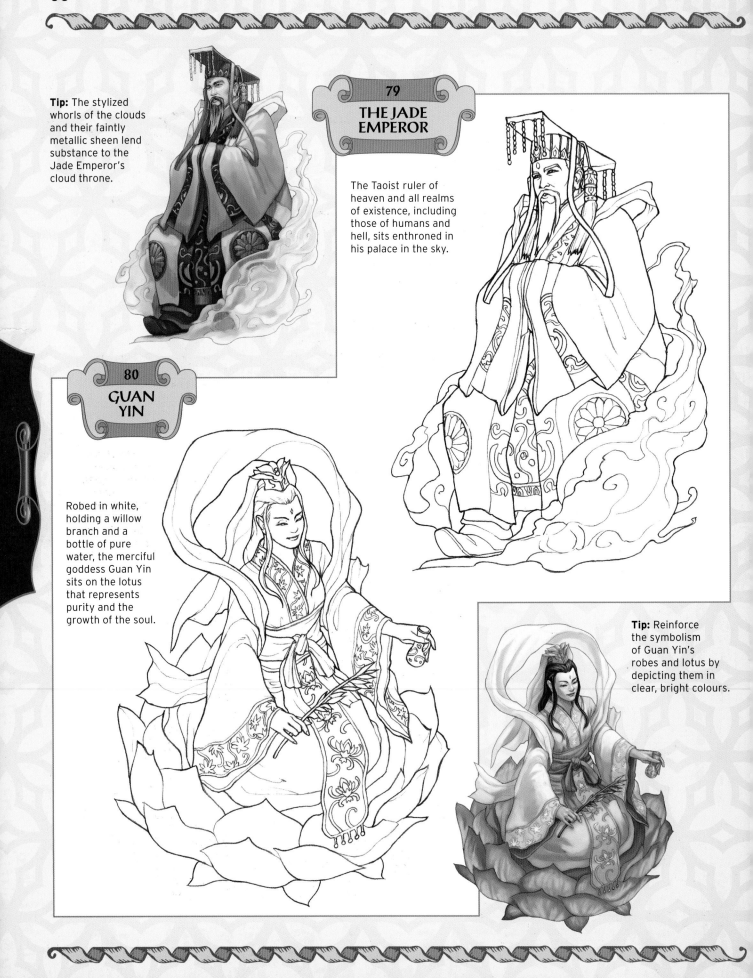

Tip: The stylized whorls of the clouds and their faintly metallic sheen lend substance to the Jade Emperor's cloud throne.

79
THE JADE EMPEROR

The Taoist ruler of heaven and all realms of existence, including those of humans and hell, sits enthroned in his palace in the sky.

80
GUAN YIN

Robed in white, holding a willow branch and a bottle of pure water, the merciful goddess Guan Yin sits on the lotus that represents purity and the growth of the soul.

Tip: Reinforce the symbolism of Guan Yin's robes and lotus by depicting them in clear, bright colours.

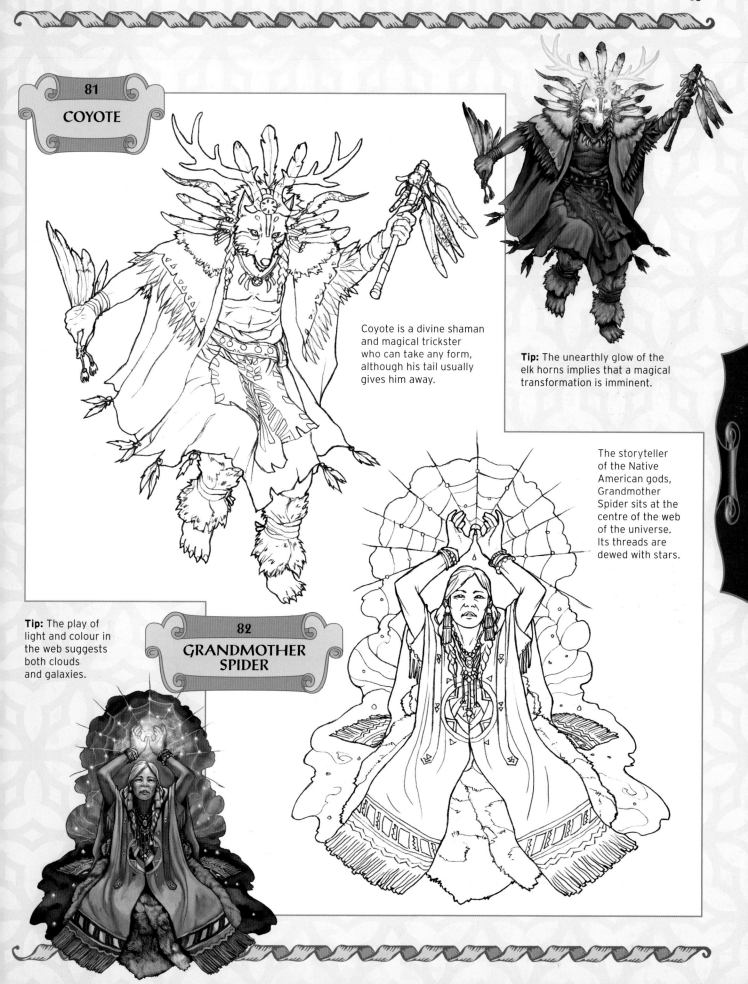

81
COYOTE

Coyote is a divine shaman and magical trickster who can take any form, although his tail usually gives him away.

Tip: The unearthly glow of the elk horns implies that a magical transformation is imminent.

The storyteller of the Native American gods, Grandmother Spider sits at the centre of the web of the universe. Its threads are dewed with stars.

Tip: The play of light and colour in the web suggests both clouds and galaxies.

82
GRANDMOTHER SPIDER

83

PARVATI

Overcome with grief on the death of his wife, Shiva, the destroyer of evil in the Hindu pantheon, turned his back on the world, allowing heaven and earth to be overrun by demons. The kindhearted princess Parvati, the personification of the mother goddess Shakti and the reincarnation of Shiva's first wife, sought to re-engage him in human affairs by marrying him. Shiva went to great lengths to resist her, but could not withstand her devotion, and when they ultimately joined in marriage, love was reborn.

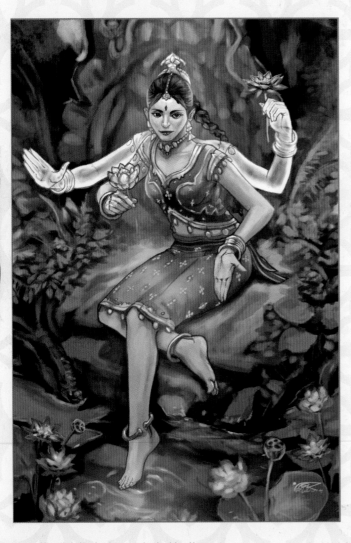

Parvati's divinity is demonstrated by the way the rocks of her mountain home have shaped themselves into a natural throne, and her extra arms, a common attribute of Hindu gods. Her humanity and divinity are visually integrated by having her human arms complete the gestures of her divine ones, and vice versa. Her complex pose suggests both the positions of yoga and the patterns of a dance — necessary talents for the wife of the Hindu lord of the dance.

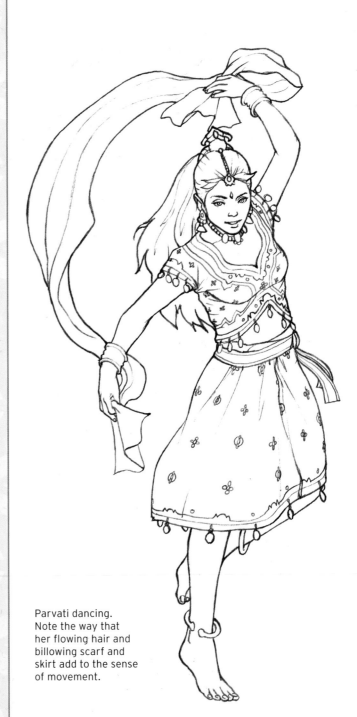

Parvati dancing. Note the way that her flowing hair and billowing scarf and skirt add to the sense of movement.

Parvati: Key Poses

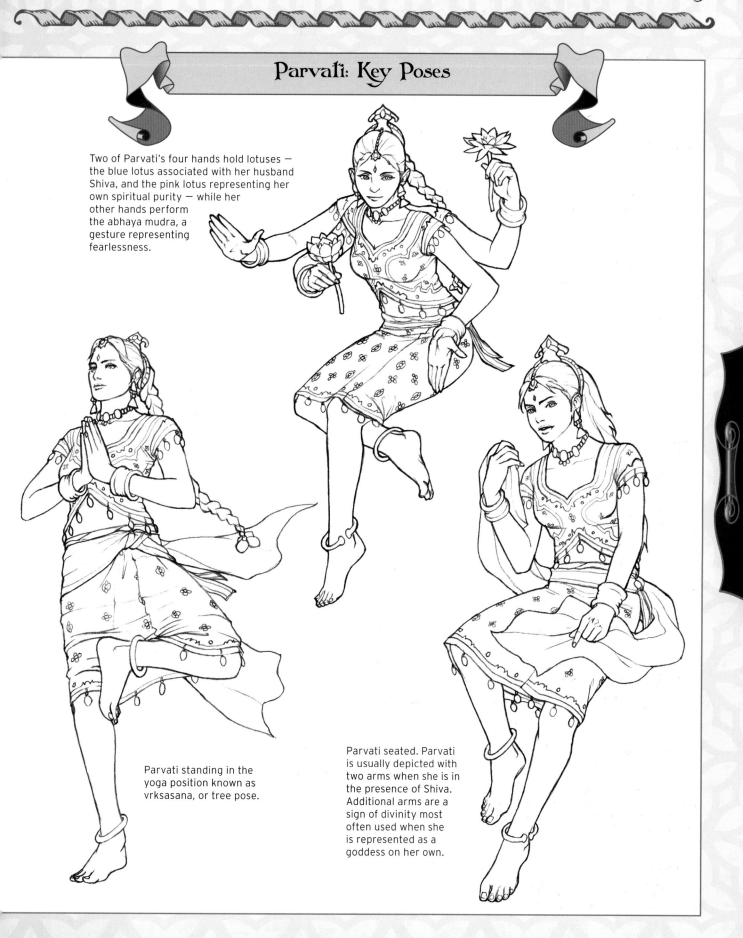

Two of Parvati's four hands hold lotuses — the blue lotus associated with her husband Shiva, and the pink lotus representing her own spiritual purity — while her other hands perform the abhaya mudra, a gesture representing fearlessness.

Parvati standing in the yoga position known as vrksasana, or tree pose.

Parvati seated. Parvati is usually depicted with two arms when she is in the presence of Shiva. Additional arms are a sign of divinity most often used when she is represented as a goddess on her own.

ANGELS

People of all cultures share a belief in divine messengers who act as intermediaries between gods and humans. Most view these messengers as beings of light and goodness, who may take human form and often come equipped with wings to help them traverse the vast distances between earth and the heavens. Early Christian theologians expanded on this concept, creating massive hierarchies of angelic hosts.

Tip: The sweep of the angel's left wing and trailing wisps of power suggests the Grim Reaper's scythe.

84 THRONE

Wheels within wheels ringed with eyes all around, the angels who supported the chariot in the prophet Ezekiel's visions were Thrones, the engines of divine justice, which grinds slow but fine.

Tip: Tilt the rings to give the wheels and the hurricane-like interior figure greater three-dimensionality.

85 AZRAEL

This angel of death wears the face of a clock, identifying it with time, the most powerful destructive force of all.

88

POWER

Powers are warrior angels armed with flaming swords to dispatch demons and other supernatural evils. The angels' sceptres relate to their other function. which is the origin of their name: conferring temporal power on humans. Here, however, the Powers are arrayed for battle, and the blue-white fire of the central Power's sword burns hotter than the being who wields it.

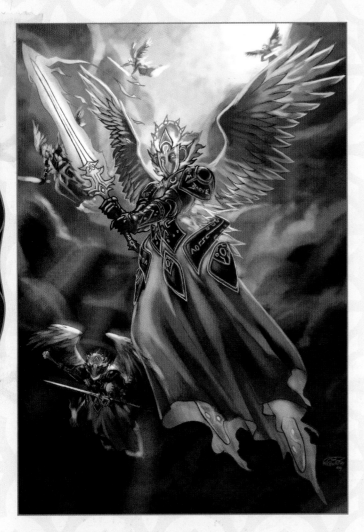

The diagonal formed by the body of the largest Power and its upraised sword spans the entire painting. Cutting across this diagonal is a line described by the Power's left wing, its arm and the rays of light streaming from the celestial realm glimpsed between its wings. Together, the diagonals form a not-quite-perfect 'X' shape. The slight irregularity of the figure adds life to the composition, while at the same time visually connecting all of the figures in the painting.

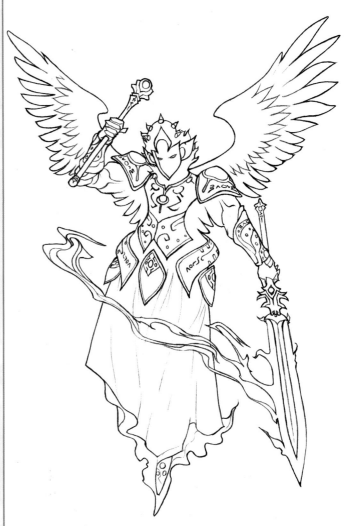

The flames trailing from the blade reflect the angle of the Power's wings and draw the eye to its ornate armour.

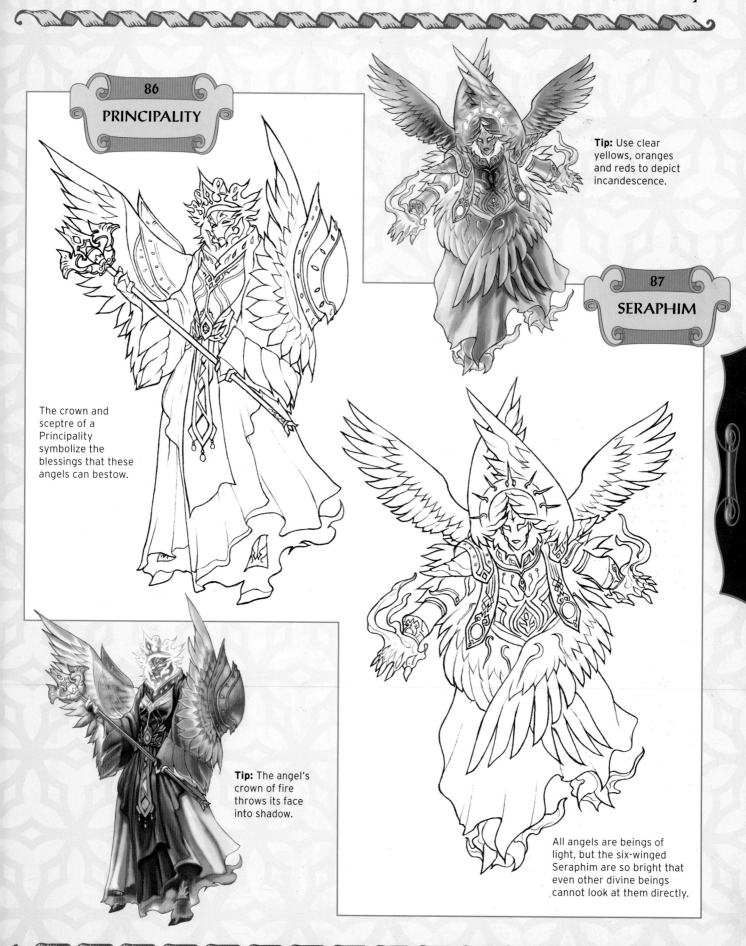

86
PRINCIPALITY

Tip: Use clear yellows, oranges and reds to depict incandescence.

The crown and sceptre of a Principality symbolize the blessings that these angels can bestow.

87
SERAPHIM

Tip: The angel's crown of fire throws its face into shadow.

All angels are beings of light, but the six-winged Seraphim are so bright that even other divine beings cannot look at them directly.

Power: Key Poses

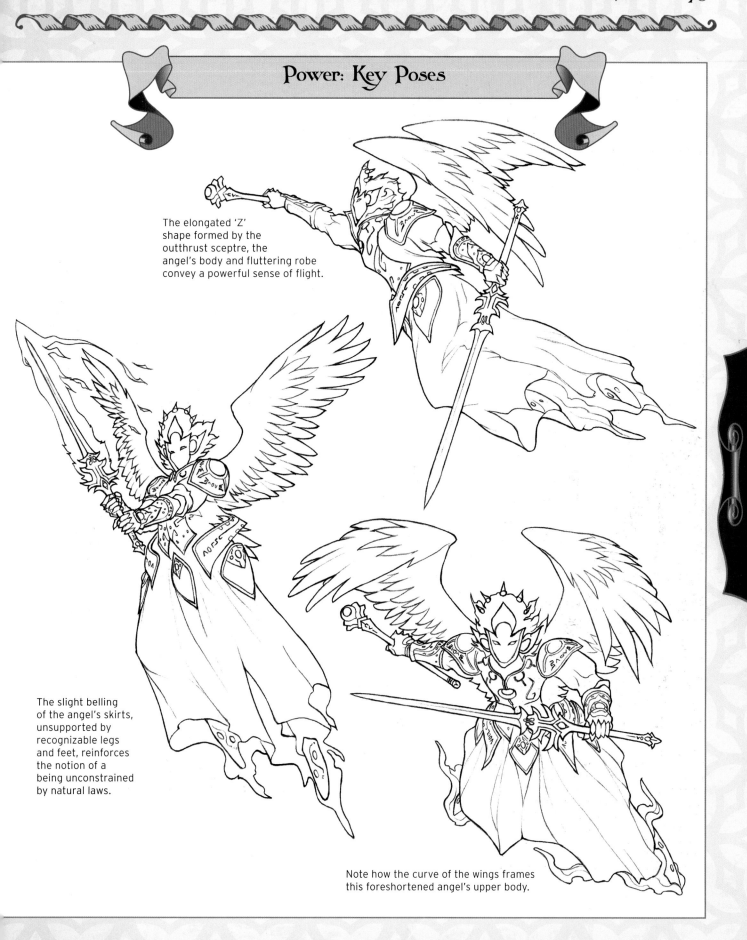

The elongated 'Z' shape formed by the outthrust sceptre, the angel's body and fluttering robe convey a powerful sense of flight.

The slight belling of the angel's skirts, unsupported by recognizable legs and feet, reinforces the notion of a being unconstrained by natural laws.

Note how the curve of the wings frames this foreshortened angel's upper body.

DEVILS & DEMONS

Whether they are fallen angels, displaced gods or manifestations of our basest desires, demons and devils provide the dark counterpoint to angels' light. They revel in evil and exult in terror. Their outward forms often reflect the hideousness of the spirit within – horns sprout from skull-like faces; misshapen bodies lumber on viciously clawed feet; razor-spined tails double as weapons. However, not all demons wear their ugliness on the outside. Some appear very attractive indeed, and they may be the most dangerous of all.

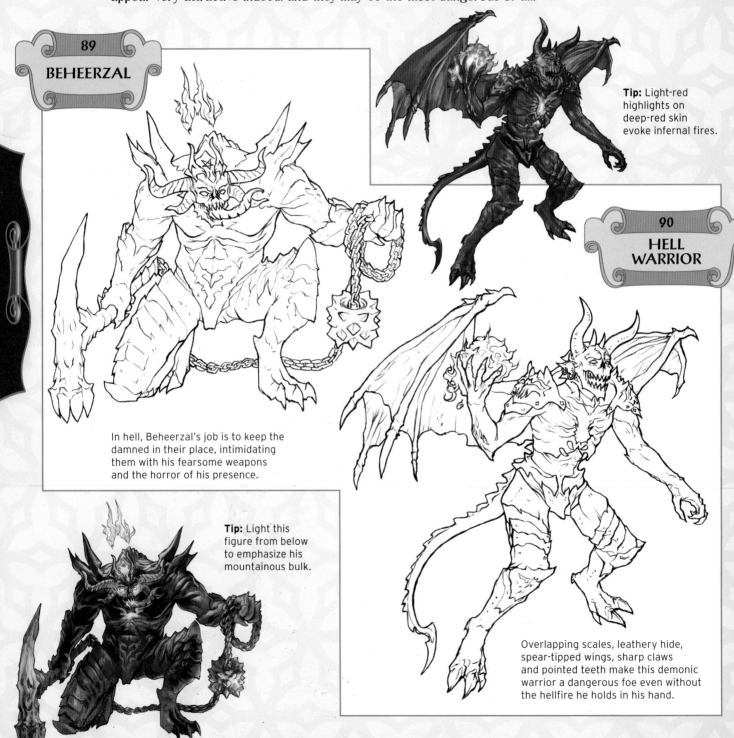

89
BEHEERZAL

Tip: Light-red highlights on deep-red skin evoke infernal fires.

90
HELL WARRIOR

In hell, Beheerzal's job is to keep the damned in their place, intimidating them with his fearsome weapons and the horror of his presence.

Tip: Light this figure from below to emphasize his mountainous bulk.

Overlapping scales, leathery hide, spear-tipped wings, sharp claws and pointed teeth make this demonic warrior a dangerous foe even without the hellfire he holds in his hand.

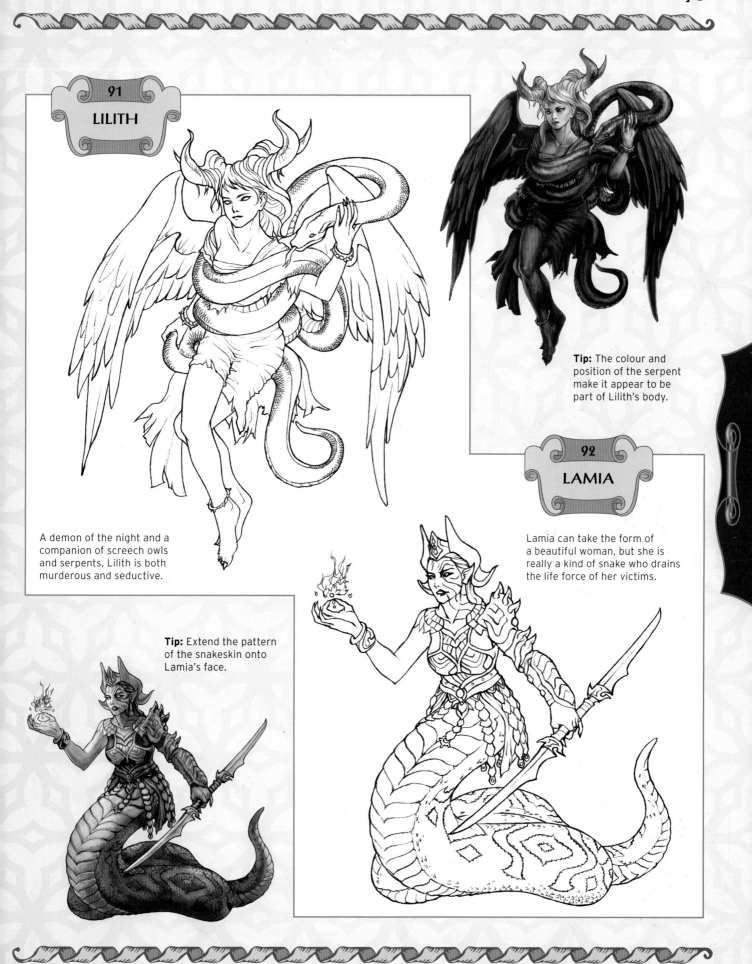

91
LILITH

A demon of the night and a companion of screech owls and serpents, Lilith is both murderous and seductive.

Tip: The colour and position of the serpent make it appear to be part of Lilith's body.

92
LAMIA

Lamia can take the form of a beautiful woman, but she is really a kind of snake who drains the life force of her victims.

Tip: Extend the pattern of the snakeskin onto Lamia's face.

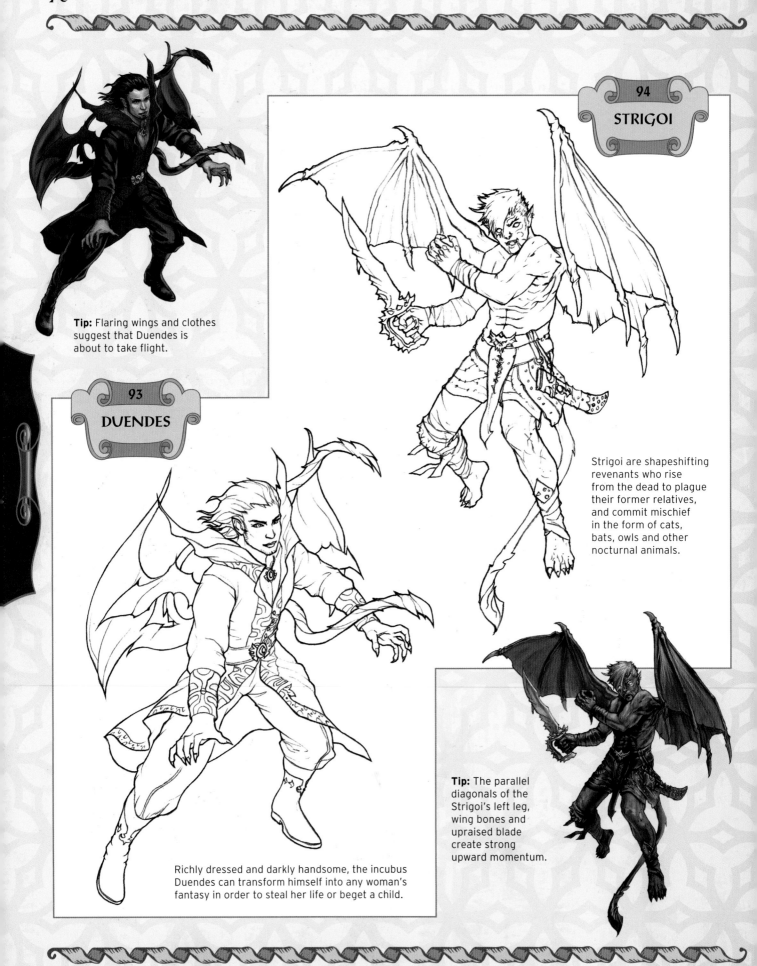

Tip: Flaring wings and clothes suggest that Duendes is about to take flight.

93
DUENDES

Richly dressed and darkly handsome, the incubus Duendes can transform himself into any woman's fantasy in order to steal her life or beget a child.

94
STRIGOI

Strigoi are shapeshifting revenants who rise from the dead to plague their former relatives, and commit mischief in the form of cats, bats, owls and other nocturnal animals.

Tip: The parallel diagonals of the Strigoi's left leg, wing bones and upraised blade create strong upward momentum.

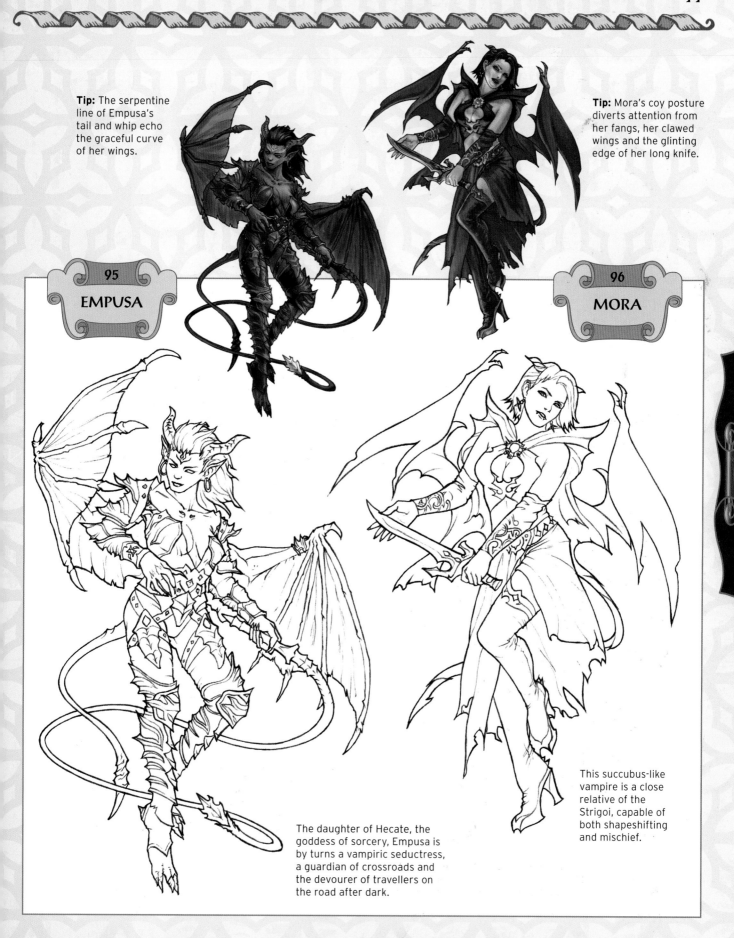

Tip: The serpentine line of Empusa's tail and whip echo the graceful curve of her wings.

Tip: Mora's coy posture diverts attention from her fangs, her clawed wings and the glinting edge of her long knife.

95

EMPUSA

96

MORA

The daughter of Hecate, the goddess of sorcery, Empusa is by turns a vampiric seductress, a guardian of crossroads and the devourer of travellers on the road after dark.

This succubus-like vampire is a close relative of the Strigoi, capable of both shapeshifting and mischief.

Monstrous

Dragons, unicorns, ogres and mermaids – what is so compelling about these fantasy icons? Beyond the world of art and literature, they adorn national flags and corporate logos. Is there something inherently pleasing about a dragon's serpentine coils or the gleaming horn of a unicorn? Does the allure of these fantasy creatures lie in the glamour of the impossible? Are they shorthand for repressed desires or nostalgia for the childhood equation

The nightmare Leyak
(page 97)

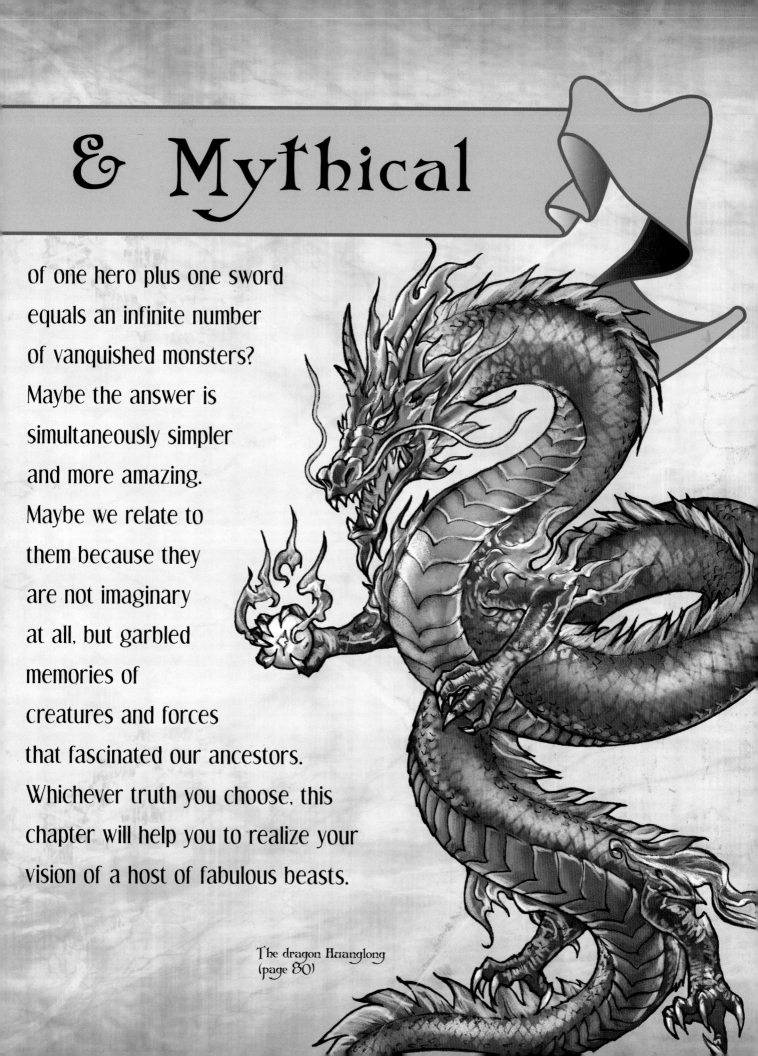

& Mythical

of one hero plus one sword equals an infinite number of vanquished monsters? Maybe the answer is simultaneously simpler and more amazing. Maybe we relate to them because they are not imaginary at all, but garbled memories of creatures and forces that fascinated our ancestors. Whichever truth you choose, this chapter will help you to realize your vision of a host of fabulous beasts.

The dragon Huanglong
(page 80)

DRAGONS

People in China, the heartland of dragon lore, might not believe the legends about dragons handed down from their ancestors, but they do not doubt that dragons exist − fossilized 'dragon bones' routinely emerge from the sands of the Gobi Desert. The earliest representations of dragons share many similarities to giant saltwater crocodiles, found throughout Southeast Asia, that, like their mythic counterparts, can sense a coming storm.

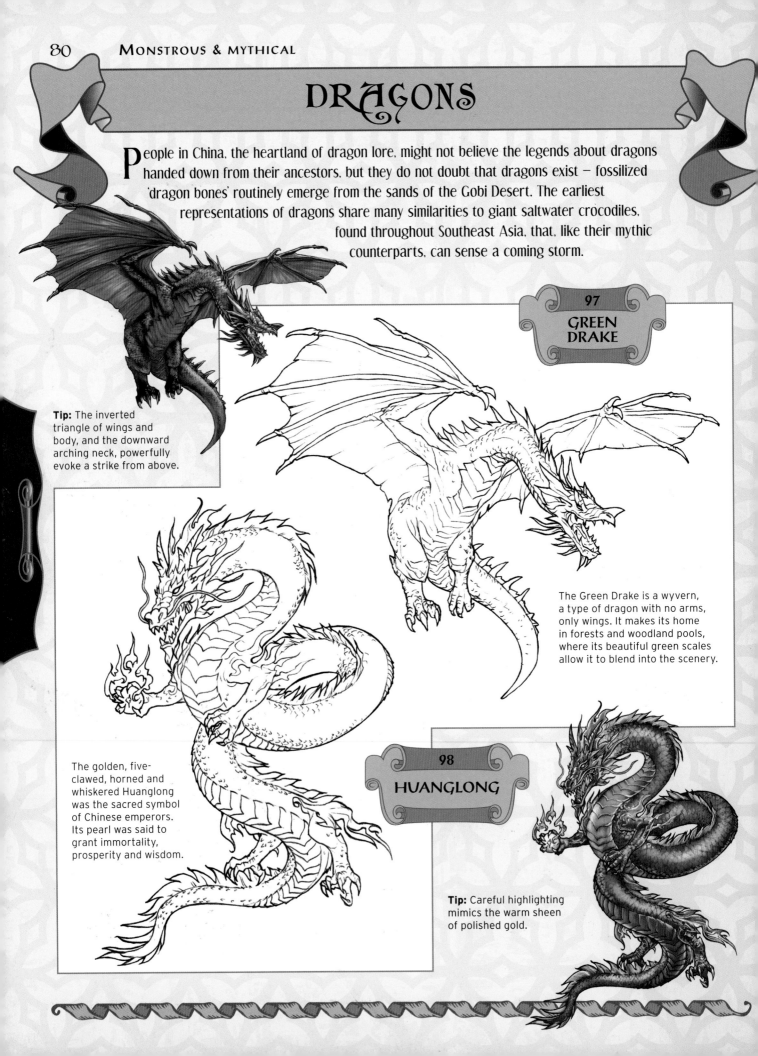

Tip: The inverted triangle of wings and body, and the downward arching neck, powerfully evoke a strike from above.

97
GREEN DRAKE

The Green Drake is a wyvern, a type of dragon with no arms, only wings. It makes its home in forests and woodland pools, where its beautiful green scales allow it to blend into the scenery.

The golden, five-clawed, horned and whiskered Huanglong was the sacred symbol of Chinese emperors. Its pearl was said to grant immortality, prosperity and wisdom.

98
HUANGLONG

Tip: Careful highlighting mimics the warm sheen of polished gold.

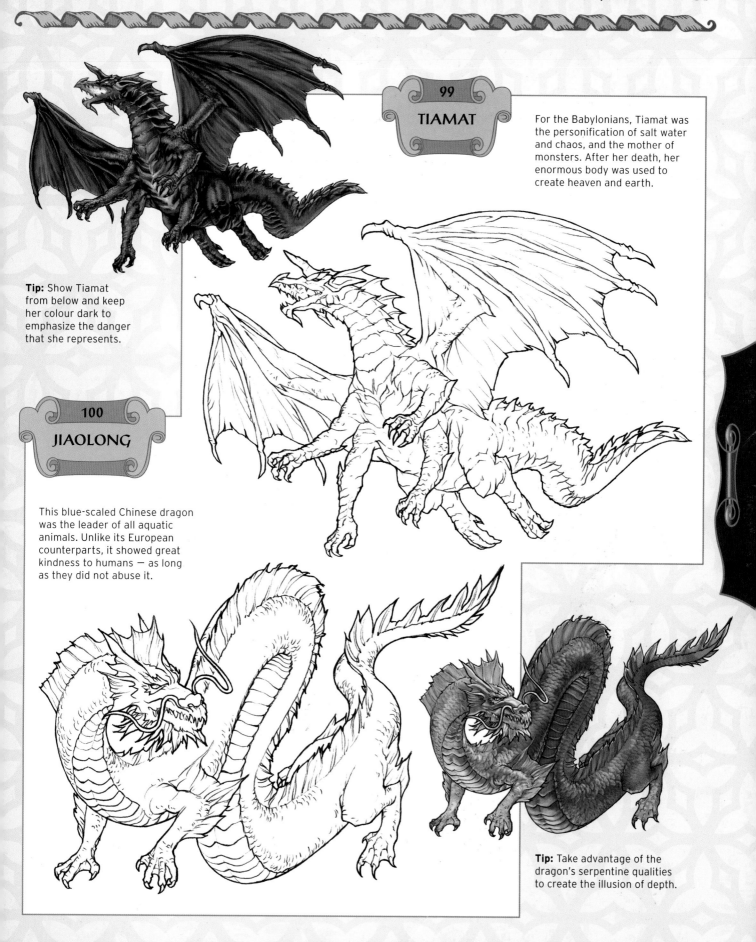

99 TIAMAT

For the Babylonians, Tiamat was the personification of salt water and chaos, and the mother of monsters. After her death, her enormous body was used to create heaven and earth.

Tip: Show Tiamat from below and keep her colour dark to emphasize the danger that she represents.

100 JIAOLONG

This blue-scaled Chinese dragon was the leader of all aquatic animals. Unlike its European counterparts, it showed great kindness to humans — as long as they did not abuse it.

Tip: Take advantage of the dragon's serpentine qualities to create the illusion of depth.

101 IRON DRAGON

What is the good of having hide tougher than a knight's armour, jaws capable of biting a cow in half and blowtorch breath if you cannot commit a little mayhem every now and then? Not content to wait around its treasure cave until some hapless would-be hero delivers himself for lunch, this dragon – as tough and dark as its name – wreaks havoc on the puny humans who presumed to build a castle in its territory.

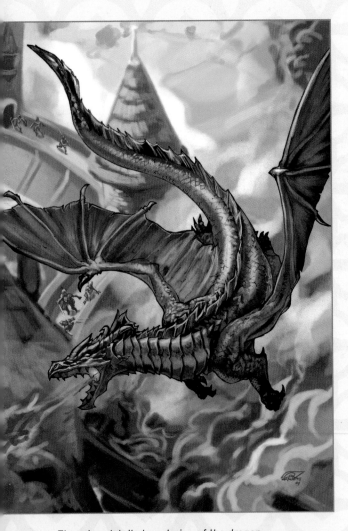

The crisp, detailed rendering of the dragon pulls it from the picture plane, increasing the immediacy of its attack. The lines of the wings and the twist of its body lead the eye to its head and the flames reaching beyond the edge of the picture. In contrast, the castle's human defenders, the walls and towers, and the green fields in the distance are presented in soft focus, as if behind a haze of smoke. This emphasizes their distance from the dragon and the viewer.

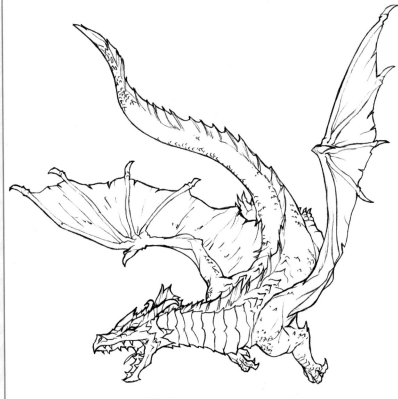

The dragon swoops swiftly downwards in a terrifying attack from above.

Iron Dragon: Key Poses

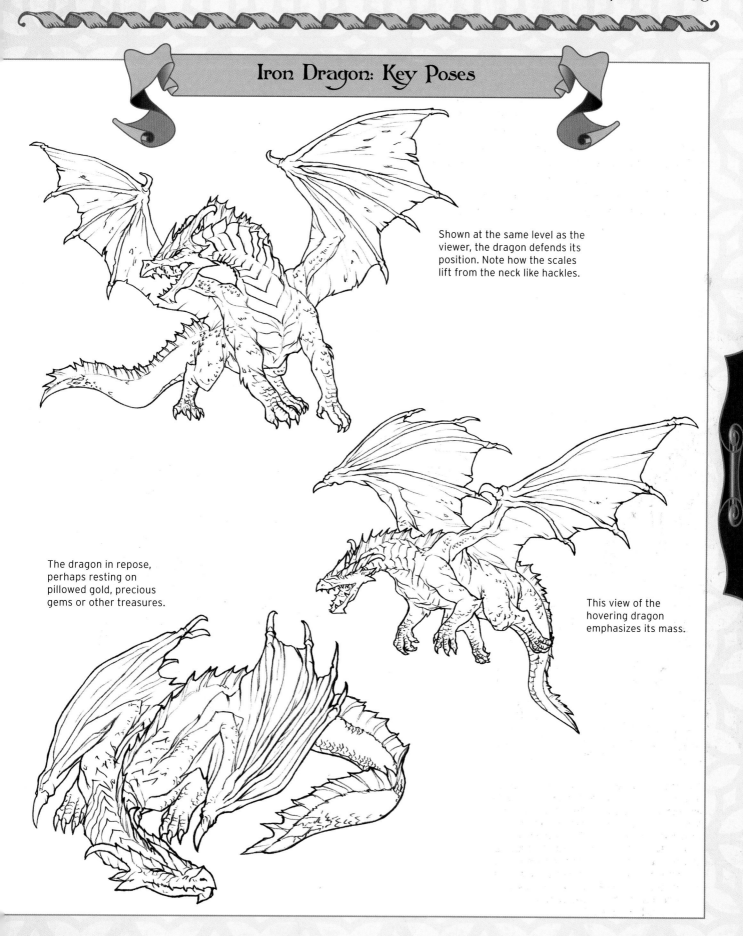

Shown at the same level as the viewer, the dragon defends its position. Note how the scales lift from the neck like hackles.

The dragon in repose, perhaps resting on pillowed gold, precious gems or other treasures.

This view of the hovering dragon emphasizes its mass.

MYTHICAL BIRDS

People have always viewed independent flight as a kind of miracle, so it should come as no surprise that birds would be chosen to symbolize heavenly phenomena such as the sun (Bennu, Garuda and Phoenix) and storms (Garuda and Thunderbird). However, these fantastic creatures may be more than metaphors. For example, the Bennu may have been modelled on a recently extinct species of heron, and the Thunderbird on large condor-like birds that became extinct about ten thousand years ago.

102

BENNU

Tip: The spread, gold-tipped feathers of the wings and trailing tail feathers suggest the rays of the morning sun.

A rare heron said to appear only once every five hundred years, the Bennu was associated with both the Egyptian sun god Ra and the annual rising of the River Nile.

103

GARUDA

Part-man, part-eagle, Garuda serves as the Hindu god Vishnu's mount. This symbol of irresistible force is so large that a grown man could hide between its feathers.

Tip: Clothes and jewellery help to mask what might be awkward transitions between the creature's human and avian elements.

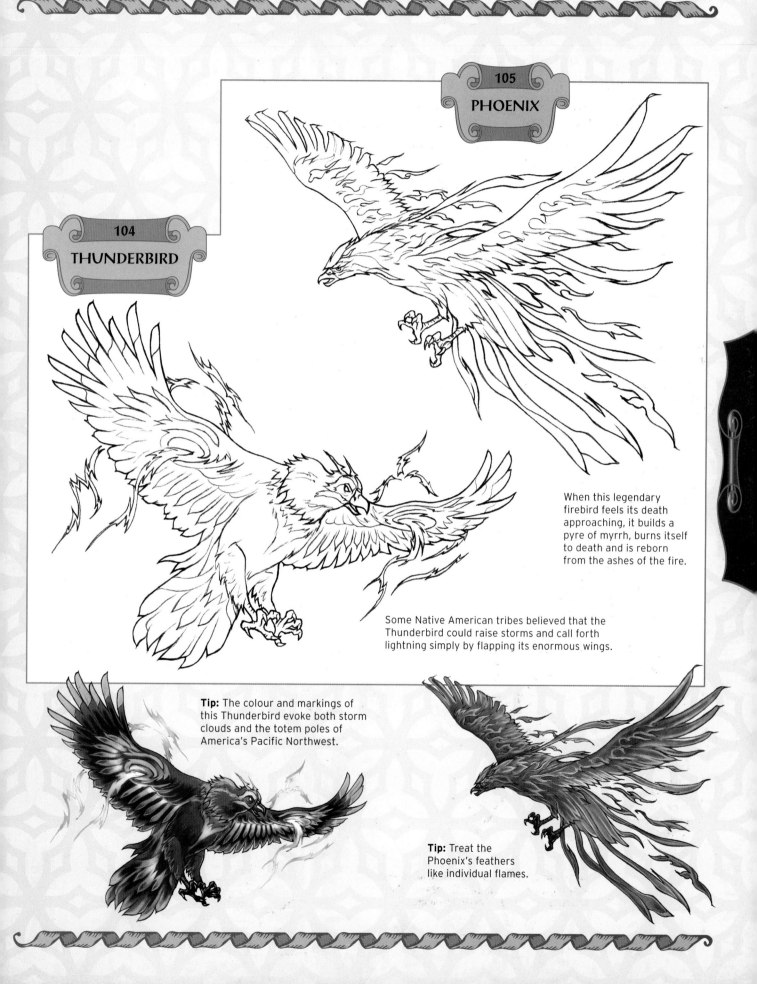

105

PHOENIX

104

THUNDERBIRD

When this legendary firebird feels its death approaching, it builds a pyre of myrrh, burns itself to death and is reborn from the ashes of the fire.

Some Native American tribes believed that the Thunderbird could raise storms and call forth lightning simply by flapping its enormous wings.

Tip: The colour and markings of this Thunderbird evoke both storm clouds and the totem poles of America's Pacific Northwest.

Tip: Treat the Phoenix's feathers like individual flames.

106
FENGHUANG

The Fenghuang was to the empress of China what the dragon was to the emperor – a symbol of strength, virtue and prosperity. Although called the Chinese phoenix, it had nothing to do with fire. Instead, its shape and plumage reflected the most beautiful characteristics of golden pheasants, mandarin ducks, cranes, parrots and peacocks. Ironically, most of these attributes belong to the male of the species, while the Fenghuang is usually considered female.

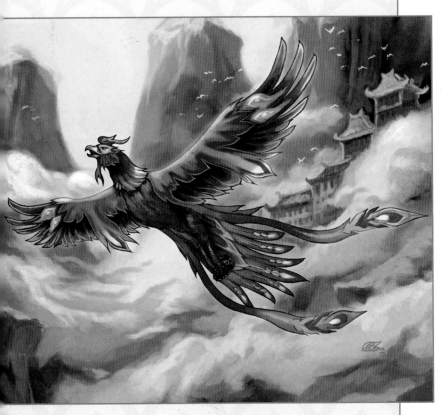

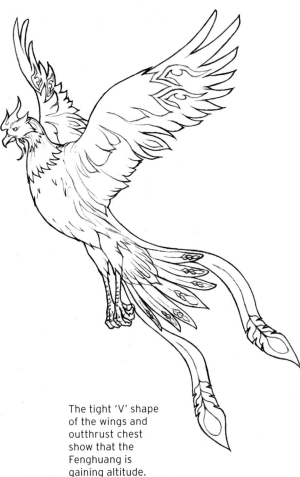

The tight 'V' shape of the wings and outthrust chest show that the Fenghuang is gaining altitude.

The broad horizontal sweep of cottony clouds provides a pleasing contrast to the hard verticals of the peaks in the background. The combination also serves as visual shorthand for high altitudes. Chinese curved roofs crown a distant row of buildings. Their position on the slope echoes the arc of the Fenghuang's wing. The bird's gorgeous plumage, with its tippets and precise patterns, evokes the formality and brilliant embroidery of imperial court robes.

Fenghuang: Key Poses

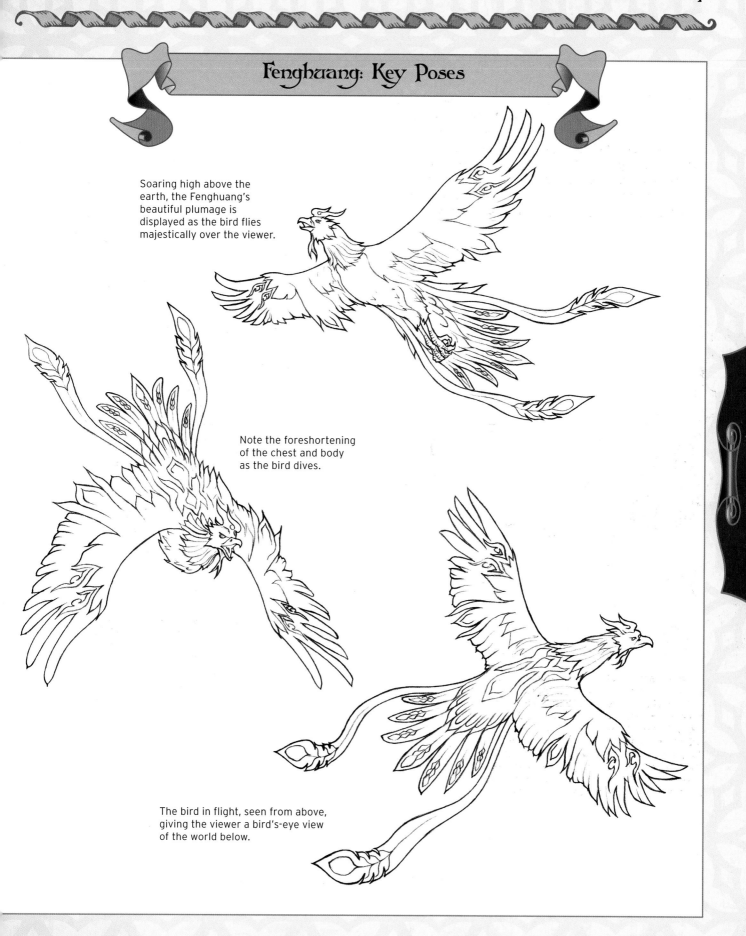

Soaring high above the earth, the Fenghuang's beautiful plumage is displayed as the bird flies majestically over the viewer.

Note the foreshortening of the chest and body as the bird dives.

The bird in flight, seen from above, giving the viewer a bird's-eye view of the world below.

FANTASY BEASTS

Fantasy art challenges the artist to make the impossible appear not only possible, but also plausible. Studying and drawing people and animals can be a big help. It is much easier to draw a centaur, for example, if you know how to draw a man and a horse. Similarly, the ribbed, leathery wings of a bat can serve as models when drawing the wings of a gargoyle.

107

MANTICORE

The man-eating Manticore has a human head on a lion's body, and is equipped with a poisonous stinger in its tail.

Tip: The Centaur's belt creates the junction between human and equine anatomy.

108

CENTAUR

Half-man, half-beast, the Centaur can be a ferocious warrior or a great teacher. Its human nature allows the artist to add clothing and weapons to the mix.

Tip: Keep the flesh tones of the face fairly dark.

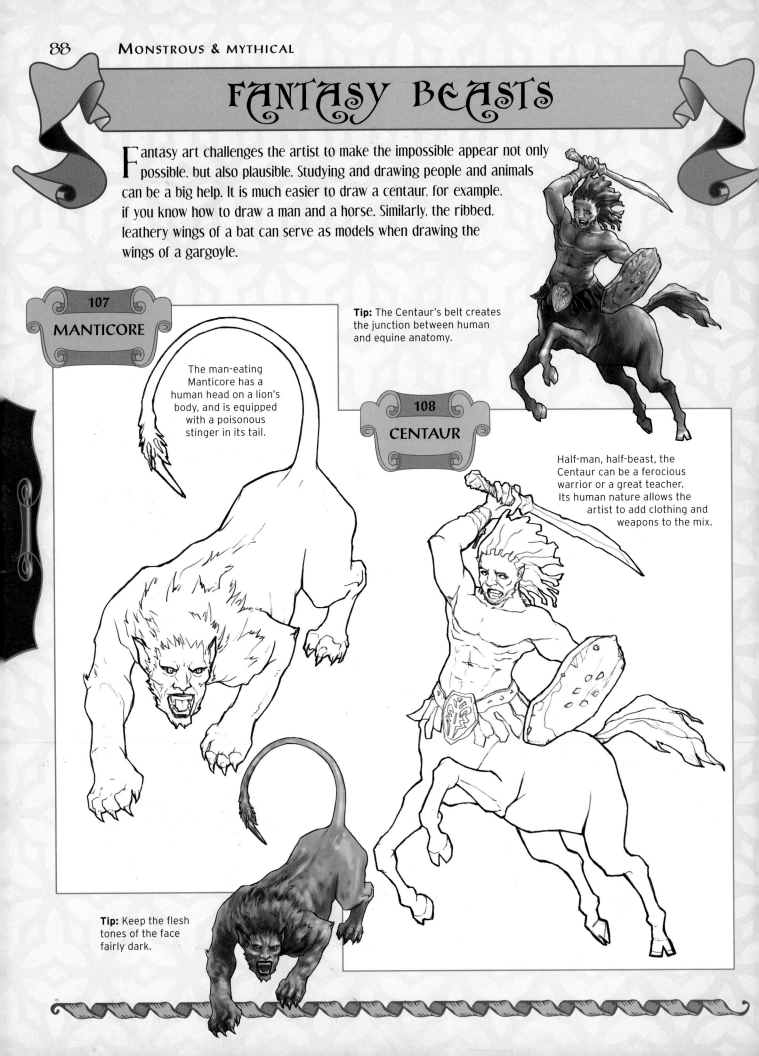

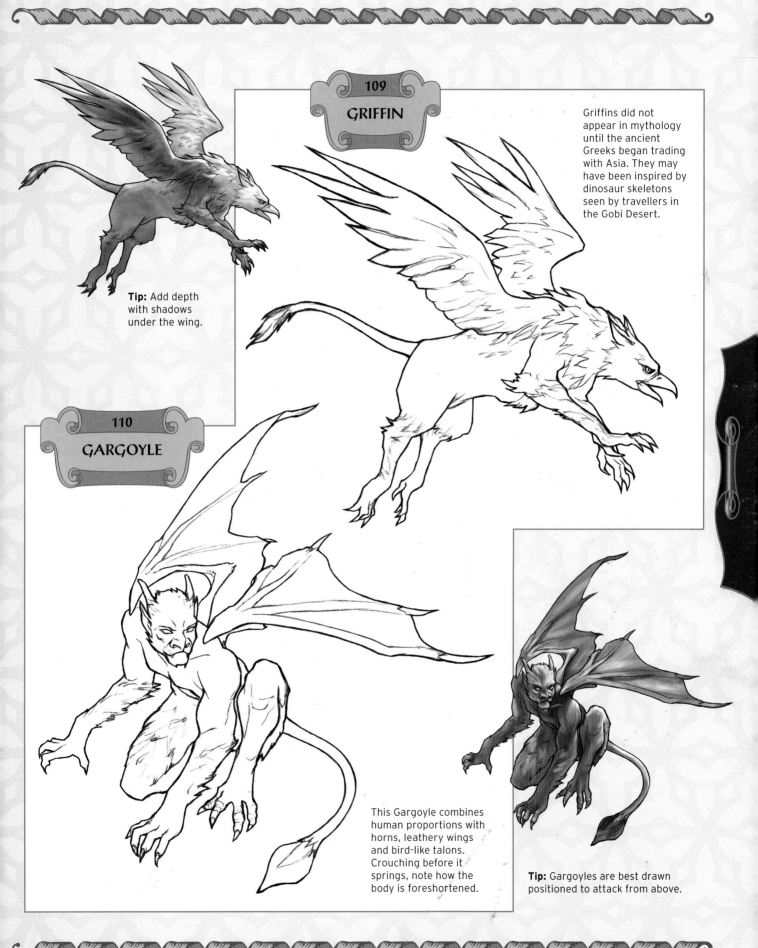

Tip: Add depth with shadows under the wing.

109
GRIFFIN

Griffins did not appear in mythology until the ancient Greeks began trading with Asia. They may have been inspired by dinosaur skeletons seen by travellers in the Gobi Desert.

110
GARGOYLE

This Gargoyle combines human proportions with horns, leathery wings and bird-like talons. Crouching before it springs, note how the body is foreshortened.

Tip: Gargoyles are best drawn positioned to attack from above.

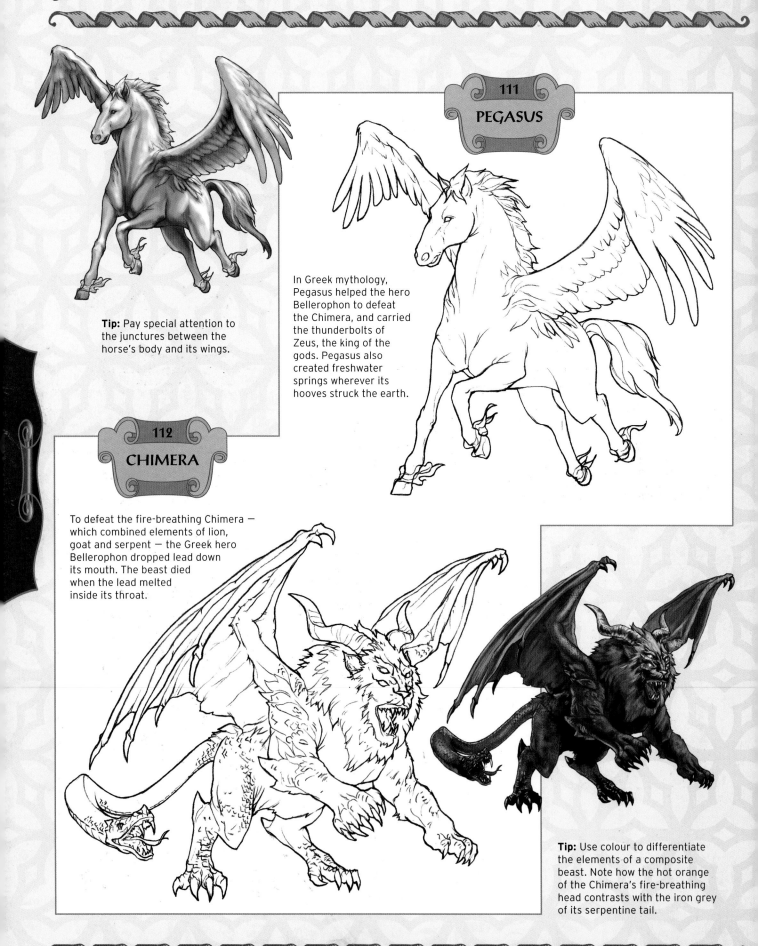

Tip: Pay special attention to the junctures between the horse's body and its wings.

111
PEGASUS

In Greek mythology, Pegasus helped the hero Bellerophon to defeat the Chimera, and carried the thunderbolts of Zeus, the king of the gods. Pegasus also created freshwater springs wherever its hooves struck the earth.

112
CHIMERA

To defeat the fire-breathing Chimera — which combined elements of lion, goat and serpent — the Greek hero Bellerophon dropped lead down its mouth. The beast died when the lead melted inside its throat.

Tip: Use colour to differentiate the elements of a composite beast. Note how the hot orange of the Chimera's fire-breathing head contrasts with the iron grey of its serpentine tail.

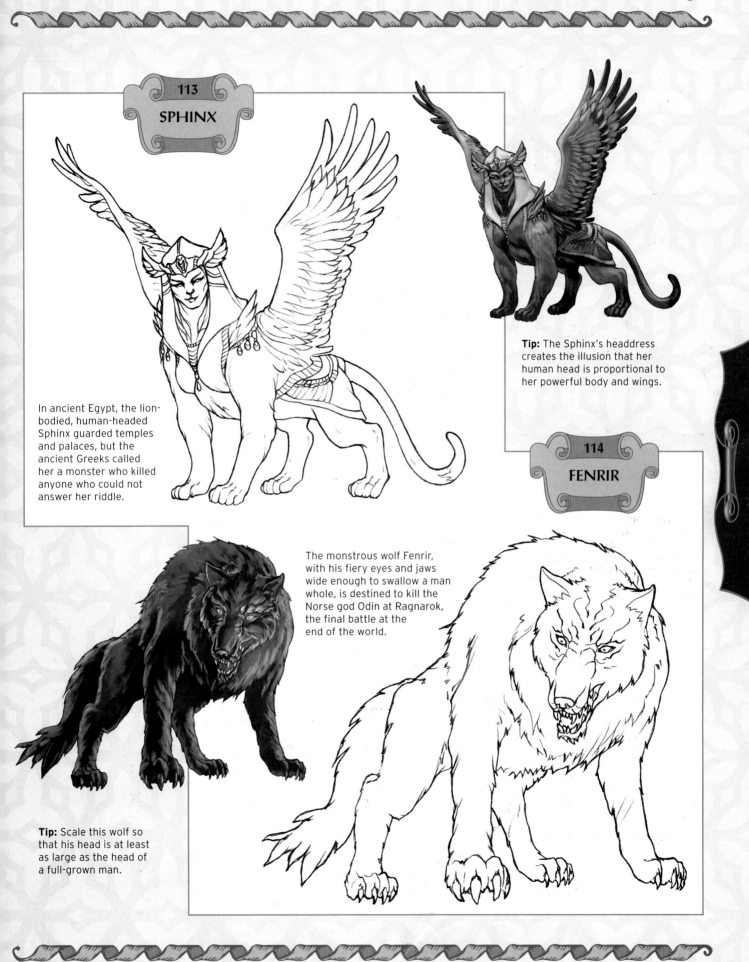

113
SPHINX

In ancient Egypt, the lion-bodied, human-headed Sphinx guarded temples and palaces, but the ancient Greeks called her a monster who killed anyone who could not answer her riddle.

Tip: The Sphinx's headdress creates the illusion that her human head is proportional to her powerful body and wings.

114
FENRIR

The monstrous wolf Fenrir, with his fiery eyes and jaws wide enough to swallow a man whole, is destined to kill the Norse god Odin at Ragnarok, the final battle at the end of the world.

Tip: Scale this wolf so that his head is at least as large as the head of a full-grown man.

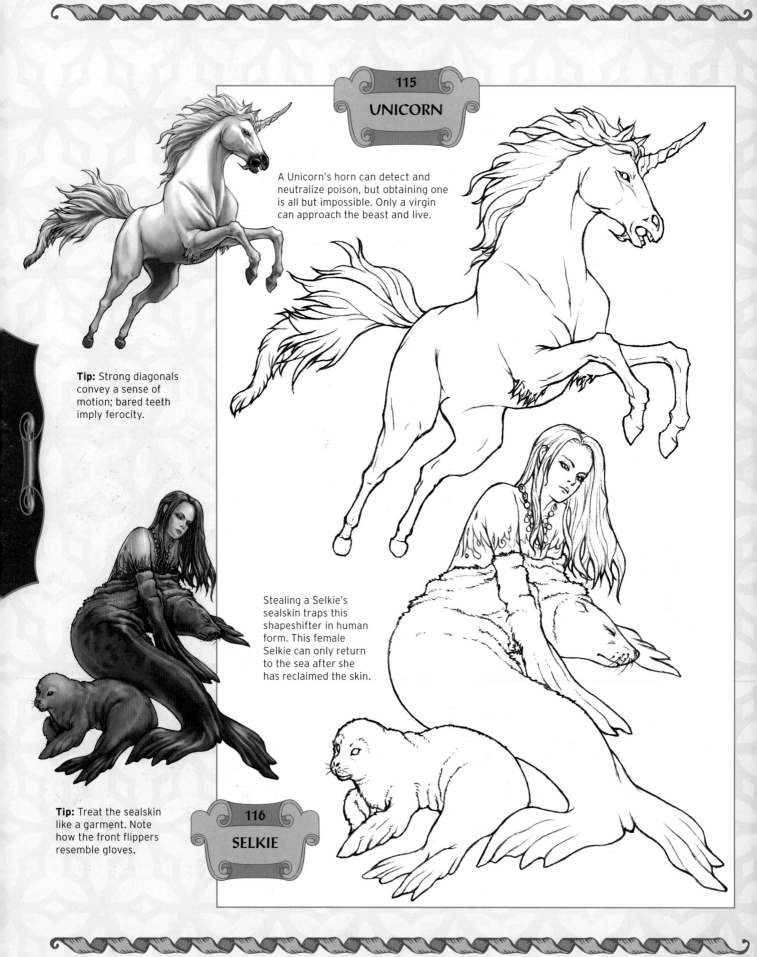

115
UNICORN

A Unicorn's horn can detect and neutralize poison, but obtaining one is all but impossible. Only a virgin can approach the beast and live.

Tip: Strong diagonals convey a sense of motion; bared teeth imply ferocity.

Stealing a Selkie's sealskin traps this shapeshifter in human form. This female Selkie can only return to the sea after she has reclaimed the skin.

Tip: Treat the sealskin like a garment. Note how the front flippers resemble gloves.

116
SELKIE

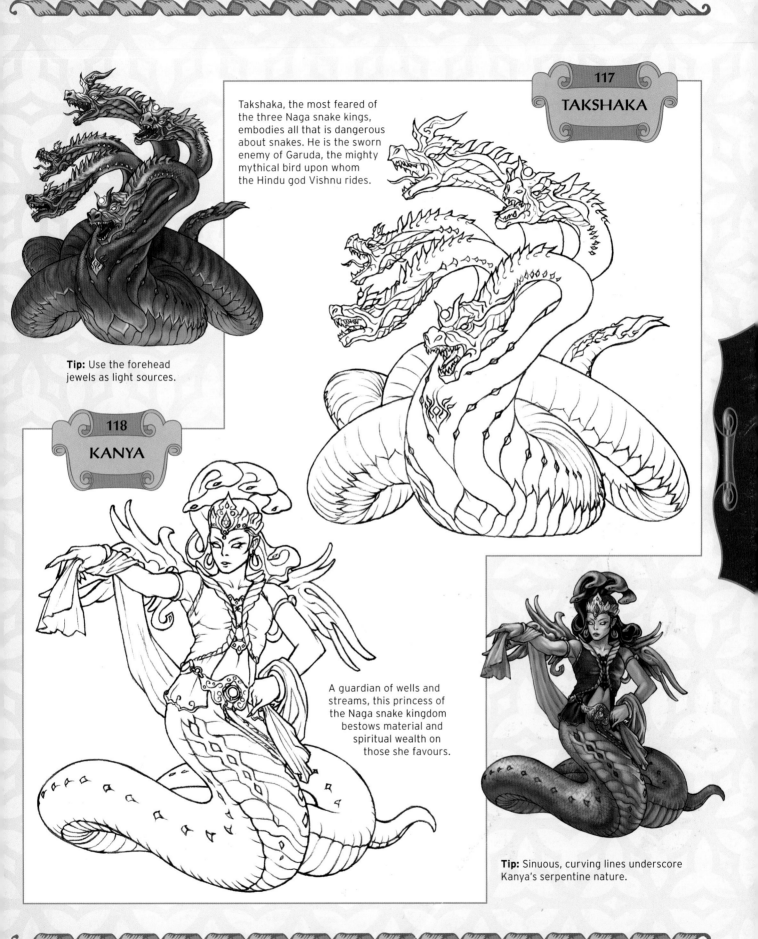

Tip: Use the forehead jewels as light sources.

117
TAKSHAKA

Takshaka, the most feared of the three Naga snake kings, embodies all that is dangerous about snakes. He is the sworn enemy of Garuda, the mighty mythical bird upon whom the Hindu god Vishnu rides.

118
KANYA

A guardian of wells and streams, this princess of the Naga snake kingdom bestows material and spiritual wealth on those she favours.

Tip: Sinuous, curving lines underscore Kanya's serpentine nature.

119

KELPIE

Travelling along the rivers and lochs of Scotland, should you ever meet a handsome, tame but unbridled black horse with water dripping from its mane, *do not touch it!* Chances are that it is a Kelpie, a carnivorous water horse with an adhesive hide. If you pet the Kelpie or, worse yet, try to ride it, you will be unable to tear yourself free when it plunges into the depths of its watery home.

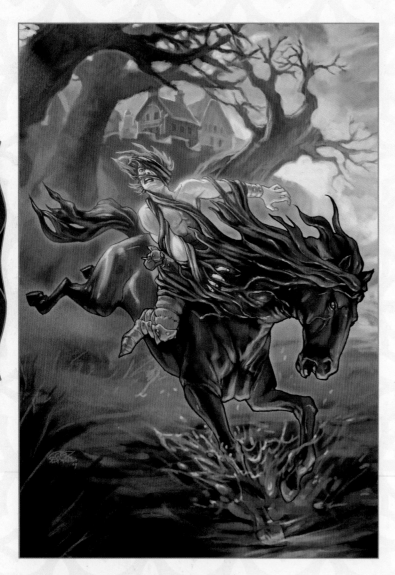

The angularity of the composition underscores the violence of the scene. The diagonal lines of the Kelpie's body and mane slash downwards at an angle perpendicular to the grasping trees. The strong right angle formed by the victim's body and left arm creates the impression of an arrow. If he were not hopelessly entangled, he would fly off the horse's back. The eeriness of the moment is captured in the twilight palette: purplish greys, smoky pinks and dusky highlights.

Emerging from the loch, note the water shearing from the Kelpie's hindquarters.

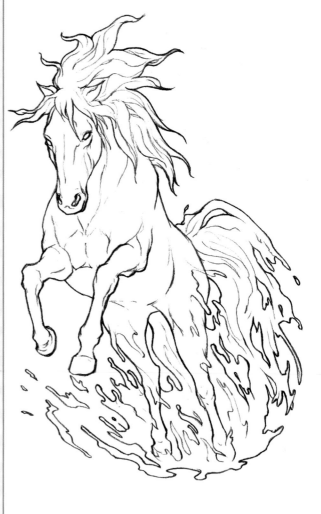

Kelpie: Key Poses

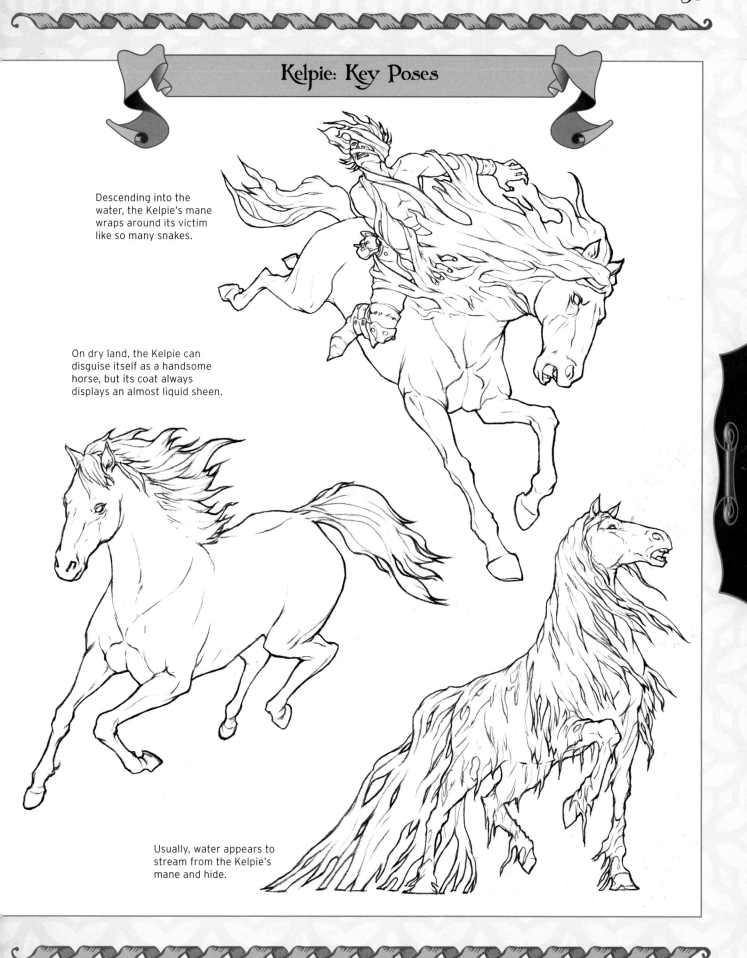

Descending into the water, the Kelpie's mane wraps around its victim like so many snakes.

On dry land, the Kelpie can disguise itself as a handsome horse, but its coat always displays an almost liquid sheen.

Usually, water appears to stream from the Kelpie's mane and hide.

NIGHTMARES

These insidious thieves of rest do not just rob a person's sleep; they also steal away that person's life. Some accomplish this by transforming the sleeper's spirit into a beast of burden that they harry night after night. Some steal a sleeper's breath, sap their strength or simply scare the person to death. More frightening still, some spend their days disguised as humans, passing undetected among us as they seek out their next victim.

Tip: Sketch Nocnitsa's head right-side-up to get the features and proportions correct.

120
THE HAG

Turned into a horse and ridden mercilessly through the night, is it any wonder that the Hag's victims waste away and die?

121
NOCNITSA

Tip: Medical illustrations provide good visual references for skeletal figures.

The Polish nightmare Nocnitsa specializes in terrifying children. Her companion, a steel-clawed Pesanta dog, sits on sleepers' chests and deprives them of breath.

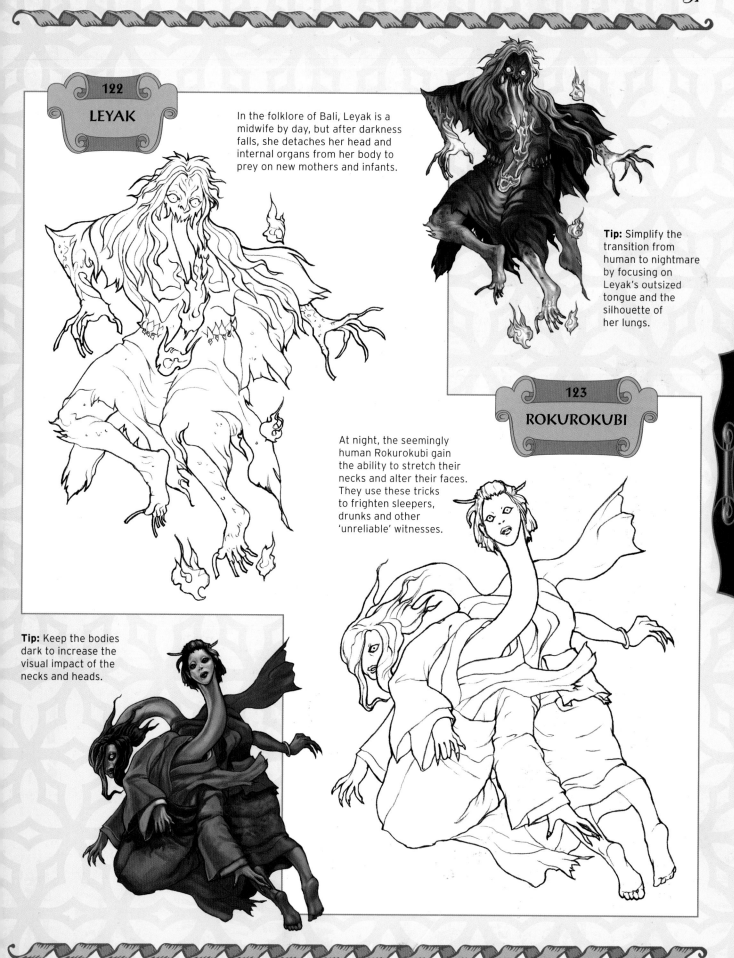

122

LEYAK

In the folklore of Bali, Leyak is a midwife by day, but after darkness falls, she detaches her head and internal organs from her body to prey on new mothers and infants.

Tip: Simplify the transition from human to nightmare by focusing on Leyak's outsized tongue and the silhouette of her lungs.

123

ROKUROKUBI

At night, the seemingly human Rokurokubi gain the ability to stretch their necks and alter their faces. They use these tricks to frighten sleepers, drunks and other 'unreliable' witnesses.

Tip: Keep the bodies dark to increase the visual impact of the necks and heads.

ORCS & OGRES

For centuries, ogres have been the featured villains of folktales, intimidating mere mortals with their size, ferocity and ability to grind their puny opponents' bones to make their bread. Smaller and more organized than their solitary cousins, orcs made their first appearance in the fiction of JRR Tolkien, who saw them as soldiers of evil, vicious and sly. Ironically, they became some of his most popular creations among subsequent writers and gamers.

Tip: Position the assassin above his target.

124
HLLUD-WAR

The veteran of many battles, this captain in the orc army of the Uruk-hai is larger and bulkier than most of his troops.

125
SETTWERDER

The orc assassin Settwerder attacks his target — and anyone else who happens to get in the way.

Tip: Keep track of your light sources, especially when dealing with characters of different sizes.

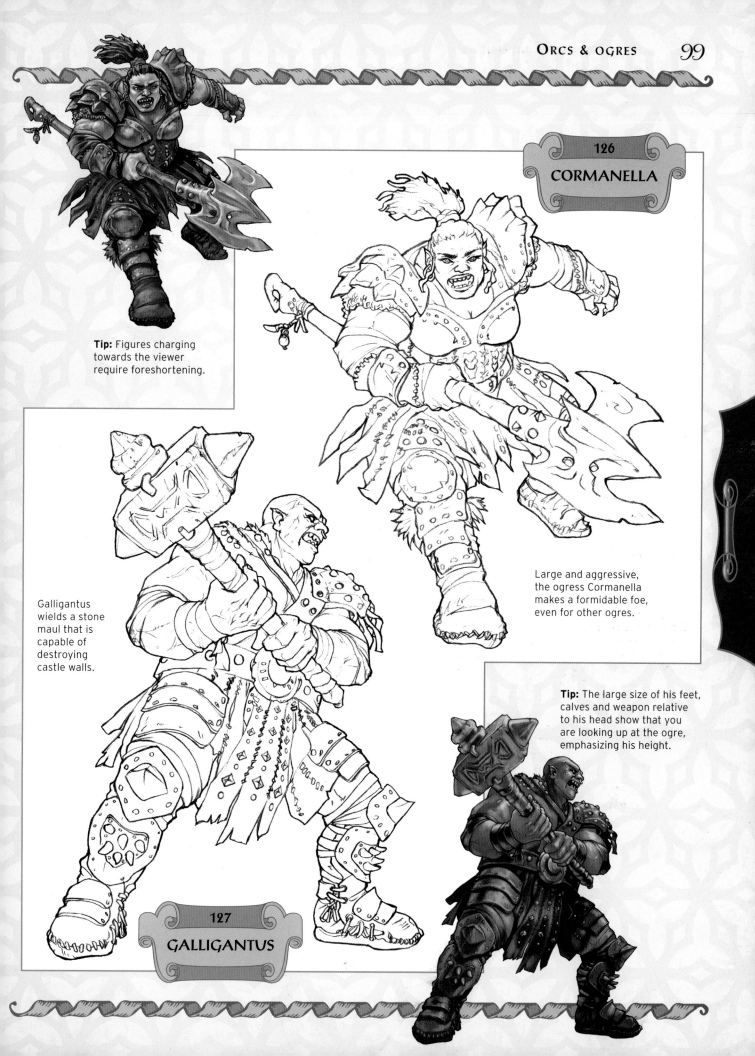

126

CORMANELLA

Tip: Figures charging towards the viewer require foreshortening.

Large and aggressive, the ogress Cormanella makes a formidable foe, even for other ogres.

Galligantus wields a stone maul that is capable of destroying castle walls.

Tip: The large size of his feet, calves and weapon relative to his head show that you are looking up at the ogre, emphasizing his height.

127

GALLIGANTUS

128

HKMUR
THE SCOUT

On a mission into disputed territory, the orc scout Hkmur is surprised by an elf warrior at the edge of a ruined sanctuary. Startled by the elf's yell, Hkmur's battle swine veers to the left, exposing its flank and its rider to the elf's blade. The orc must decide whether to turn the beast and fight, or flee. If the elf is a straggler, Hkmur needs to kill him before he can raise the alarm, but what if there are more elves hiding in the trees?

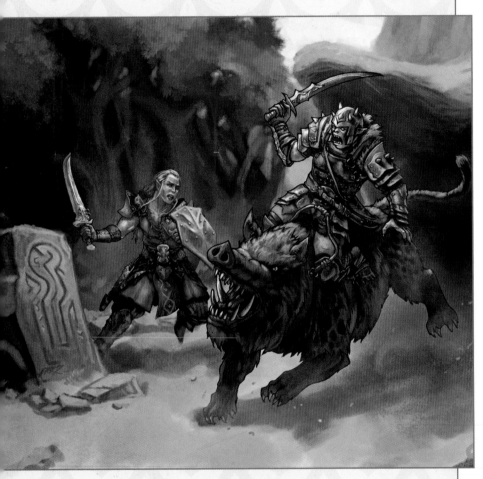

Shielding himself from a frontal attack, Hkmur turns to face a foe behind him.

The composition is divided into two distinct halves. The cool shadows of the forest and intricately carved stone on the left belong to the verdant world of the elves. The orc's sphere is rough stone, dust, and dark armour and pig. The crisp rendering of the orc and his mount draw the eye, making the more impressionistically rendered elf appear to recede into the background. The effect is underscored by the loose oval described by the orc's sword, hunched figure and the swine's forequarters.

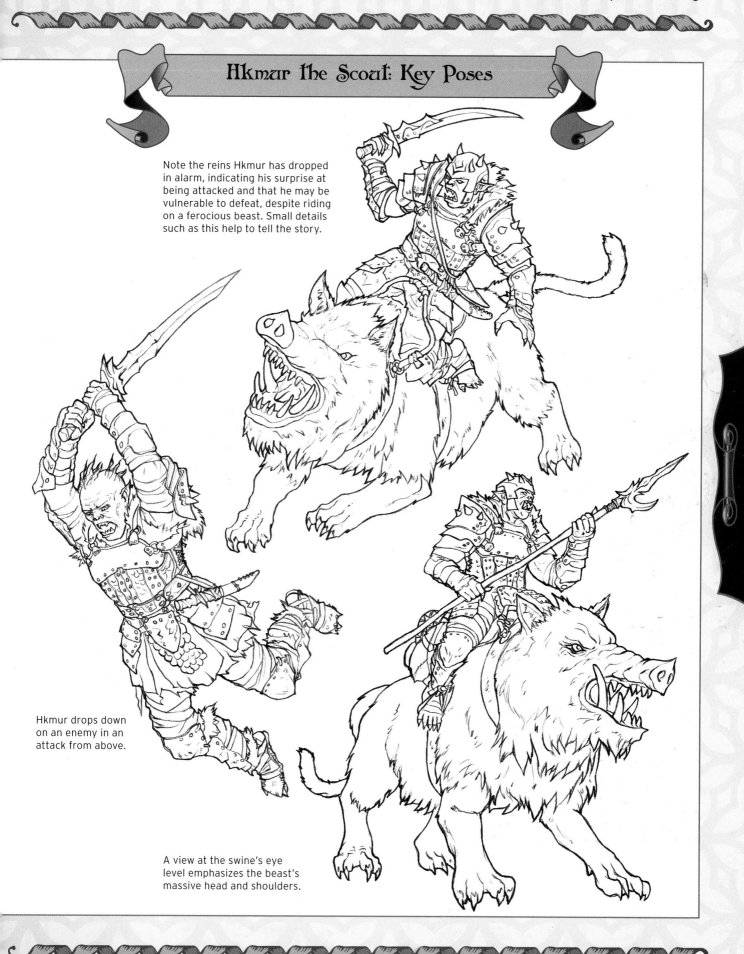

Hkmur the Scout: Key Poses

Note the reins Hkmur has dropped in alarm, indicating his surprise at being attacked and that he may be vulnerable to defeat, despite riding on a ferocious beast. Small details such as this help to tell the story.

Hkmur drops down on an enemy in an attack from above.

A view at the swine's eye level emphasizes the beast's massive head and shoulders.

GHOULS

Demons or the undead – with ghouls, the distinction gets blurred. The first reports of *ghul* and *gouleh* came from travellers in ancient Arabia. These evil genies haunt graveyards and desert wastes, preying on wanderers, robbing graves and eating the dead. They can transform themselves into the image of those they have consumed, and seem to have the power to infect others with their dreadful appetites – or is that just a rumour started by evil sorcerers, who have long sought to animate the dead for their own nefarious purposes?

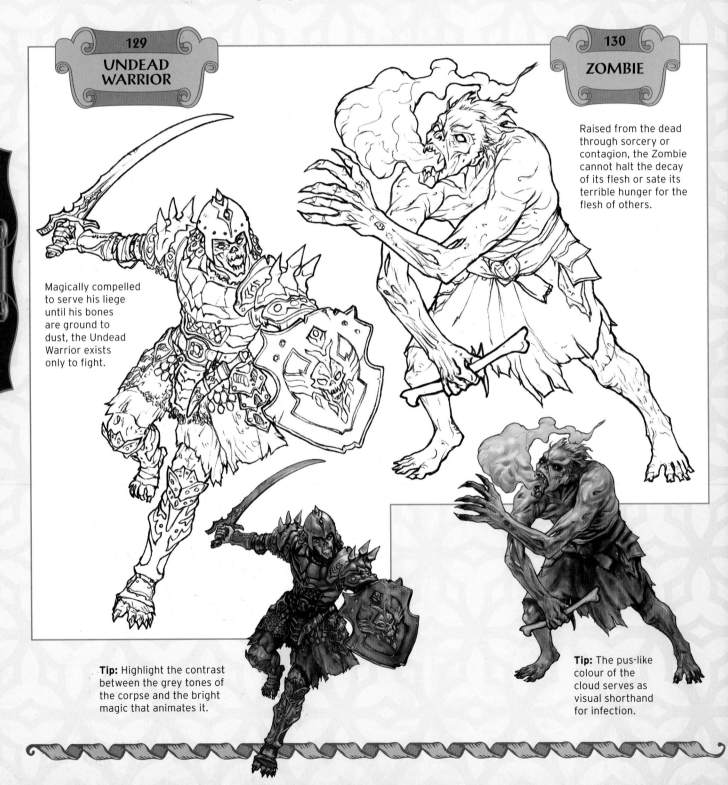

129 UNDEAD WARRIOR

Magically compelled to serve his liege until his bones are ground to dust, the Undead Warrior exists only to fight.

Tip: Highlight the contrast between the grey tones of the corpse and the bright magic that animates it.

130 ZOMBIE

Raised from the dead through sorcery or contagion, the Zombie cannot halt the decay of its flesh or sate its terrible hunger for the flesh of others.

Tip: The pus-like colour of the cloud serves as visual shorthand for infection.

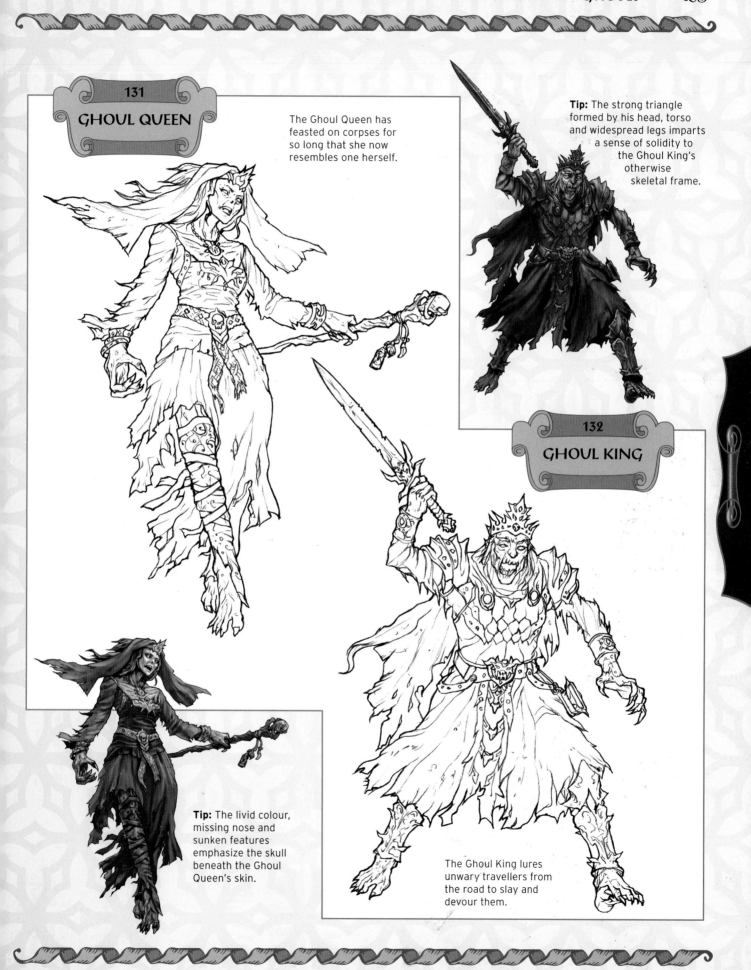

131

GHOUL QUEEN

The Ghoul Queen has feasted on corpses for so long that she now resembles one herself.

Tip: The strong triangle formed by his head, torso and widespread legs imparts a sense of solidity to the Ghoul King's otherwise skeletal frame.

132

GHOUL KING

Tip: The livid colour, missing nose and sunken features emphasize the skull beneath the Ghoul Queen's skin.

The Ghoul King lures unwary travellers from the road to slay and devour them.

YOKAI

Seen through the lens of Japanese folklore, the world is populated by inquisitive, mercurial beings called Yokai. Although some prefer the solitude of forests and other desolate places, most are fascinated by humans. Many heroes of Japanese history supposedly enjoyed their aid, but it is important to remember, especially in summertime when the worlds of Yokai and humans draw near, that these are supernatural creatures whose thoughts, feelings and agendas are very different from ours.

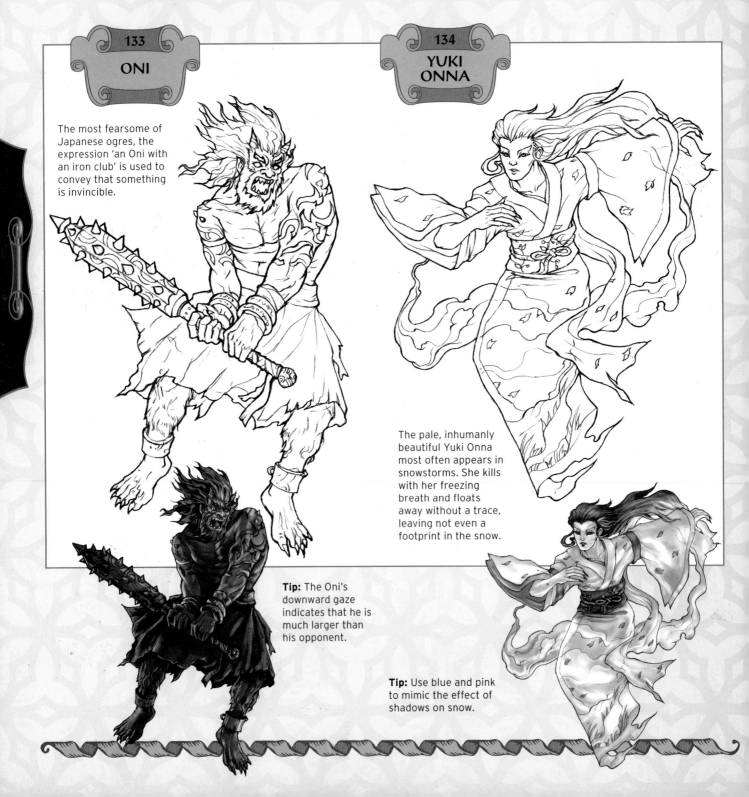

133
ONI

The most fearsome of Japanese ogres, the expression 'an Oni with an iron club' is used to convey that something is invincible.

Tip: The Oni's downward gaze indicates that he is much larger than his opponent.

134
YUKI ONNA

The pale, inhumanly beautiful Yuki Onna most often appears in snowstorms. She kills with her freezing breath and floats away without a trace, leaving not even a footprint in the snow.

Tip: Use blue and pink to mimic the effect of shadows on snow.

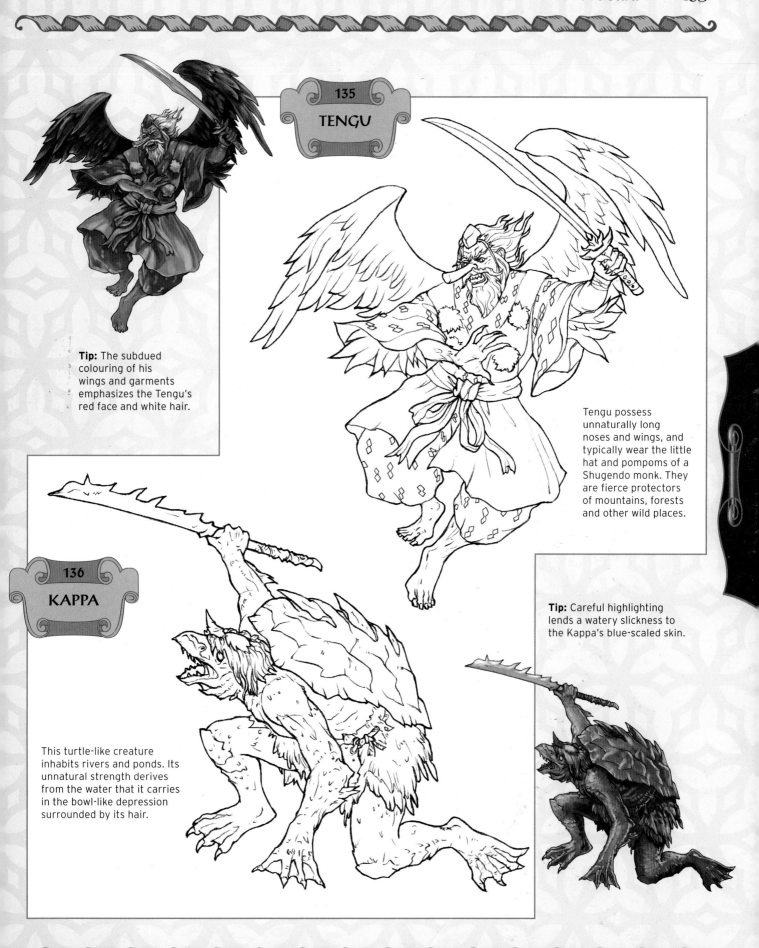

135
TENGU

Tip: The subdued colouring of his wings and garments emphasizes the Tengu's red face and white hair.

Tengu possess unnaturally long noses and wings, and typically wear the little hat and pompoms of a Shugendo monk. They are fierce protectors of mountains, forests and other wild places.

136
KAPPA

This turtle-like creature inhabits rivers and ponds. Its unnatural strength derives from the water that it carries in the bowl-like depression surrounded by its hair.

Tip: Careful highlighting lends a watery slickness to the Kappa's blue-scaled skin.

137
KITSUNE

Kitsune are magical foxes that enjoy human company and often assume our shape – like the Native American shapeshifting shaman Coyote, however, they do not always remember to hide their bushy tails. In fox form, the relative strength of their elemental power is shown by the number of their tails, with nine tails signifying almost god-like power for good or ill.

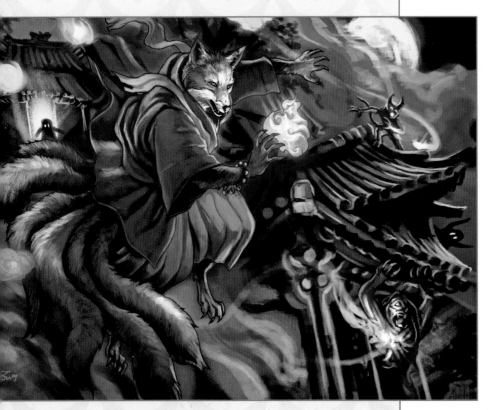

A male Kitsune wearing the robes and prayer beads of a Buddhist monk uses fox fire to battle the evil spirits that are infesting a ruined temple. The six coloured flames (including the one striking the spirit in the lower right) represent the different powers associated with the tails. The fox seems to surround the lower part of the temple. His gestures and the rooflines draw the eye to two of his foes. A third looms in the glowing window behind him.

Poised above the fray, a female Kitsune archer prepares to fire. The shape of her breastplate enhances the draw of her bow.

Kitsune: Key Poses

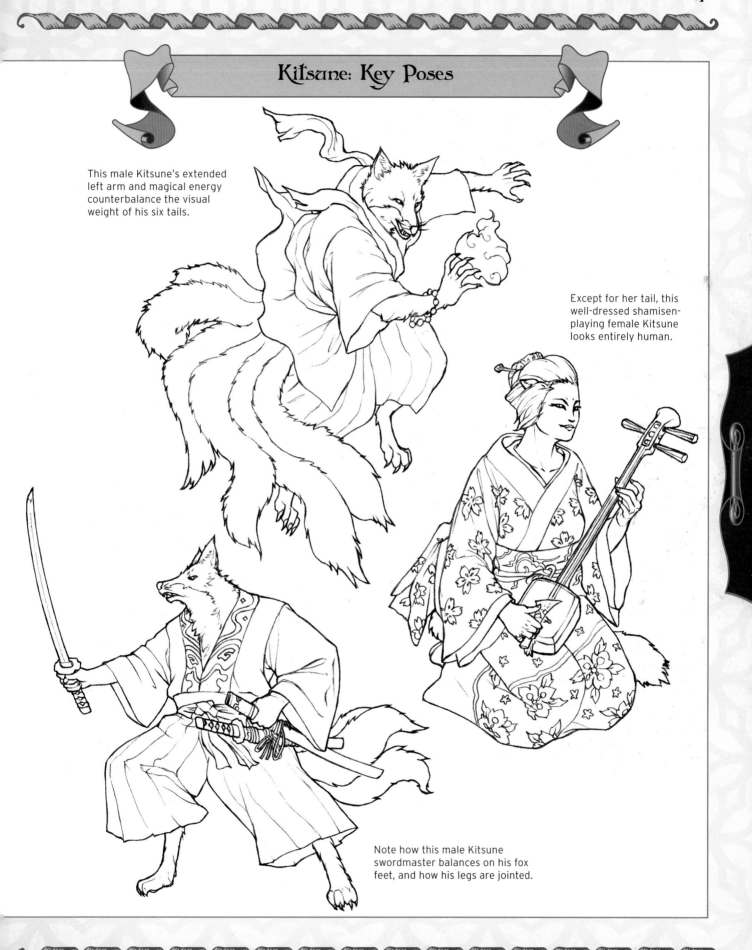

This male Kitsune's extended left arm and magical energy counterbalance the visual weight of his six tails.

Except for her tail, this well-dressed shamisen-playing female Kitsune looks entirely human.

Note how this male Kitsune swordmaster balances on his fox feet, and how his legs are jointed.

GREMLINS & GOBLINS

Not everyone can be a fairy queen or lord of all the elves. The high courts of the fair folk could not exist without their version of ordinary people – innumerable sprites with little magic and faces only a mother of their own species could love. Goblins fill the ranks of fairy armies; gremlins serve as fairy agents in the mortal world – they made quite a name for themselves bedevilling aircraft in World War II, and have recently turned their attention to computers.

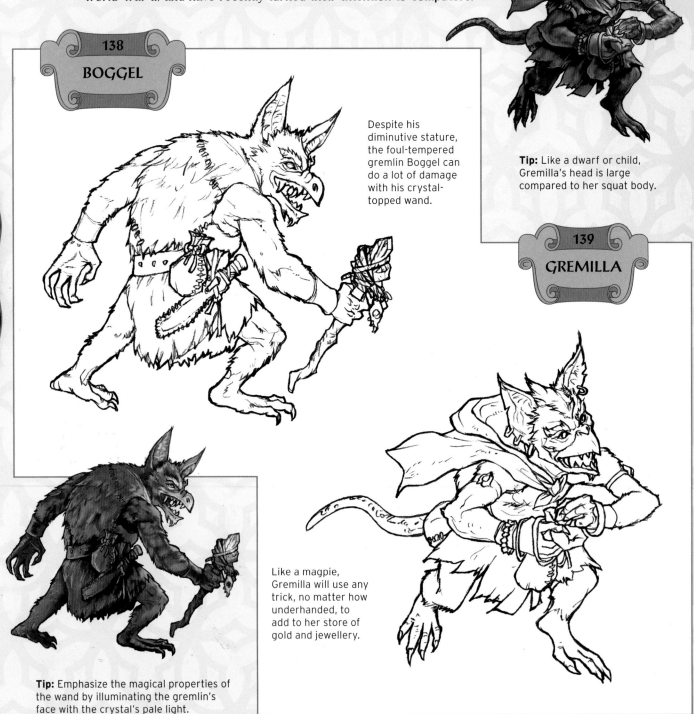

138

BOGGEL

Despite his diminutive stature, the foul-tempered gremlin Boggel can do a lot of damage with his crystal-topped wand.

Tip: Like a dwarf or child, Gremilla's head is large compared to her squat body.

139

GREMILLA

Like a magpie, Gremilla will use any trick, no matter how underhanded, to add to her store of gold and jewellery.

Tip: Emphasize the magical properties of the wand by illuminating the gremlin's face with the crystal's pale light.

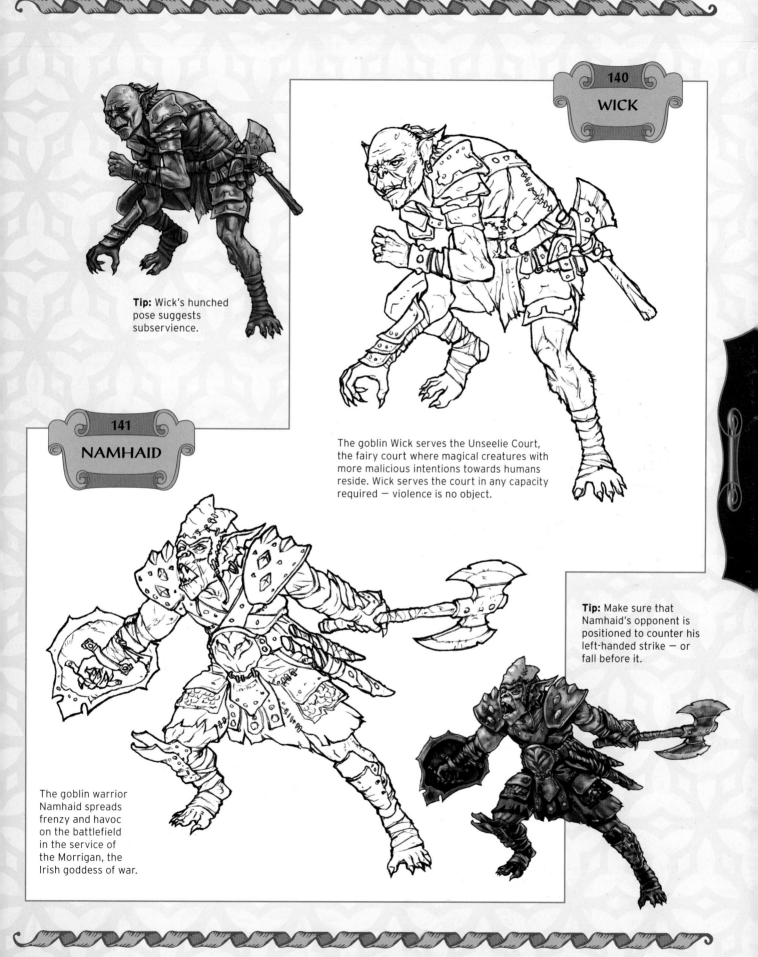

140

WICK

Tip: Wick's hunched pose suggests subservience.

The goblin Wick serves the Unseelie Court, the fairy court where magical creatures with more malicious intentions towards humans reside. Wick serves the court in any capacity required — violence is no object.

141

NAMHAID

Tip: Make sure that Namhaid's opponent is positioned to counter his left-handed strike — or fall before it.

The goblin warrior Namhaid spreads frenzy and havoc on the battlefield in the service of the Morrigan, the Irish goddess of war.

MERFOLK

Water is the source of all life and one of its most efficient destroyers. The merfolk – mermaids, mermen and all their semiaquatic kin – have personified this duality from the very first mermaid story told in ancient Assyria. The fish goddess Atargatis fell in love with a mortal shepherd, but her embrace proved deadly. Horrified and ashamed, she threw herself into the sea, but being a goddess, she could not die. Instead, she was transformed into a creature that was both beautiful woman and fish.

Tip: Melusine's mermaid form traditionally includes both fairy and serpentine elements.

142

TRITON WARRIOR

One of the sea god Poseidon's many grandsons, this fierce warrior of the ocean is protected by the natural armour of seashells and sharp barnacles growing from his shoulders and arms.

The mermaid sorceress Melusine loved and married a mortal knight. She made him rich and bore his children, but abandoned him when he broke his promise and spied on her in the bath.

143

MELUSINE

Tip: Merfolk are usually seen through water, which affects their colouring. Remember to adjust accordingly when they emerge into sun- or moonlight.

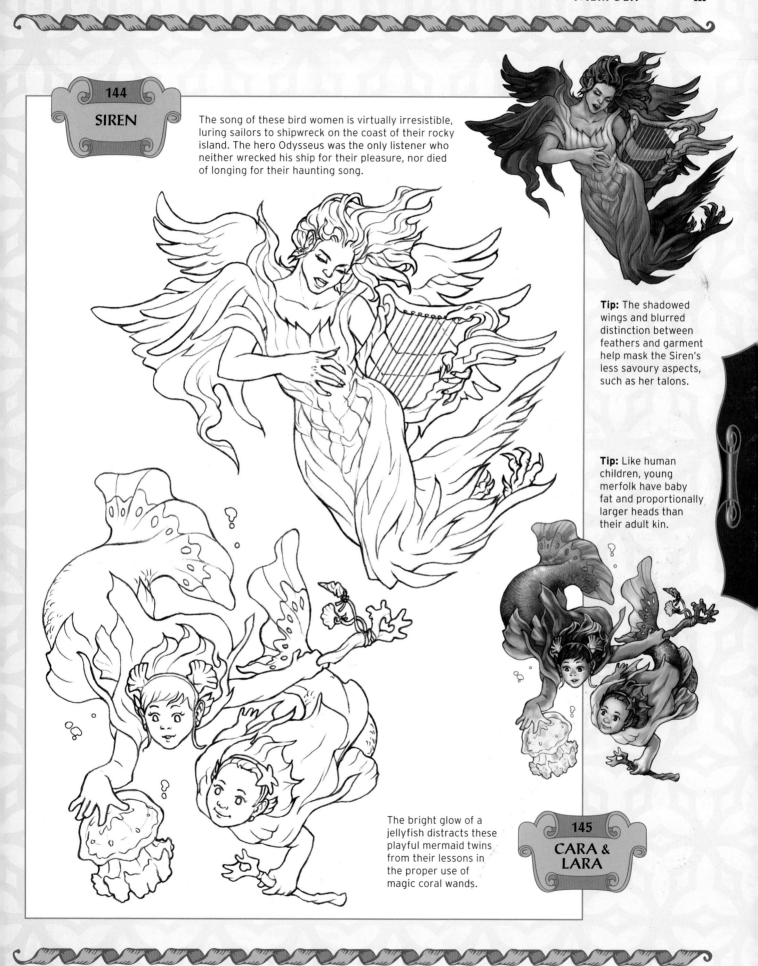

144

SIREN

The song of these bird women is virtually irresistible, luring sailors to shipwreck on the coast of their rocky island. The hero Odysseus was the only listener who neither wrecked his ship for their pleasure, nor died of longing for their haunting song.

Tip: The shadowed wings and blurred distinction between feathers and garment help mask the Siren's less savoury aspects, such as her talons.

Tip: Like human children, young merfolk have baby fat and proportionally larger heads than their adult kin.

The bright glow of a jellyfish distracts these playful mermaid twins from their lessons in the proper use of magic coral wands.

145

CARA & LARA

146

ZOSTERA

The light radiating from the sea-glass blade of her glaive helps guide the mermaid Zostera as she explores the ocean floor near the remains of a once lofty tower. Her flowing hair and the supple arc of her tail, which is positioned higher than her head, give the viewer a sense of weightlessness and display her underwater grace. A nearby shark presents no more danger than the birds soaring over the waves far above her.

Her hair billowing like the sea grass for which she was named, Zostera eyes the sea creatures swimming in her wake. Her slightly foreshortened form tilts away from the viewer.

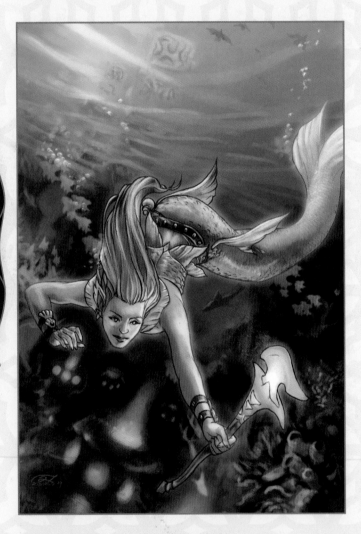

As with night scenes, illumination is critical to underwater paintings. Here, the artist deploys several muted light sources: sunlight beaming through the waves onto Zostera's tail and hair; the bioluminescence of deep-sea creatures; and the mermaid's glaive, a combination weapon and magic wand. The thinnest possible glaze of blue mimics the effect of looking through water without entirely obscuring her creamy complexion and strawberry blond hair.

Zostera: Key Poses

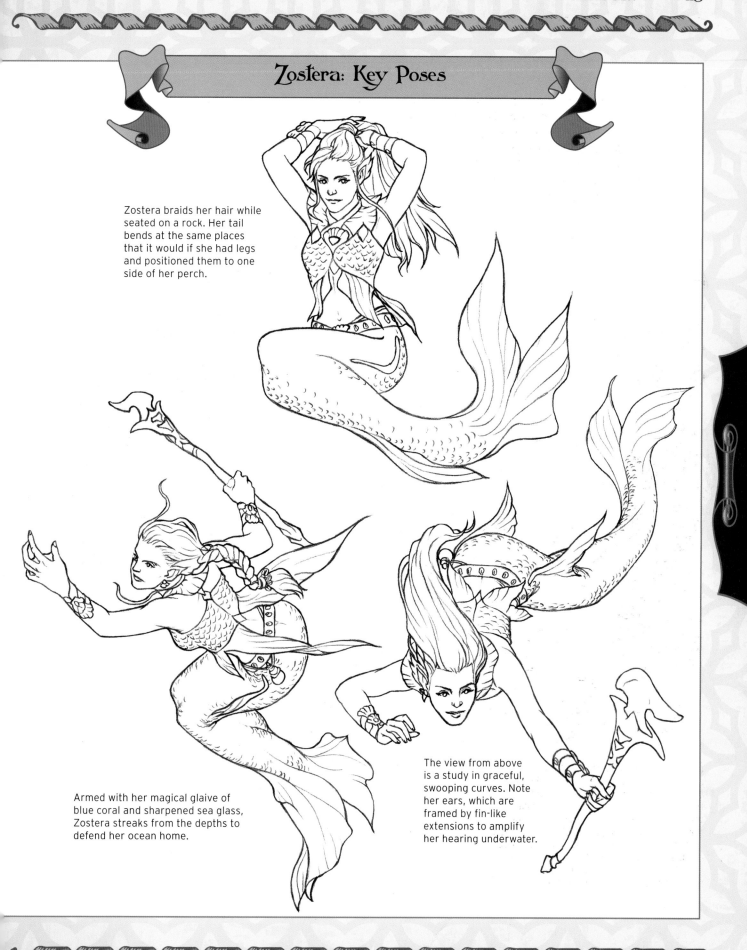

Zostera braids her hair while seated on a rock. Her tail bends at the same places that it would if she had legs and positioned them to one side of her perch.

Armed with her magical glaive of blue coral and sharpened sea glass, Zostera streaks from the depths to defend her ocean home.

The view from above is a study in graceful, swooping curves. Note her ears, which are framed by fin-like extensions to amplify her hearing underwater.

IMPS & FAMILIARS

Imps and familiars perform the same functions for witches, wizards and sorcerers as goblins and gremlins do for the aristocrats of the fairy world. Little demons, known as imps, can be conjured to serve their masters by cleaning, spying and milking the neighbours' cows dry. The opposable thumbs of their true forms aid them in precision work, but make it hard to disguise their infernal origins. Those that manifest themselves in more ordinary shapes are called familiars. Cats, bats and toads get most of the press, but any pet will do.

147
BLACK ASH

148
WATCHER

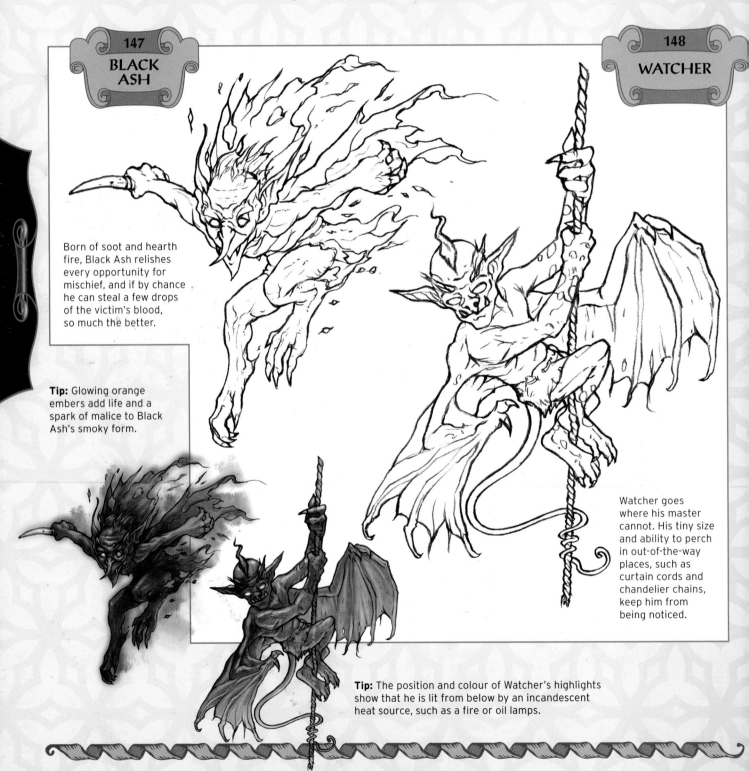

Born of soot and hearth fire, Black Ash relishes every opportunity for mischief, and if by chance he can steal a few drops of the victim's blood, so much the better.

Tip: Glowing orange embers add life and a spark of malice to Black Ash's smoky form.

Watcher goes where his master cannot. His tiny size and ability to perch in out-of-the-way places, such as curtain cords and chandelier chains, keep him from being noticed.

Tip: The position and colour of Watcher's highlights show that he is lit from below by an incandescent heat source, such as a fire or oil lamps.

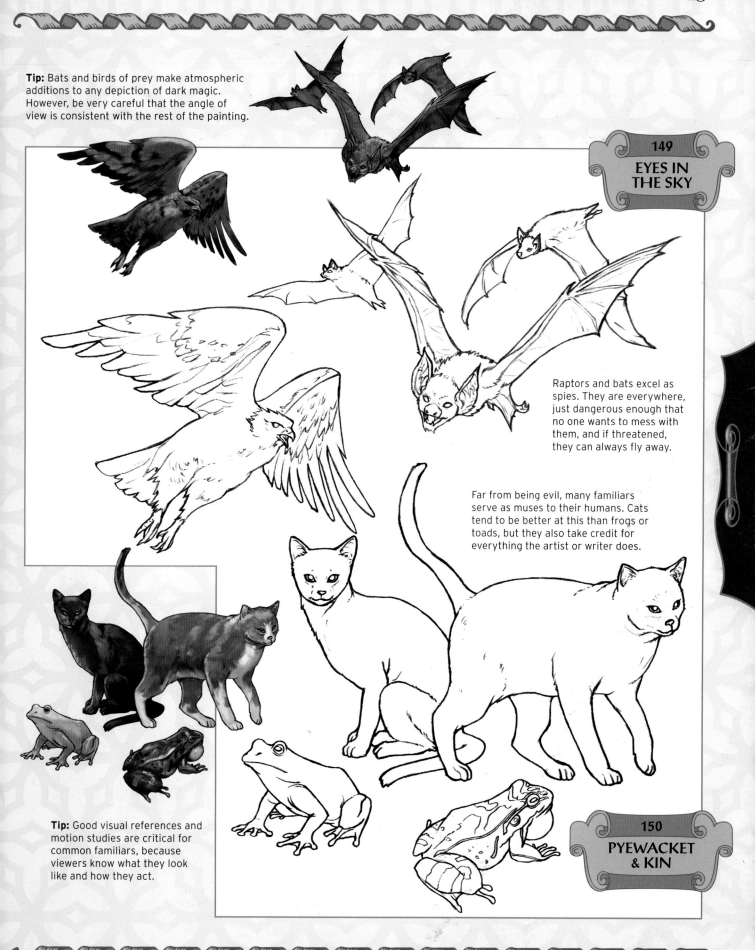

Tip: Bats and birds of prey make atmospheric additions to any depiction of dark magic. However, be very careful that the angle of view is consistent with the rest of the painting.

149
EYES IN THE SKY

Raptors and bats excel as spies. They are everywhere, just dangerous enough that no one wants to mess with them, and if threatened, they can always fly away.

Far from being evil, many familiars serve as muses to their humans. Cats tend to be better at this than frogs or toads, but they also take credit for everything the artist or writer does.

Tip: Good visual references and motion studies are critical for common familiars, because viewers know what they look like and how they act.

150
PYEWACKET & KIN

Techniques &

Now that you have seen the many possibilities of fantasy art, it is time to start creating your own. The following pages describe the media most often used by today's fantasy artists, as well as the process used to develop characters and tips on adapting the templates to produce new ones. It would take a much bigger book than this to explain all the different traditional and digital techniques that can be used to create fantasy art, but this chapter explains

Under Siege (page 135)

Backgrounds

some of the basic processes to get you started on the right track. Experiment and explore the options until you find what works for you. The chapter also contains templates for ten fantasy landscapes, setting the scene for an infinite number of visual stories. This is the stuff that dreams are made of — compelling imaginary worlds that invite the viewer to suspend disbelief in the extraordinary. Take it, shape it, reinvent it and make a few legends of your own.

Sorcerer's Den (page 134)

TOOLS & MEDIA

Today's artist can create in a variety of media – traditional, digital, and combinations of the two. The figures in this book were first sketched in pencil, then scanned and coloured digitally. The process could just as easily be reversed, with a digitally drawn image used as the basis of a traditional painting. The choice is yours, but do not restrict your creativity. Try as many media and methods as you can. Some will feel more natural than others, but it is always worth exploring the potential of a new medium or technique before discounting it.

◀ Pencils

Graphite pencils are graded from very faint hard (H) pencils to soft black (B) ones; HB pencils are medium grade. Experiment to find which is best for you. Some artists use a craft knife or scalpel to sculpt their pencil tips to the exact shape they require; pencil sharpeners give a more regular shape to the tip. Mechanical pencils with replaceable leads produce a consistent line weight and do not need sharpening. A non-repro blue pencil, commonly used by animators, is an erasable coloured pencil. It is less prone to smudging and smearing than graphite, and when scanned, the colour can be desaturated and resaturated in whatever hue required.

Sketchbook

Inspiration can strike at any time, and you want to nail your idea to the page there and then. Sketchbooks are available in many shapes and sizes. Hard covers offer the best protection. Ringbound spines open flat for drawing and copying, and provide a handy place to clip a pen.

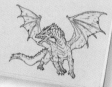

▶ Eraser

Erasers are not just for correcting mistakes. They can also be used to refine pencil lines and to add highlights in shaded areas. Plastic erasers lift the most graphite, but can damage the paper if used with too much force. Kneaded erasers can be moulded into different shapes. Clean erasers regularly; dirty areas can be cut away with a craft knife or rubbed against a clean sheet of paper.

◀ Copying materials

Tracing paper and transfer (or graphite) paper can be used to transfer the templates from this book to your art paper or board. Acetate is useful for adjusting the size of the templates using a grid system.

▼ Paper and board

Experiment with the different kinds of drawing paper and art board, and find out if you prefer a smoother or rougher texture. Paper should be heavy and tough enough to handle repeated drawing and erasing. Work as large as you can. This will give you the chance to add more detail, and it is also easier to hide little anomalies when the work is reduced in size for printing. If you intend to scan your work, you may have to limit yourself to A4 paper, because larger format scanners are expensive. No matter which paper or board you choose to draw on, if you intend to colour it, make sure that it will support your chosen colouring media.

▶ Inks

Indian ink offers a good, solid black for inking line drawings (page 123), but it can also be diluted with water to offer a brownish-grey halftone. Coloured inks can be mixed to achieve subtle colours, or laid one over the other in transparent glazes. Many artists combine inks with other media, such as paints or pencils, to create a variety of effects. The advantage of inks is that their colours are strong and consistent.

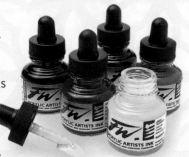

▶ Coloured pencils

Coloured pencils are clean, easy to use and provide a relatively inexpensive way to colour your work. They can also be combined with other media, such as acrylics. Some artists prefer the waxy feel of coloured pencils for sketching as well as colouring.

◀ Markers

Felt marker pens come in a variety of bright, mess-free, consistent colours. The ink may be opaque or transparent, and pen tips come in various sizes and shapes. Markers must be used on bleedproof marker paper. Permanent black markers are a popular choice for inking (page 123).

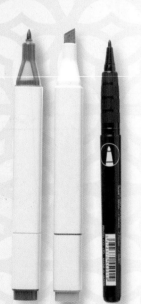

◀ Pastels

Pastels create different effects, depending on the binder used to hold the colour pigment. This can range from dry and chalky to oily, and includes water-soluble pastels or pencils for detailed work. Soft pastels need a textured surface to hold the pigment, and should be sprayed with fixative to prevent smudging.

◀ Watercolours

Watercolour can be a difficult medium to control, but the results are unique and spectacular, with bright, vivid colours and wonderful texture. This medium can be employed in many different ways, making it very flexible. Watercolour does not mix well with other media, although coloured ink gives very similar results and can be used in mixed media work.

▼ Brushes

There is an enormous variety of brushes to choose from. Begin with budget brushes while you practise and find out which widths and lengths you prefer, then invest in quality brushes, which last longer and give better results.

▼ Acrylics

Many professional fantasy artists use acrylic paints because of their flexibility and relatively low cost compared to oil paints. Acrylics provide bright, easily mixed colours with low odour and easy clean-up. They dry very quickly, which can be positive or negative, depending on your working method. Chemical retarders are available to prolong drying time, and gels can be mixed with acrylics to change their appearance.

▼ Gouache

These bright, permanent, opaque watercolours are probably the most popular paints among illustrators. They can be diluted with water for transparent applications or applied in opaque overlays.

▶ Oils

Oil paints remain the first choice for many artists because of the range of effects they can produce, from almost transparent glazes to dense, creamy colours and three-dimensional brushstrokes. Oil paints take longer to dry than other media, allowing the artist more time to push the colours around and mix them on the canvas.

WORKING DIGITALLY

Computers have transformed the commercial art world. Just a decade ago, art created using a computer was unusual; now it is commonplace and fast becoming the standard. Many young artists find the digital environment more familiar and comfortable than traditional media. Even work created using traditional media becomes digital before publication, because almost all printing processes are now digital. However, it is important to recognize that a computer is merely a tool — skill and imagination are also required.

◀ Scanner

Whether you wish to scan a sketch as a starting point for a digital painting or to digitize a handpainted artwork for printing, a scanner is essential. Most scanners have very high optical resolutions that are more than adequate for scanning linework. Getting decent colour scans is another matter, and if you have handpainted your images, you may be better off getting them scanned professionally, particularly if they are going to press. Scanners come in two sizes: A4 and A3. Ideally, you should get the larger model, because this will let you scan large drawings in one piece, but they are very expensive. An A4 model can be purchased cheaply, and you can scan larger drawings in sections and piece them together digitally if necessary.

▲ Computer

Most modern computers are powerful enough to run a painting application, but you will need a quality graphics card and as much RAM as you can afford. Graphics applications, such as Photoshop, will use all the memory you have and still want more. Macs are popular with artists and designers, while PCs are renowned for their animation capabilities. Whether you decide on a desktop or laptop will be dictated by your personal working habits. Laptops take up less space and are portable, but good desktops are more powerful and have greater storage capacity. When it comes to monitors, size and quality are critical. Make sure that the monitor is properly calibrated so that colours are displayed as accurately as possible. A larger monitor can be attached to a laptop if required. Nearly all computers come with CD/DVD burners as standard, which are indispensable for making back-ups, although a second external hard drive is also advisable for this purpose.

◀ Graphics tablet

A graphics tablet is a more natural way for a digital artist to work than using a mouse. A stylus is used to draw on the tablet in the same way that you use a pencil to draw on paper. Depending on the hardware, the tablet can read pressure, angle, rotation and other parameters from the stylus, and feed the information to the art software. Tablets are available in a variety of sizes and sensitivities. Hardware is also available to integrate tablet technology with a flat panel display, which allows the user to draw directly onto the screen.

▶ Printer

Good-quality inkjet photo printers can be purchased cheaply. The big trap with inkjets is the cost of replacement ink and quality paper. A printer that has separate cartridges for each colour will be more economical. Laser printers are faster than inkjets and the cost of consumables is lower per print, but the initial outlay is higher. If you intend to sell prints of your work, you may find professional reproduction more economical.

Digital paint programs

Digital paint programs can mimic numerous kinds of traditional media, create unique digital effects and combine both in the same painting. At first glance, the painting of Parvati (page 68) appears very traditional, but a closer look reveals a combination of techniques that would be almost impossible to achieve in a single traditional medium.

▶ Parvati's face displays the clear colours and crisp detail characteristic of acrylics.

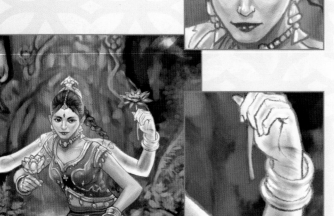

▲ Digital effects are shown to great advantage in the intense, fluorescent glow of her second set of arms.

▲ Loose brushwork and soft washes of pigment, similar to watercolour, characterize the flowers and water at her feet.

CHOOSING THE RIGHT SOFTWARE

The program you choose will depend on personal preference and the style of art you are producing. You can often download free trial versions from the manufacturer's website, so you can try several and decide which you prefer before buying. There is also lots of alternative software, such as Shareware and Open Source, that is cheaper than the major commercial packages and will still do the job.

Adobe® Photoshop
www.adobe.com
Photoshop is the longest-established and best-known digital art software. A simple yet powerful set of drawing and painting tools is complemented by a versatile, comprehensive suite of image adjustment tools, making this the first choice for many professional artists. Photoshop has the additional feature of Image Ready, which is a highly effective package for producing simple animations and preparing artwork for use on the internet.

Paint Shop Pro
www.corel.com
With many similarities to Photoshop, Paint Shop Pro also provides a suite of powerful image adjustment tools but at a fraction of the price. Drawing and painting tools are limited, however, and it is available for PC only.

Corel® Painter
www.corel.com
Painter excels at emulating traditional media, and the sophisticated painting engine gives you almost limitless possibilities when creating your own brushes and effects. There is even a palette on which you can mix colours. Painter is very popular with digital artists who come from a traditional paint-on-paper background, but is suitable for all levels of expertise.

ArtRage
www.ambientdesign.com
ArtRage's simple, clean interface hides some very clever painting tools. The toolset is small when compared to some other art software, but the focus here is simply on painting, and the results are excellent, with some very pleasing natural media effects. It provides a competitively priced introduction to digital painting.

Autodesk® SketchBook Pro
www.autodesk.com
An economically priced application, providing responsive drawing and painting tools and an elegant interface that keeps the focus firmly on the artwork. This software is particularly suited to sketching and line drawing.

CREATING CHARACTERS

The templates in this book are designed to save you the time of sketching your characters from scratch, so you can simply copy them exactly using a variety of techniques – tracing, using a grid, photocopying or scanning, for example. Once you have gained some confidence, you can also try adapting the templates. This can be as simple as changing a warrior's weapon to that of an assassin, or as complex as drawing a completely new character of your own using a template as the model for an action pose.

Tracing the templates

Place tracing paper over the image that you wish copy, secure it with masking tape (use paperclips if you are worried about damaging the original) and draw the main elements of the subject onto the tracing paper using an HB pencil. You can then scan the tracing into a computer or transfer it onto a traditional painting surface using transfer paper. An easy way of resizing an image is to photocopy it at the required size, and then transfer it to the painting surface with transfer paper.

1 Secure the tracing or photocopy face up onto the painting surface, and place a sheet of transfer paper between them. If you cannot find ready-coated transfer paper, make your own by rubbing an HB graphite stick all over one side of a piece of photocopier paper to coat it with powder. Use a sharp 4H pencil to draw over the main lines of the traced image.

2 Check the image on the painting surface as you are working, with the tracing sheet still secured in place (it is difficult to realign an image after you have removed it). Retrace any faint lines if necessary and erase any stray marks.

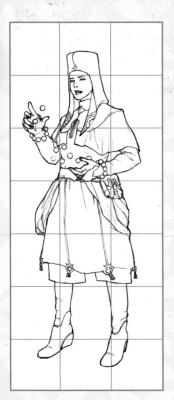

Using a grid

Using a grid is the traditional technique for enlarging or reducing an image. It can also be used to create same-size copies. Draw a grid of 2.5cm (1in) squares on a sheet of acetate. Secure the acetate grid over the template with masking tape. On your painting surface, use an HB pencil to draw a faint grid with the same number of squares. To enlarge the image, use bigger squares; to reduce it, use smaller ones. Copy the information in each square, one square at a time.

▲ As long as the pencilled grid lines are very faint, the paint will cover them. You can erase any lines outside the picture area after the painting is complete.

REGISTRATION MARKS

You may wish to enlarge a template by scanning it at the required size, and then print it out for tracing onto a traditional painting surface. Most home printers only print on standard-size papers, so larger images may need to be pieced for tracing. Some programs and printers create 'tiled' prints to facilitate this process. With tiled printing, the image is printed onto multiple sheets of paper that you can then piece together. Depending on the program or printer, there should be an area of overlap at the edges of each sheet, plus registration and crop marks to aid alignment. If you cannot do tiled printouts, you can add registration and crop marks yourself to make the job easier.

Crop marks indicate edges of image

Overlay registration marks to aid alignment

Scanning the templates

You can scan the templates directly from the book, or scan tracings or photocopies of them if you prefer — for example, you may wish to trace a template and make some adaptations to it by hand first. If there is artwork visible from the other side of the paper ('show through'), you can reduce this by placing black card over the back of the paper.

Always scan at the highest optical resolution that your scanner permits, and never below 300 dpi. There is a choice of three scanning modes: line (bitmap), grayscale or colour. Line or grayscale mode is best for scanning line art. Colour mode may be useful if you do your sketches with coloured pencils rather than graphite. If you want to scan hand-coloured images, it is usually better to get them scanned professionally, particularly if you intend to use them for print. Unless you have a properly calibrated, colour-matched system, you will find that what you see printed does not look like what you spent so long creating.

1 Choose line mode for scanning black-and-white, inked images (see box); use a resolution of not less than 600 dpi for this mode. Line mode ignores any lines that are less than about 50 per cent black, so any light pencil lines will disappear.

2 Choose grayscale mode for scanning pencil drawings, such as the templates in this book, because it will capture the full tonal range of the pencil and retain the subtle detailing in the strokes.

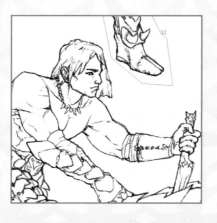

3 Clean up the scans if necessary; for example, if you have scanned directly from the book, you will need to delete unwanted elements, such as nearby characters and captions. Start by cropping out as much of the unwanted areas as possible, then use the various selection and eraser tools available in your particular program to delete any remaining areas until you have a clean line drawing on a white background.

INKING

The linework in a traditional comic book or graphic novel is usually drawn in pencil and then inked with black ink. This provides consistently black lines that add depth to the drawing and help it to stand out on the page when printed. Indian ink is traditionally used, and can be applied with a pen or brush. Brushes and dip pens require practice, so try inking a photocopy of your drawing before attempting the real thing.

Inking can also be done digitally, ideally by drawing over the lines using a stylus and graphics tablet rather than a mouse, which is harder to draw with. Again, digital inking takes practice, but you do have the luxury of an Undo command. Make sure that you draw the ink lines on a separate layer (page 140), so that you can return to the original scan if necessary.

Whether you choose to ink your drawings or not will depend on personal preference and the style of art you wish to produce. The templates in this book have dark, hand-drawn pencil outlines, with some paler sketched lines for detail and texture; none has been inked.

4 Adjust the quality of the linework if desired. For example, you can make the lines appear crisper by increasing the contrast of the scan, or vice versa; you can do this using either Levels or Curves in Photoshop, for example. Alternatively, you may wish to ink the line art (see box).

Original scan

Contrast increased

Adapting the templates

What makes this book uniquely suited to the needs of fantasy artists is the wide range of figures and poses collected in a single space. You do not have to copy the templates exactly, but can adapt them to suit your needs. This could involve making a small change, such as swapping a sword for a dagger, or the creation of a completely new character using the templates as reference for different action poses.

Many of the characters in this book can be adapted with a simple costume change. For example, the outlines of Sharkam's armour (page 18) are very similar to those of a Roman soldier. With a few substitutions — a different helmet, a gladius belted to his waist — he could become a Roman centurion. Since this is fantasy, remember that you do not need to limit the changes to clothes and equipment. Wings, limbs and textures can be added, altered and substituted between human and nonhuman characters.

What about if you want to create your own character from scratch? There is a wealth of visual reference material available — images in books and on the internet, historic paintings and sculptures, photographs and comics. You can also use the templates. Regardless of whether you want to learn how to foreshorten a bent leg or realistically depict movement on a two-dimensional plane, you will find a good model in this book.

Combining templates

Try combining elements of different templates to create a new character. In this example, only minor modifications to the elements were required in order to fit the pieces together.

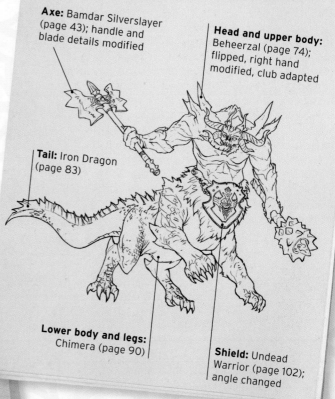

Axe: Bamdar Silverslayer (page 43); handle and blade details modified

Head and upper body: Beheerzal (page 74); flipped, right hand modified, club adapted

Tail: Iron Dragon (page 83)

Lower body and legs: Chimera (page 90)

Shield: Undead Warrior (page 102); angle changed

Human or creature?

When combining templates to create a new character, remember that this is the world of fantasy, so you can select elements from both human and nonhuman creatures.

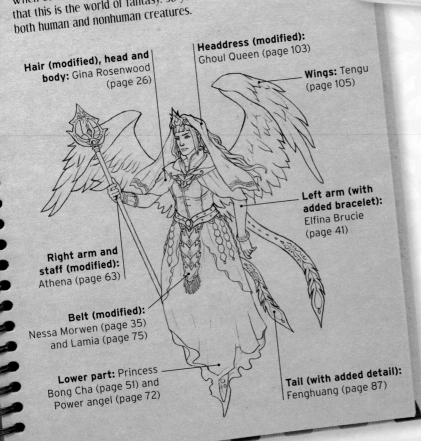

Hair (modified), head and body: Gina Rosenwood (page 26)

Headdress (modified): Ghoul Queen (page 103)

Wings: Tengu (page 105)

Left arm (with added bracelet): Elfina Brucie (page 41)

Right arm and staff (modified): Athena (page 63)

Belt (modified): Nessa Morwen (page 35) and Lamia (page 75)

Lower part: Princess Bong Cha (page 51) and Power angel (page 72)

Tail (with added detail): Fenghuang (page 87)

USING A LIGHTBOX

By piecing together traces or scans, or digitally manipulating the templates, you can create as many new figures as you like. If you work traditionally rather than digitally, you may find a lightbox useful for trying out different adaptations of the templates. You can buy a lightbox or make one from an old drawer with a white Perspex sheet on top and a fluorescent light strip inside. Use the lightbox to collage images together by overlaying different elements of the composition on separate sheets of paper. You can use tracing paper on its own to almost the same effect, but it is not quite as good. Some artists use a lightbox built into their drawing board so that they can switch between the two without having to move.

Characterization

Fantasy art exists to tell a story. This may be the depiction of a battle, a contest between good and evil, or a fairy-tale scene. Whatever the case, the key to a good story is characterization. Who are your characters and why would a viewer be interested in them? The subjects of fantasy art — people, creatures, otherworldly beings, even landscapes — need to demonstrate compelling personalities that extend the story in the viewer's mind far beyond the painted scene.

Every figure in this book displays a distinctive personality, from the battle fury of Albert Landlock (page 16), racing to meet the enemy, to the radiant Fenghuang (page 86), soaring over a fog-shrouded mountain. Their posture, accessories, context and colours all speak to who and what they are. Copying images like these is a good way to learn the tricks of visual characterization, which you can then apply to your own drawings.

Templates as reference

Instead of piecing together elements of the templates, you can use them as reference for drawing your own characters from scratch. Here, templates of four different creatures are used as inspiration for drawing a dragon's head.

CHARACTER PROFILING

The more you know about your characters — where they live, what they eat, how they move, how they react to surprise — the better your portrait will be. One trick used by artists and writers alike is to create a character profile for each subject as if you were going to role play them. Some of the things you would want to know include:

Personal details
Archetype (hero, villain, etc) / Name / Age / Gender

Appearance
Height / Weight / Physique / Hair, skin and eye colour / Colour and type of hide, skin, scales, fur or feathers / Number and arrangement of limbs / Type of diet / Distinguishing marks and how they were acquired / Clothing style / Accessories (hat, jewellery, etc) / Weapons and their use

Home life
Family / Other relationships / Place of birth / Current residence / Hobbies and pastimes

Curriculum vitae
Education / Intelligence / Occupation / Economic status / Special skills

Personality
Motivations (needs, wants) / Weaknesses or flaws / Strengths / Fears / Spiritual beliefs or lack of them / Philosophies / Ambitions

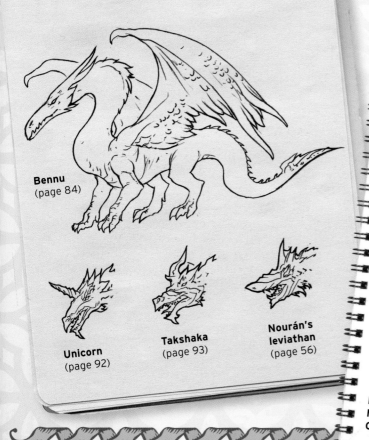

Bennu
(page 84)

Unicorn
(page 92)

Takshaka
(page 93)

Nourán's leviathan
(page 56)

Character development

Start thinking about the personality of a new character, such as this female Garuda sorcerer, before you even pick up a pencil or stylus. Keep adding to the character's profile as you develop its appearance and pose, such as what its powers might be. Think also about suitable colour schemes.

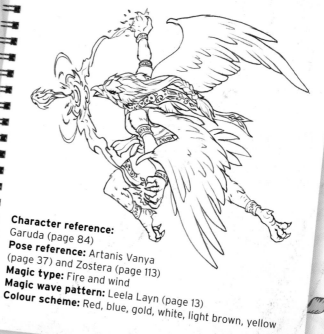

Character reference:
Garuda (page 84)
Pose reference: Artanis Vanya (page 37) and Zostera (page 113)
Magic type: Fire and wind
Magic wave pattern: Leela Layn (page 13)
Colour scheme: Red, blue, gold, white, light brown, yellow

SETTING THE SCENE

The setting provides the context for the fantasy story – a fire-breathing dragon swooping low over the battlements of a castle suggests a very different story from the same dragon circling an isolated volcanic peak. The way in which figures are integrated into the setting, using scale, perspective, composition and lighting, also helps to reveal the plot. You can find plenty of reference material for fantasy backgrounds in books and on the internet, and there are also ten background templates on the following pages. You can use a background template in its entirety, or crop into a smaller section for a close-up scene. Like the character templates, they can be copied exactly or adjusted as needed.

Perspective

Artists use the rules of perspective to help create the illusion of a three-dimensional scene. Perspective is determined by the horizon line. In most paintings, this is set in the middle of the canvas, at eye level. Set it lower and the viewer will see the scene from above. Set it high, and the viewer will be lower than the action. The horizon line also defines the perspective of the objects within the picture. In the real world, parallel lines (such as the lanes of a road) appear to converge in the distance.

In a painting, the illusion of distance is created by having objects grow smaller as they approach one or more vanishing points. Set on the horizon line, vanishing points define the shape of the structures and features within the painting, and the foreshortening of the figures and objects occupying the space. In practical terms, a gargoyle lurking on the roof of a chapel at the far end of a graveyard will appear smaller than one perched on a gravestone at the front of the painting.

Colours also tend to become muted with distance, known as atmospheric perspective, so to convey that an object is far away, you can fade it.

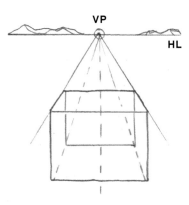

One-point perspective

VP

HL

◀ The lines of the road meet at the vanishing point (VP) on the horizon line (HL). If you draw lines fanning out from the vanishing point to create a cube, you can see that the cube appears to foreshorten as it recedes from the viewer. Foreshortening affects both the objects and figures in your scenes.

▼ Use two-point perspective for objects that appear to be at an angle to the viewer.

Two-point perspective

VP

HL

VP

▶ Foreshortening occurs when an object or figure is viewed at an angle, causing parts of the figure to recede or grow smaller as they point away from the viewer. Note how the body of the Gargoyle (page 89), crouched at an angle, is foreshortened. The use of foreshortening will help to give your figures three-dimensional depth and emphasize their action.

VIEWPOINT

After you decide the story that the painting will tell, you need to figure out how you want to tell it. The way a viewer sees the story determines his or her visual and emotional response to it. Is the viewer at eye level with the characters, seeing the scene as they do? Does the observer look down from above, taking a physically and emotionally more distant bird's-eye view? Or is the position that of a fallen foe, or a lurking scorpion awaiting its chance to strike?

Size and scale

Scale — the relative size of the elements in a painting — is the key to many artistic illusions. We assess the size of an object by comparing it with something else. For example, how do you show the size of a giant in a painting the size of your hand? You show the giant's size in comparison to other objects that the viewer is familiar with — trees or a proportionally tiny human, for example. Scale is also one of the ways in which the artist tells the viewer what is important in a painting. Most of the time, your subject will be the biggest object in the painting, but not always. Fortunately, the artist has other ways of getting his or her point across, such as composition and lighting.

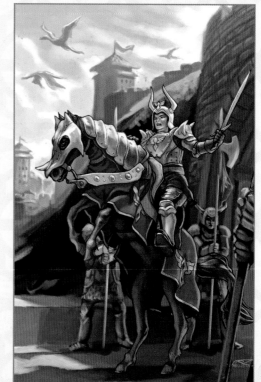

▲ The size of the giant Kumbhakarna (page 48) is visually defined in comparison to ordinary-size people and objects. The use of foreshortening also emphasizes his size.

▼ Thjostar the Slasher (page 32) is the best-lit element in the painting, which helps to identify him as the hero of the story.

Composition

Composition — the arrangement of objects and colours in the painting — plays a big role in directing the viewer to the most important elements. The chevalier Faucon de Valois is not the largest object in the painting, but the eye goes straight to him. The compositional trick here is the contrast between the diagonal formed by his rearing horse and the verticality of all the other elements in the painting. The diagonal is out of step with the rest, and that difference draws the eye, leading it straight to the figure of the knight.

However, there is more at work here than the play of diagonal against vertical. The knight and horse are also the brightest elements in the scene. The chevalier's armour is crisply detailed and shiny. The blue of his horse's trappings is the most intense swathe of colour in the picture. It is even more saturated than the banner at his back. Everything else in the painting is softly rendered and shadowy by comparison.

▲ The viewer's eye will focus on what it sees most clearly. In the painting of Faucon de Valois (page 54), colour and crisp rendering help to define the chevalier as the focal point.

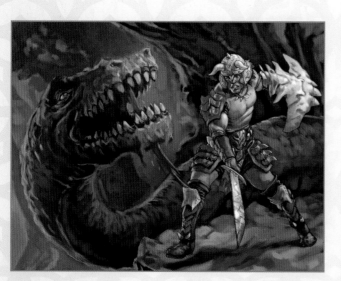

Lighting and story

How you light your figures sends many messages to the viewer, who will expect the most important objects in the painting to be the best lit. It is the same in the movies, where the star is the one who gets the best lighting. Looking at Thjostar the Slasher, we expect him to be the hero, because he is the one bathed in light. That same light picks out the monster's enormous teeth and preternaturally bright golden eye, reinforcing the compositional connection between monster and slayer.

Note, too, the way man and beast look at each other. Thjostar's face is grim and determined; the monster's gaping jaw suggests hunger. In addition to being linked by composition and lighting, they are connected by their respective purposes: the beast, to eat the slayer; the slayer, to kill the beast before it eats him. The painting tells the story of their struggle, and gives the viewer more than a few clues about its eventual outcome.

1 MOUNTAIN PASS

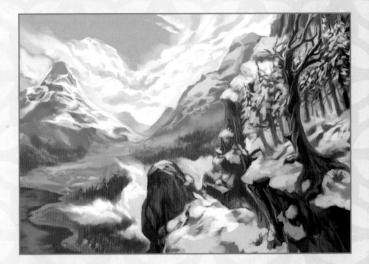

Snow-capped peaks guard the entrance to a fertile valley watered by mountain streams. Dense stands of fir run all the way down to the chill waters of the lake. The lake's depth and denizens are the stuff of legend. This could be the taiga that Baba Yaga calls home, or the rich, rugged landscape where the Thunderbird takes flight. Dragons and Yeti, elves and dwarves may have sheltered in its crags – humans, too, and they will fight to call it home.

Suggested Characters

35 Waghest Raygor

54 Baba Yaga

56 Yeti

104 Thunderbird

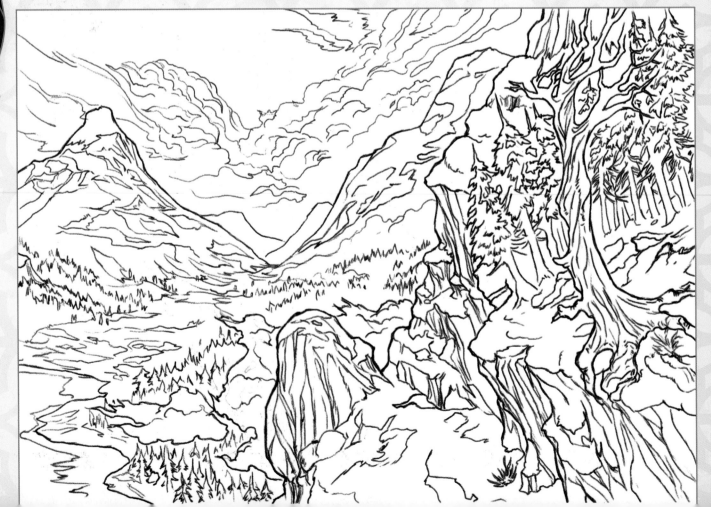

2
BEYOND THE CLOUDS

Gods and immortal heroes often dwell in palaces above the clouds, hence the need for winged steeds and feathered messengers. Here, twin dragons call to mind the celestial abode of the Jade Emperor, but with a few minor changes to the drawing, they could become the horses of a sun god's chariot speeding to their nightly rest. Those stately columns could just as well mark the entrance to Mount Olympus or the twilight glories of Valhalla.

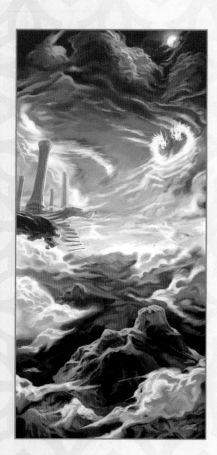

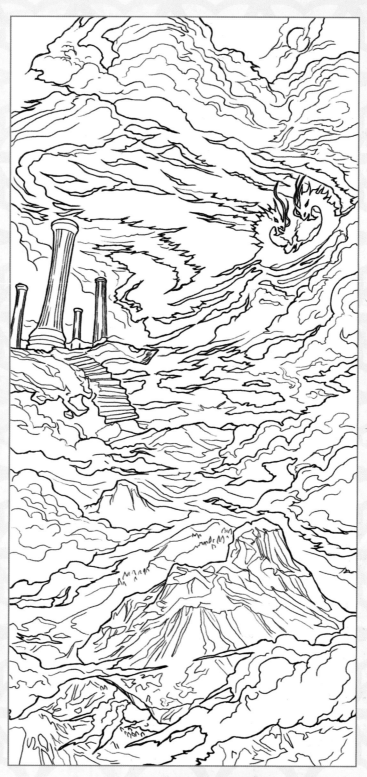

Suggested Characters

74 Loki

76 Zeus

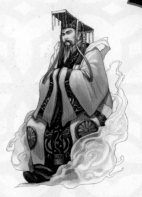

79 The Jade Emperor

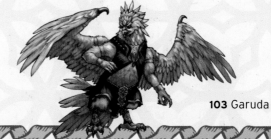

103 Garuda

3 ENCHANTED CAVERNS

From King Arthur and the Knights of the Round Table to Qin Shi Huang and his terracotta army, legends are seldom permitted to die. Instead, they lie in suspended animation in magical caves beneath the world's great mountains, waiting for the call to awaken to their nations' defence. These caves are countries unto themselves, with waterfalls and pools, secret passages and walls of precious crystals. Among mortal races, only dwarves can safely venture inside, because they honour the earth and do not reveal its secrets lightly.

Suggested Characters

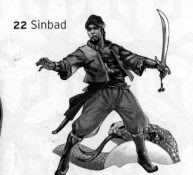

22 Sinbad

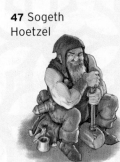

47 Sogeth Hoetzel

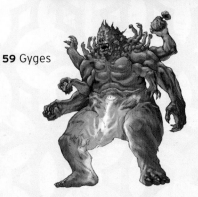

59 Gyges

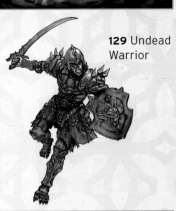

129 Undead Warrior

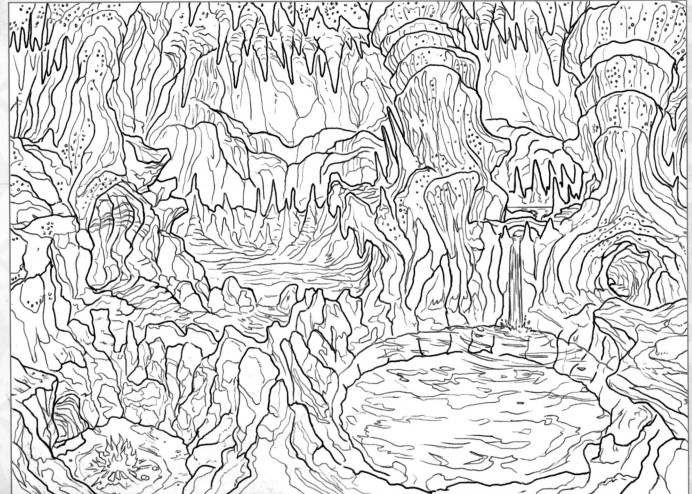

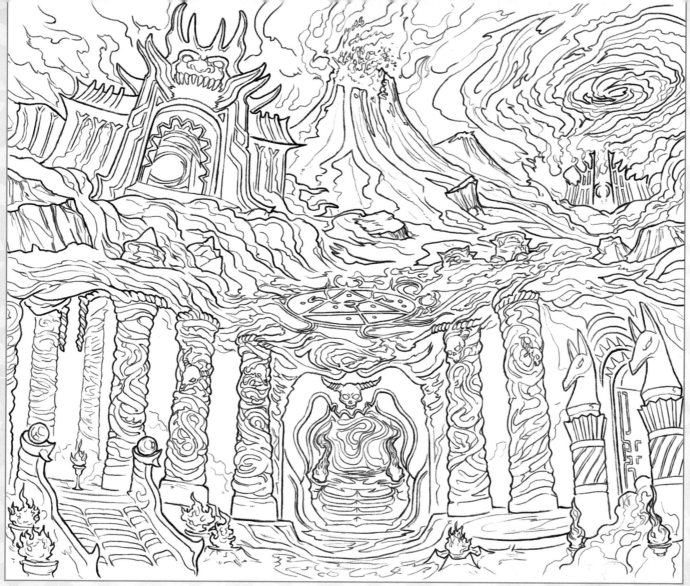

Suggested Characters

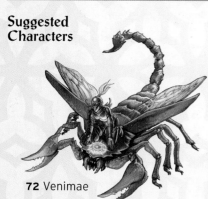

72 Venimae

89 Beheerzal

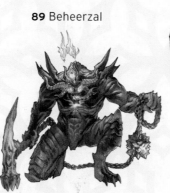

95 Empusa

112 Chimera

4
WHERE DEMONS REIGN

In a volcanic world ruled by demons, a subterranean shrine to infernal gods guards the secret to dark powers and the key to limitless wealth. What enterprising devil could resist – even if the bones of those who failed become part of the sanctuary's decor? All the quest requires is surviving the lethal landscape, penetrating the strong enchantment barring the gate, defeating the shrine's fearsome guardians and harnessing the magic of the talisman suspended above the altar.

5 INTO THE WOODS

An arm-like branch, sleeved with ivy and hallucinogenic red and white toadstools, points the way to the heart of the forest, where elves make their home. The path looks ordinary enough, but why do the trees seem to pull you in? What waits for you beyond those arching branches? Will you stumble into a fairy ring and be forced to dance your life away? Or will you fall prey to wolves or an assassin's bolt?

Suggested Characters

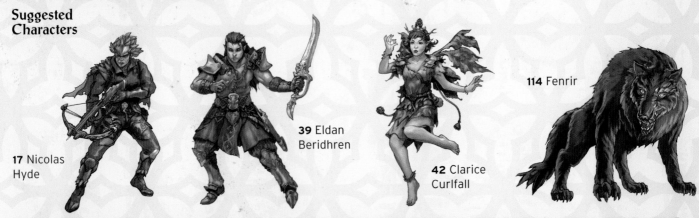

17 Nicolas Hyde

39 Eldan Beridhren

42 Clarice Curlfall

114 Fenrir

6
UNDERWATER LAIR

A whirlpool churns the waters not far from a rocky shore. An experienced sailor sees the danger, but not necessarily the cause, or what lies beneath the treacherous waves. Precious coral and pearls jewel the depths. Fabulous wrecks from the Americas and Indies, and lost masterpieces from Greece and Rome, lie half-submerged on the ocean floor. Richer and more elusive still are the cities of the merfolk, a landscape as alien as any on the moon – and no less dangerous.

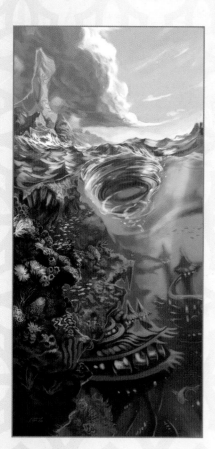

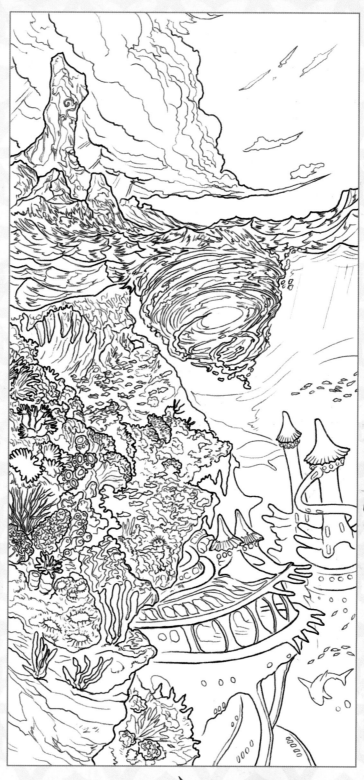

Suggested Characters

21 Tyr Thorsen

70 Nourán

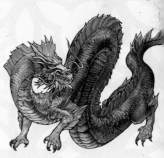

100 Jiaolong

142 Triton Warrior

7
SORCERER'S DEN

In a dank cellar dug beneath a desecrated temple, the foulest sorceries take shape. Torches fuelled by tallow rendered from the fat of animals (and humans) sacrificed to infernal powers light a tortuous path to the heart of evil. Here, the fates of kingdoms are decided, hearts are turned from their true purpose and the dead give voice to prophecies false and true. Will the hero succumb to the sorcery or destroy the root of its tainted power?

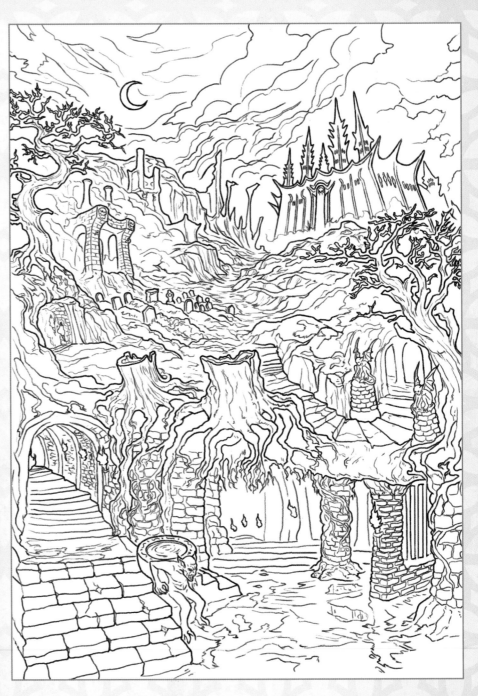

Suggested Characters

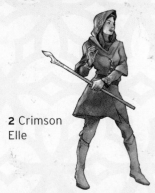

2 Crimson Elle

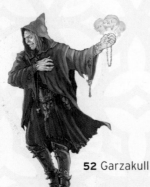

52 Garzakull

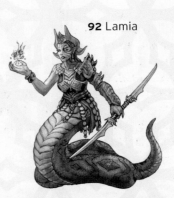

92 Lamia

138 Boggel

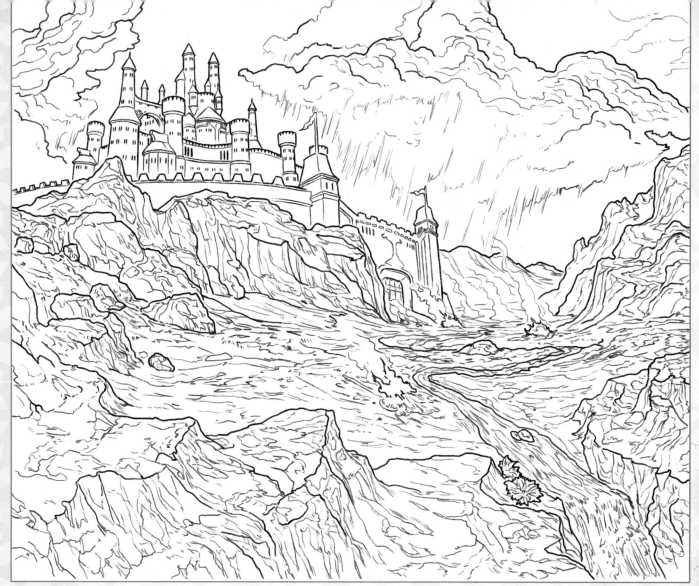

Suggested Characters

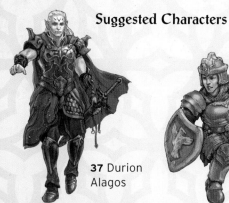

37 Durion Alagos

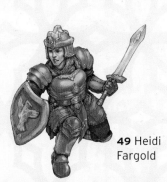

49 Heidi Fargold

99 Tiamat

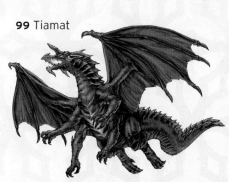

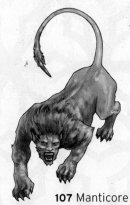

107 Manticore

8

UNDER SIEGE

The gods are angry. The siege looks as if it may last as long as the Greeks' ten-year battle on the plain of Troy. The castle walls, enchanted generations before, turn aside both projectiles and rams. Its granite foundation resists the best efforts of the attackers. Monstrous beasts lurk in the rocky crevasses. Even the thunderbolts of the Storm Lords fall harmlessly on barren ground. However, the fortress may yet be taken by stealth, defeated by hunger or overwhelmed by its defenders' despair.

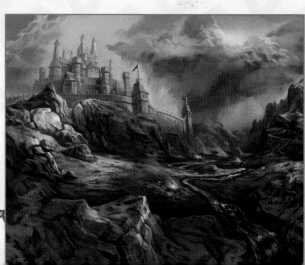

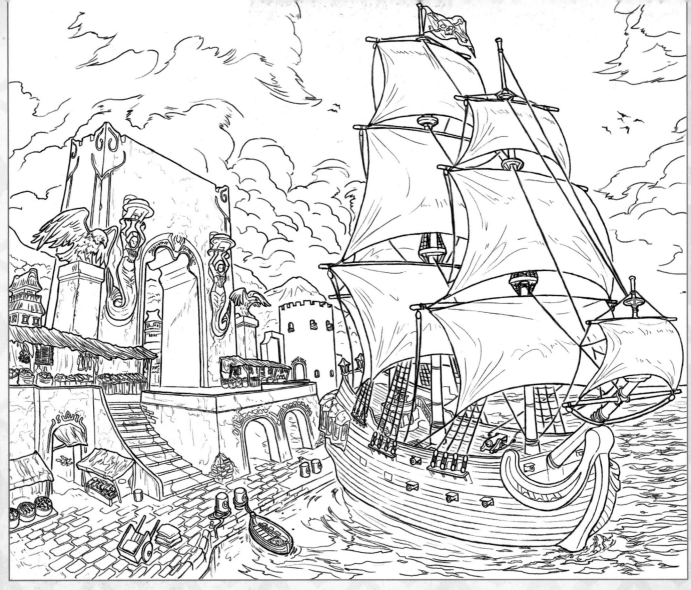

Suggested Characters

26 Rodan Niero

30 Joanna

62 Princess Bong Cha

110 Gargoyle

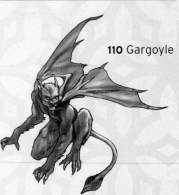

9
PIRATE GALLEON

The pirates docked on market day, Jolly Roger flying high, and all the merchants fled. Why was there no warning of the villains' approach? Why were the cannons of the gun tower silent? For that matter, why have the pirates not fired on the town? Could it be a diplomatic visit, queen of the seas to ruler of the land? No, it could not be so simple or benign. There must be mischief afoot. Why else would the princess bring a dark mage and set her gargoyle to watch?

10
MAGE'S MANSION

Finally, a lair where a wizard of any age could feel at home – or travel to another time using the latest in tomorrow's technology under the watchful eye of an ancient gargoyle. The dome's windows open onto sunlit vistas from the other side of the world, but sinister creatures lurk in the nighttime world of the mansion itself. Do they await the mage's command to wreak havoc, or are they probing the mansion's defences in hope of stealing the source of the magician's power? Each room sets the stage for a different story – a haunting in feudal Japan, palace intrigue in medieval Europe, dark deeds in a Victorian library or a destination more exotic yet.

Suggested Characters

3 Wizard Prince
5 Graviton
6 John Seco
7 Zavortan
24 Shay Ieira

43 Rosie Mylan
60 Princess Elena
62 Princess Bong Cha
96 Mora
122 Leyak

123 Rokurokubi
136 Kappa
148 Watcher

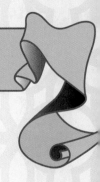

APPLYING COLOUR

Colour choices and placement have a dramatic impact on any artwork. Professional artists use certain colour combinations – as well as contrasting values – to draw the eye and emphasize the key elements of a painting. Colour also exerts a subtle yet significant influence on the mood and emotion of an image.

Colour wheel

The relationship between colours is shown using the colour wheel. Red, yellow and blue are the primary colours (marked 'P'), so called because they cannot be mixed from other colours. When two primaries are mixed together, they produce the secondary colours (marked 'S'). Red and yellow make orange; red and blue make purple; blue and yellow make green. The colours in between, created by mixing varying amounts of a primary and secondary colour, are the tertiary colours (marked 'T').

The colour wheel is valid for digital artwork as well as traditional media. Digital colours can be 'mixed' with predictable results by overlaying hues with varying levels of opacity.

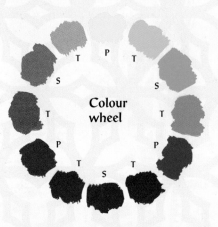

Colour wheel

▶ The painting of Graviton (page 12) uses harmonious and complementary colour combinations. Notice how vivid the complementary red vest appears in contrast to the green of the force field, while the harmonious gold of the helmet creates a subtler effect.

Harmonious and complementary colours

Colours that sit next to each other on the colour wheel, such as red and orange, are called harmonious colours. They create a harmonious effect. Complementary colours lie opposite each other on the colour wheel. They are also known as contrasting colours, because they enhance each other's brightness and create a dynamic effect when used together. Complementary colours are often used as accents to enliven a colour scheme.

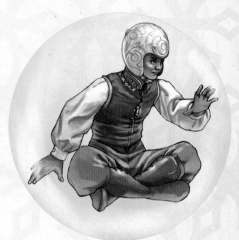

Contrasting values

The term value (or tone) simply describes the lightness or darkness of any colour, regardless of its hue. Paintings with little or no tonal contrast look dull and bland, while differences of tone can add visual punch and create a feeling of depth and three-dimensional form in the painting.

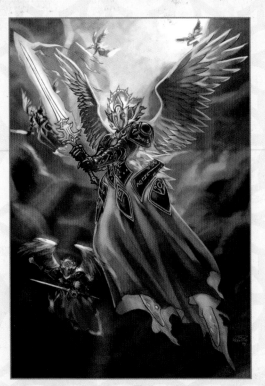

◀ This painting of a Power angel (page 72) relies on contrasting values for its impact. Notice how the shadows and dark elements intensify the apparent heat of the oranges and the pale flames surrounding the upraised sword.

COLOURS AND MOOD

Colours have strong symbolic meanings, and make a powerful contribution to the mood and atmosphere of a painting. For example, red is often associated with danger or conflict. Most blues and greens impart a calm, tranquil atmosphere. Colours also have an association with temperature: red, orange and yellow are warm colours; blue, cyan and green are cool. However, colours may vary – certain greens appear unhealthy, and the hottest flames burn blue.

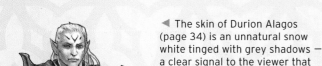

◀ The skin of Durion Alagos (page 34) is an unnatural snow white tinged with grey shadows — a clear signal to the viewer that this elf has a dark purpose.

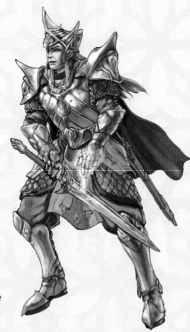

▶ In contrast, Calanon (page 34) has natural skintones, and his use of white magic is emphasized by his shining armour and the turquoise light passing from hand to sword.

Colour schemes

When deciding what colours to use for your painting, think about what the viewer will expect to see. Even a black-and-white sketch will lead you to certain assumptions — a golden crown and rosy cheeks for a princess, for example. The artist must choose whether to work with the audience's expectations, or attempt to shock them with a surprising scheme. Ask yourself how this decision might influence the viewer's reaction to the painting.

The light source may also influence the colour scheme. Neutral light reveals a surface's natural colour, while a strongly coloured light will visibly tint all the surfaces that it illuminates. Consider how perceived colours are different during bright daylight or a vivid sunset, for example.

If you have a strong feeling for the colour you wish to apply to a particular element of a painting, choose other colours that work well alongside it — a complementary background colour is always a good choice.

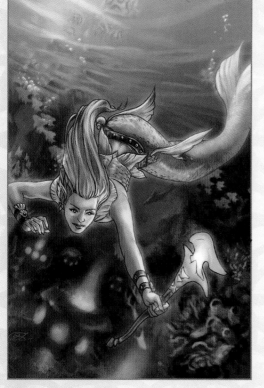

▶ Experiment with individual colour combinations as small thumbnails. You can then create a rough colour sketch of the painting to test your favourite schemes. This allows you to experiment with many colour schemes before committing yourself.

◀ The primary light source in the painting of Zostera (page 112) is the glaive that glows in the mermaid's left hand. Note how the play of light and shadow on her face is tinged with the same aquamarine colour.

LIGHT AND SHADE

For the novice artist, one of the hardest things to master is lighting — where the light source is and how it affects the character. This means getting the correct proportion of highlights and shadows, and making sure they are consistent throughout the image. If you find it difficult to imagine where highlights and shadows should appear, set up a mannequin or action figure toy and direct a spotlight on it. Take photographs of the figure in different lighting for reference.

The colouring process

The colouring process will vary, depending on your choice of media and preferred way of working. Most professional fantasy artists colour images digitally, which has the advantage that colour can be applied without damaging the original drawing. It is also easier to correct mistakes and alter colour schemes. The following sequence describes a basic procedure for colouring digitally using Photoshop, but the same principles can be applied to other programs. Refer to a manual or online help for more detailed information on your particular software.

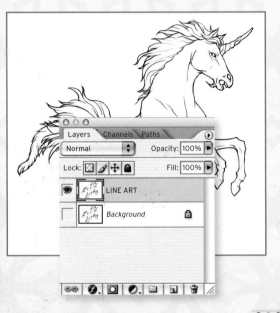

1 Duplicate the Background layer and label it Line Art or something similar. Switch off (but do not delete) the Background layer with the original drawing on it, so that you cannot see it but can go back to it if necessary.

2 Select the appropriate colour mode — CMYK if you plan to print the artwork; RGB if it is for screen only. Then make the Line Art layer transparent by choosing Multiply at the top of the Layers palette. This makes all white areas of the image transparent, and will allow you to see the line drawing through the layers of colour.

3 Start by laying down the base colours, remembering to group each colour or type of item together on separate layers. To colour a particular area of your artwork, you first need to select it (the selected area is defined by a dotted line). There are several tools on the toolbar that you can use. The Marquee tool is useful for selecting simple geometric shapes; the Lasso tool for drawing around an area manually; and the Magic Wand for selecting defined areas where the colour or tone is distinct.

LAYERS

Most image-editing programs allow you to put different elements on different layers. The layers are independent of each other, so you can work on each layer individually without affecting the others. This allows you to experiment with different colours and compositions more easily. You can switch the visibility of each layer on or off, reorder the layers, apply different digital effects to each one, adjust the opacity and transparency of each layer and so on.

Try to get into the habit of naming and organizing layers in groupings that make sense to you. Being able to find what you need easily, and being able to change layer orders quickly, are important to your work flow. For example, you can allocate one layer per colour, or one layer per object. Assigning a colour to its own layer makes it easier to alter that colour at a later stage. On the other hand, if you want to add effects to a particular object, assigning it to its own layer will help. The method you choose will depend on how you like to work and may change from one painting to the next.

Make sure that you save a copy of the image in a format that retains the layers, so that you can edit it later if necessary.

Marquee

Lasso

Magic Wand

Brush

Paint Bucket

Eraser

Dodge and Burn

Eyedropper

Toolbar

4 After selecting an area, choose Select > Modify > Expand. Set the Expand By value to 1–3 pixels. This expands the area so that the edges are slightly under the linework; this avoids getting pale fringing between the lines and the colour. Anything missed can be touched up later with a few brushstrokes.

5 Create a new layer for the colour. You can either select a colour from a palette or create your own. It is also easy to match an existing colour in your work by clicking the Eyedropper tool, then clicking on the colour you wish to match.

DIGITAL COLOURING TIPS

It is well worth spending some time exploring the various options available in your particular paint program – interesting effects can be discovered through making mistakes.

Special effects

Most paint programs provide lots of filters and effects to enhance your images. Use them with discretion, rather than just because they are there, but do be adventurous. The History palette will help you to repeat an effect.

Adding texture

Texture adds interest and realism to your paintings. Make marks with real objects, such as a toothbrush or sponge, using black paint on white paper, and scan the results. Most paint packages will allow you to create custom brushes from your scanned marks, or the scan can simply be overlaid onto the painting.

Coloured lines

Although a black ink outline is standard in comic-book art, you do not have to keep it like that. Try colourizing the line drawing (use the Hue and Saturation panel in Photoshop).

Canvas ground

Adding a canvas ground can affect the whole impression and style of your art. If you can scan something, it can be used as a ground – textured paper or canvas, for example. Simply lay the scan, multiplied (transparent), over the painting. The texture will set the colour and textural harmony for the whole piece.

6 Fill the selected area using the Paint Bucket (Fill) tool. Make the layer transparent by choosing the Multiply option. Adjust the opacity of the colour using the percentage slider.

7 Use a brush to paint darker shadows and lighter highlights on separate layers. You can choose from a variety of brush types and sizes. A useful technique is to select the area to be coloured (Step 3), then click on the layer you wish to paint on. You can then use a large brush to paint the area quickly; the area selection creates a mask that will keep the colour contained within the edges. You can also make tonal adjustments for highlights and shadows using the Dodge tool to lighten areas, or the Burn tool to darken them.

8 Continue building up texture and colour. Switch off the linework layer now and again so that you can see if you have missed any areas or little spots. If you need to touch up any missed areas, make sure that you do the retouching on the right layer.

INDEX

A

acrylics 119
Adobe® Photoshop 121
adventurers 24—25
Agni Mukha 45
Albert Landlock 16
angels 70—73
Anubis 62
armour 16—17, 19, 33, 34, 35, 37, 72
Artanis Vanya 36—37
ArtRage 121
Arun Nakha 30
assassins 20—23
Atargatis 110
Athena 62, 63
Alila Fayza 17
Autodesk® Sketchbook Pro 121
Aysel Gwynith 39
Azrael 70

B

Baba Yaga 45
backgrounds 128—137
Bamdar Silverslayer 43
bandits 28—29
barbarians 30—33
beast masters 56—59
beasts, fantasy 88—95
Beheerzal 74
Bellerophon 90
Bennu 84
Beyond the Clouds (background) 129
birds, mythical 84—87
Black Ash 114
board 118
Boggel 108
Brisingamen 64
Brunhilda the Valkyrie 53
brushes 119

C

Calanon 34
camouflage 21
canvas ground 141
Cara & Lara 111
castle 135
caverns 130
Centaur 88
characterization 125
characters:
 creating 122—125
 development 125
 profiling 125
Childeric the Frank 30
Chimera 90
Clairre Ashen 20
Clarice Curlfall 38
clerics 26—27
clouds 129
colour schemes 139
colour wheel 138
coloured pencils 119
colouring process 140—141
 toolbar 140
colour(s):
 applying 138—141
 character and 26
 complementary 138
 contrasting values 138
 harmonious 138
 light sources and 139
 mood and 138
 tone 138
composition 127
computers 120
 software 121
copying: materials for 118
Corel® Painter 121
Cormanella 99
Coyote 62, 67, 106
Crimson Elle 10
crop marks 122
Cyclops 25

D

Dark Raven 10
Darsoz 21
demons 74—77
 subterranean world of 131
devils 74—77
digital work 120
 colouring process 140—141
 toolbar 140
 colouring tips 141
 layers 140
 paint programs 121
dino-beast 58—59
dragons 78—83
Duendes 76
Durion Alagos 34
dwarves 42—43

E

Eldan Beridhren 35
Elfina Brucie 40—41
elves 34—37
Empusa 77
Enchanted Caverns (background) 130
enlarging 122
erasers 118
Eyes in the Sky 115
Ezekiel 70

F

fairies 38—41
familiars 114—115
Faucon de Valois 54—55
Fenghuang 86—87
Fenrir 91
Firouz Mirza 52
foreshortening 32—33, 53, 73, 126
Freya 64—65

G

galleon, pirate's 136
Galligantus 99
Gargoyle 89
Garuda 84, 93
Garzakull 44
Ghoul King 103
Ghoul Queen 103
ghouls 102—103
giants 48—49
Gina Rosenwood 26
goblins 108—109
gods and goddesses 62—69
gouache 119
Grandmother Spider 67
graphics tablets 120
graphite paper 118
graphite pencils 118
Graviton 12
Green Drake 80
Gremilla 108
gremlins 108—109
grid: using 122

H

Hades 57
Hag 96
Hagen of Burgundy 53
Hecatonchires 49
Heidi Fargold 43
Heimdall 64
Hell Warrior 74
helmets 31
highlights 40, 42, 45, 80, 105, 139
Hkmur the Scout 100—101
Hllud-War 98
horsemen and -women 52—55
horses 52—55
 water 94—95
Huanglong 80
Hymir Grull 49

I

imps 114—115
incubus 76
inking 123
inks 119
Into the Woods (background) 132
Iron Dragon 82—83

J

Jade Emperor 66
Jar Toram 30
Jareed 58—59
Jiaolong 81
Joanna 29
John Seco 12

K

Kanya 93
Kappa 105
Karren Kruse 42
Kelpie 94—95
Khutulun 52
Kismet Grey 22—23
Kitsune 106—107
Kublai Khan 30
Kumbhakarna 48

Griffin 89
Guan Yin 66
Gyges 49

L

La Qierak 31
Laksmita 56
Lamia 75
layers 140
Leela Layn 13
leviathan 56
Leyak 97
light and shade 139
lightbox: using 124
lighting 127, 139
Lilith 75
Loki 62, 64
Lucienne Sol 14–15

M

mages 12–15
Mage's Mansion (background) 137
magic 10, 12
mansion 137
Manticore 88
markers 119
Marzono 16
media 118–121
Medusa 62
Melusine 110
merfolk 78, 110–113
mood: colours and 138
Mora 77
motion: indicating 45
Mountain Pass (background) 128
mythical figures 78–79
 beasts 88–95
 birds 84–87
 dragons 80–83

N

Namhaid 109
Nessa Morwen 35
Nicholas Hyde 21
night scenes 36
nightmares 96–97
Nocnitsa 96
Nora Vaundu 46–47
Nourán 56

O

Odin 91
Odysseus 25, 111

ogres 78, 98–101
Oilel Orin 44
oils 119
Oni 104
orcs and ogres 98–101
outlaws 28
Owankane 28

P

paint programs: digital 121
Paint Shop Pro 121
paints 119
paper 118
Parvati 60, 68–69
pastels 119
Pegasus 90
pencils:
 coloured 119
 graphite 118
perspective 126
Philip of Macedon 30
Phoenix 85
Pirate Galleon (background) 136
pirates 28–29
Power 72–73
Prince Alexei 51
Prince Rayner Silverstar 50
princes and princesses 11, 50–51
Princess Bong Cha 51
Princess Elena 50
Principality 71
printers 120
Pyewacket & Kin 115

R

Reddin Bayram 20
reducing 122
registration marks 122
Robin Hood 20
Rodan Niero 27
Rokurokubi 97
Rosie Mylan 38

S

Sacagawea 24
scale 127
scanners 120
scanning 123
scene: setting 126–137

scholars 26–27
Sequina 24
Seigoro Kazuki 17
Selkie 92
Seraphim 71
settings 128–137
Settwerder 98
Shakti 68
Sharkam 18–19
Shay Ieira 26
Shiva 61, 68
siege 135
Sinbad 25
Sir Henry Morgan 29
Siren 111
Sixzo 28
size 127
sketchbook 118
software 121
Sogeth Hoetzel 42
sorcerers 44–47
Sorcerer's Den (background) 134
special effects 141
Sphinx 91
story: lighting and 127
Strigoi 76
swords 30

T

Takshaka 93
techno-mages 12–15
templates:
 adapting 124
 as reference 125
 scanning 123
 tracing 122
Tengu 105
texture 141
thieves 20
Thjostar the Slasher 32–33
Throne 70
Thunderbird 85
Tiamat 81
Tolkien, JRR 98
tones: contrasting 138
toolbar: for colouring 140
tools 118–121
tracing paper 118
transfer paper 118
transformations 62
Triton Warrior 110
Tyr Thorsen 24

U

Undead Warrior 102
Under Siege (background) 135
Underwater Lair (background) 133
underwater scenes 82
Unicorn 78, 92

V

values (colour): contrasting 138
vampire 77
Venimae 57
viewpoint 126
Vikings 24

W

Waghest Raygor 31
warriors 16–19
 demonic 74
 dwarf 43
 goblin 109
 Undead Warrior 102
Watcher 114
watercolours 119
Where Demons Reigns (background) 131
Wick 109
Wizard Prince 11
wizards 10–11
woods 132

Y

Yeti 48
Yokai 104–107
Yuki Onna 104

Z

Zavortan 13
Zenita 39
Zeus 63
Zhang Rong Fu 27
Zombie 102
Zostera 112–113
Zuntor 11

ACKNOWLEDGEMENTS

Rafi Adrian Zulkarnain
www.rafiadrian.com

From the bottom of my heart, I'd like to express my thanks to Michelle Pickering and Kate Kirby at Quarto Publishing for the opportunity of working on this fabulous project. Special thanks to Jean Marie Ward, the author of the book, without whose wonderful words my artworks would not be so well described or named. Great thanks to my family, mother, father and brothers for their encouragement to finish the book. And last, thank you to all the readers and fantasy art enthusiasts. This book would not have been possible without the devotion and support of the people mentioned above.

Jean Marie Ward
www.jeanmarieward.com

Like any child, it takes a village to raise a book. This one was no exception. Many thanks to artist Rafi Adrian Zulkarnain for painting pictures it was a joy to write about; to our editor Michelle Pickering for creating the best possible frame for Rafi's work and for making my words read almost as well as the art; to Paul Barnett for introducing me to this splendid company; and always, to my husband Greg Uchrin, for everything.